The Evolution of Washington, D.C.

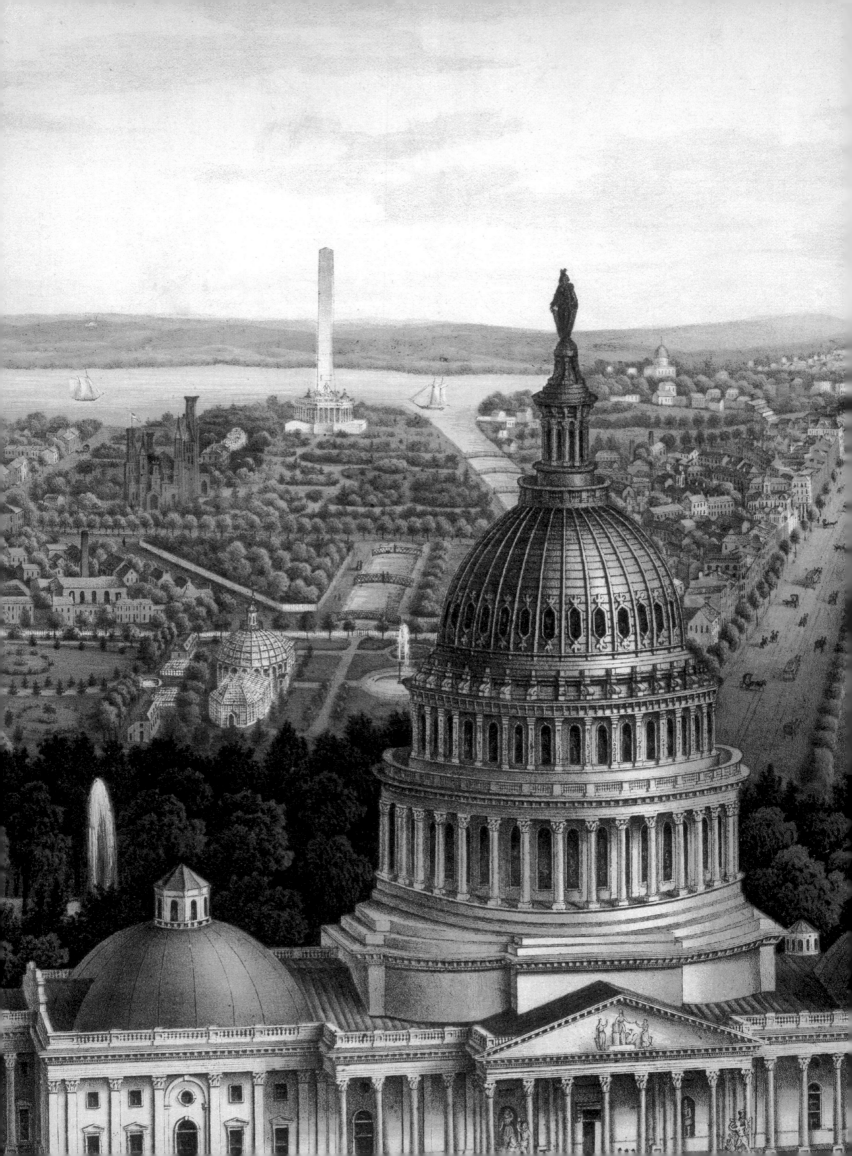

THE EVOLUTION OF
WASHINGTON, D.C.

Historical Selections from the Albert H. Small Washingtoniana Collection at the George Washington University ⟶ JAMES M. GOODE

SMITHSONIAN BOOKS · WASHINGTON

©2015 by the George Washington University

The George Washington University
2121 Eye Street NW
Washington, DC 20052

Distributed by Smithsonian Books
Director: Carolyn Gleason
Editor: Christina Wiginton

This book may be purchased for educational, business, or sales promotional use. For information, please write: Special Markets Department, Smithsonian Books, P. O. Box 37012, MRC 513, Washington, DC 20013

Printed in Lynchburg, VA, by Progress Printing

19 18 17 16 15 5 4 3 2 1

Copy Editor: Joanne Reams
Book Design: Robert L. Wiser

Library of Congress Cataloging-in-Publication Data
Goode, James M.
 The evolution of Washington, D.C. : historical selections from the Albert H. Small Washingtoniana Collection at the George Washington University / James M. Goode ; [foreword by] Laura W. Bush ; [introduction by] John Wetenhall ; [commentaries by] Steven Knapp.
 pages cm
 ISBN 978-1-58834-498-4 (hardback)
1. Small, Albert H. (Albert Harrison)—Art collections—Catalogs.
2. Washington (D.C.)—Buildings, structures, etc. 3. Washington (D.C.)—Maps. 4. Historic buildings—Washington (D.C.) 5. Washington (D.C.)—History I. Title.
 F195.G633 2015
 975.3—dc23
 2014027168

♾ This paper meets the requirements of ANSI/NISO z39.48-1992 (Permanence of Paper)

Case: *Panoramic View of Washington City, from the Dome of the Capitol, Looking West,* colored lithograph published by Edward Sachse, Baltimore, 1856. See pages 36–37 and 42–43 for comparative views.

Frontispiece. The Capitol as completed in 1865. See pages 42–43.

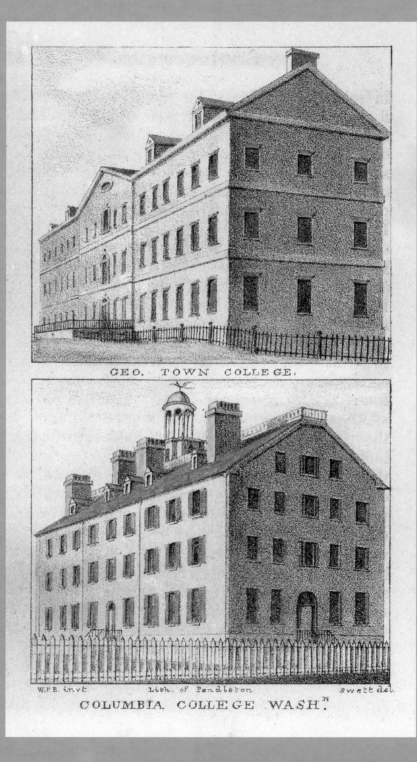

GEO. TOWN COLLEGE.

W.P.E. invt Lith. of Pendleton swett del.

COLUMBIA. COLLEGE WASH.ᴺ

The first two colleges in Washington were Georgetown and Columbian (now the George Washington University). See pages 62–63.

Foreword

Washington, D.C., is home to some of our nation's most historic landmarks, including the Woodhull House at the George Washington University, which is the perfect place for this significant collection of rare maps, prints, and manuscripts pertaining to our capital city.

Our capital belongs to the American people, and it is where we confront our national challenges and celebrate our triumphs. The city of Washington serves as the backdrop for pivotal meetings between world leaders, and it projects American ideals internationally. It is important for the American people to understand the city's history and its own unique development.

The Albert H. Small Center for National Capital Area Studies at the George Washington University is the ideal location for citizens and scholars to study this fascinating history. I am thrilled that Albert Small's comprehensive, unparalleled collection of Washingtoniana documents will become part of the university's curriculum and will educate and inform our children and grandchildren, for generations to come.

Laura W. Bush

Laura W. Bush
First Lady of the United States
2001–2009

Invitation

I began my Washingtoniana Collection over sixty years ago. As a third generation Washingtonian, the story of our nation's capital has always been important to me, and the collection I have assembled shows the city's development. I am drawn to the stories that go with each print, map, book, and letter. I have had a lot of enjoyment acquiring them, and I believe they will truly enrich our understanding of the history of our nation's capital.

One exceptional item in my collection is a print of two steamships that once traveled the Potomac River. I remember my father taking me on overnight trips to Norfolk on one steamer in the print, *District of Columbia*, during the 1930s. That grand ship made quite an impression on me as a boy, and I look back on that voyage fondly to this day. But they are part of another era now—an era that is in danger of being forgotten. That is why I am proud that my collection will live on in this catalogue, and at the George Washington University, where future generations can use it to study and appreciate this great city.

Albert H. Small

Albert H. Small
President
Southern Engineering Corporation

Message

Steven Knapp
President
The George Washington
University

In 2011, the George Washington University was proud to be selected as the new home of the Albert H. Small Washingtoniana Collection. Mr. Small's generosity in sharing his collection with our university and the public illuminates our shared heritage and will provide unique insight into the history of our nation and its capital city.

We at George Washington are striving to be ever more *of*, as well as *in*, Washington, D.C, and we take seriously our role as a vibrant center of cultural and historical discovery and discussion. Albert Small's Washingtoniana Collection is a natural extension of that mission, providing unparalleled opportunities for students and scholars to engage in a lively exchange of ideas and energies, which is so important to the cultural health of not only this nation but also the world.

Mr. Small's commitment to strengthening cultural and educational opportunities for all Americans serves as an inspiring reminder of what it means to be a citizen of the United States and exemplifies the values of service and leadership envisioned by our university's namesake.

Steven Knapp

Introduction

John Wetenhall
Director
The George Washington
University Museum
and the Textile Museum

Albert Small's extraordinary gift of Washingtoniana establishes the new George Washington University Museum as a center of Washington area studies and a place for public audiences to appreciate historical treasures that detail the founding of our nation's capital. These revealing maps, documents, books, and ephemera will provide the basis for classes and seminars, academic studies, museum exhibitions, and digital learning for decades.

This remarkable collection takes its place alongside the treasures of Washington's Textile Museum—the other anchor of this new museum—which brings nearly 20,000 rare and beautiful works of fabric art from cultures around the world. The university's existing holdings, primarily of modern and contemporary art, will also contribute to this rich cultural mix. Together, these wondrous collections may seem disparate in material, content, and geographic origin, but at their core, they tell us about the values and aspirations of human beings: societies that adorn themselves and their environments to express their own identities and beliefs, and a young nation wanting to share its vision of a promising future for all the world to see.

John Wetenhall

Preface

Upon hearing of Albert Small's gift, Chris Coover, Senior Specialist of Books and Manuscripts at Christie's in New York, said: "Albert Small, a native Washingtonian, has methodically assembled the single most significant and extensive collection in private hands relating to the history and development of Washington and the District of Columbia." He added that "this remarkable collection—some 50 years in the making and impossible to duplicate today—is a treasure trove of rare maps, drawings, letters and documents, lithographs, books and ephemera, and is a testament to his passionate enthusiasm as a collector."

Small's first purchase, which ignited his passion for collecting Washingtoniana, was actually made in New York City, on a visit there in 1949. From an antiquarian bookshop there, he purchased a 1905 manuscript notebook, illustrated with photographs, that describes the boundary stones that surveyor Andrew Ellicott laid to mark the perimeter of the District of Columbia in 1791. The stones enclosed the 100 square miles of what would become our capital city.

I have been privileged to be curator of the Albert H. Small Washingtoniana Collection since 1992. I was also working on my Ph.D. from the George Washington University at that time and writing my dissertation on the design and construction of the U.S. Capitol extension.

The 90 items selected for inclusion in this catalogue, approximately one-tenth of the collection in 2015, are important because they tell the stories of pivotal moments in the city's history, and their craftsmanship and artistic detail are also worthy of study in their own right. It is my hope that readers of this catalogue will gain a greater appreciation and understanding of the evolution of our nation's capital.

There are a number of people I would like to thank for their contributions to this catalogue. Robert Perry, a former trustee of the George Washington University, put his unwavering support behind this project. Our assistant curator, Anne Dobberteen, provided invaluable assistance in the areas of research, writing, and editing. Thirteen students from the history and museum studies departments at the George Washington University conducted research. Their unpublished essays are listed in the bibliographies of each item researched. Two professors, William Becker and Laura Schiavo, guided their work. Professors Becker, Tyler Anbinder, and Kenneth Bowling contributed introductions for the three parts to this catalogue. Additionally, professors Bowling and Anbinder developed the two inaugural exhibitions on the founding of Washington, D.C., and Washington during the Civil War.

The potential for engagement with Albert Small's collection is enormous. This catalogue and the two inaugural exhibitions are just the beginning.

James M. Goode

James M. Goode
Curator
The Albert H. Small
Washingtoniana Collection

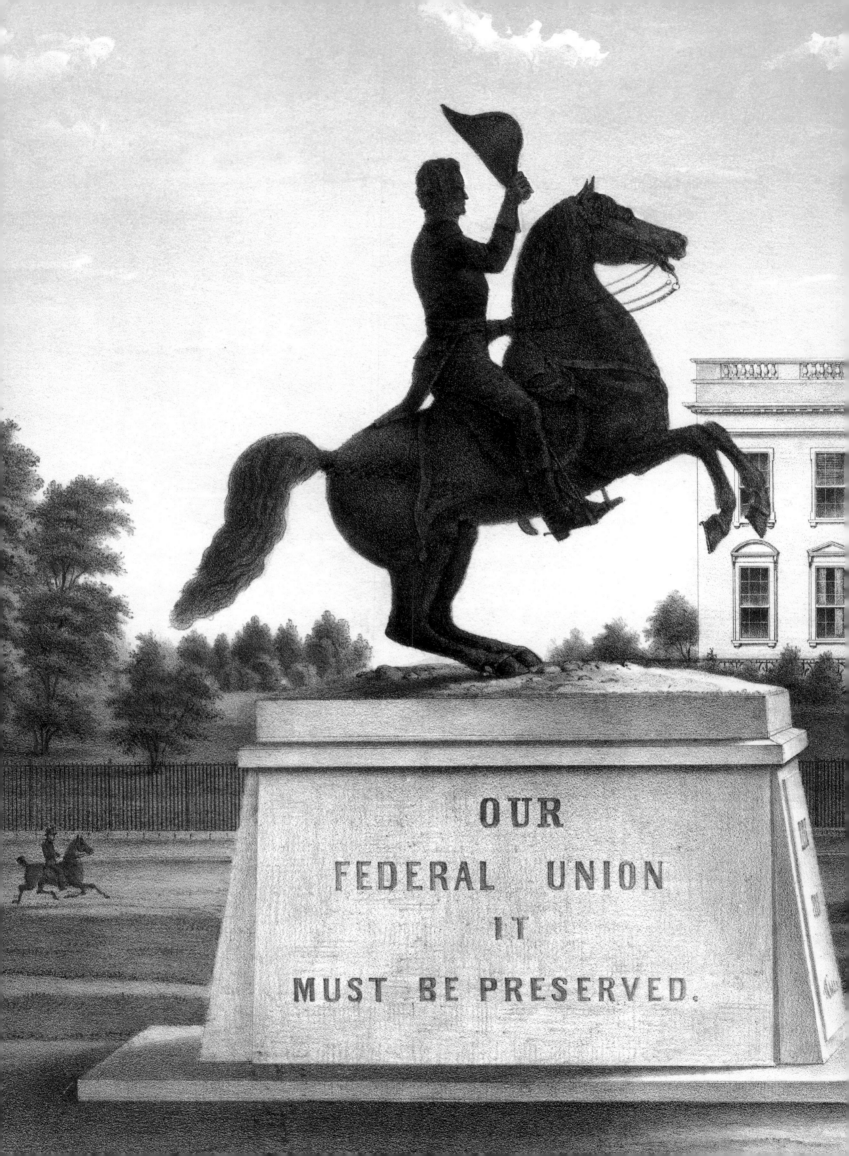

OUR
FEDERAL UNION
IT
MUST BE PRESERVED.

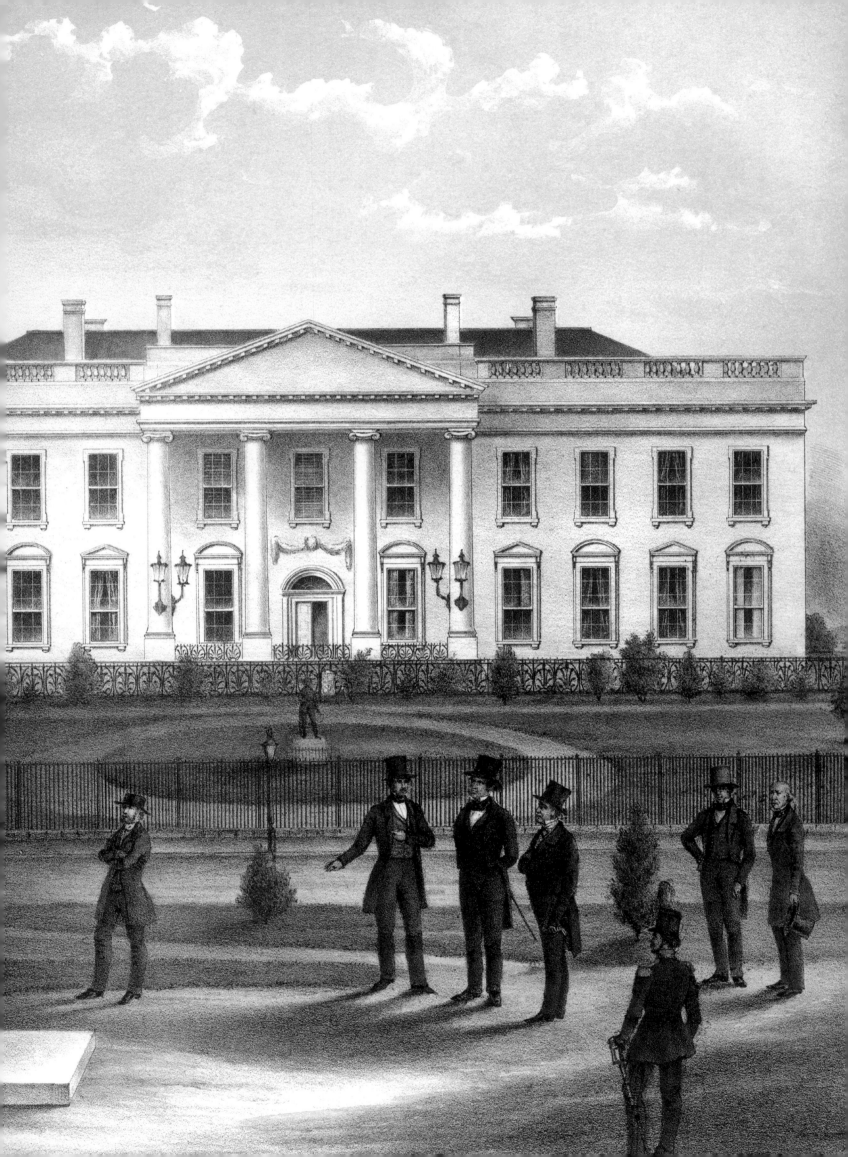

PART ONE

The Early Decades

1790–1860

Overleaf. The equestrian statue of Andrew Jackson was the first bronze sculpture cast in the United States. See page 83.

The Albert H. Small Washingtoniana Collection is rich in resources for the study of Washington, D.C., in the years before the federal government moved to its new capital on the Potomac River in 1800. And because the fight over the location lasted so long and divided Americans, it is also rich in materials that provide new information about federal policies during the early years of the republic.

Standing out among these resources are the maps. Several, including the stunning Priggs "Alligator Map," show the area between the Potomac and Anacostia rivers before it was chosen by Congress in 1790. Others demonstrate international interest in the planned city during its development in the 1790s. Supplementing these are views of the surrounding area, most famously George Beck's 1801 painting.

For scholarship, perhaps the most important part is the collection of broadsides and manuscripts, for they dispel several myths that have long dominated Washington area studies. The broadsides include the 1790 Residence Act and the 1791 Amendatory Act, which allowed for the inclusion of Alexandria, Virginia, within the 100-square-mile federal district. Among the manuscripts, several stand out. Many relate to Daniel Carroll of Duddington, the largest landowner in the city. One is arguably the best description of congressional politics during the early stages of the fight over the capital's location. Others bring forward the role of George Walker, the first person to promote the area and who convinced French-born Continental army officer Pierre Charles L'Enfant to lay his brilliant plan over the entire 6,000 acres between the rivers, an immense urban space for the 18th century. L'Enfant had arrived in New York from Paris in 1778 to join the Continental army. He soon changed his name to Peter, which he retained until his death in Maryland in 1826.

Once Congress moved to Washington in November 1800, the city's first newspaper, the *National Intelligencer*, was established. The Collection contains 48 issues from that first year, which detail many early developments including the celebration of the Fourth of July and the auction of building lots in Rhodes Tavern.

But without question, the richest part of the manuscripts relate to the man who had so long dreamed of placing the seat of federal government on his beloved Potomac, George Washington. They demonstrate his daily involvement with the construction and nurturing of the city during his presidency and even afterward. Others, including his floor plan for two houses on Capitol Hill, illustrate his investment of personal resources to forward the project. But most important, they document his support for L'Enfant and the plan that so captivated the president, even after L'Enfant had resigned, rather than his acceptance of supervision from a nonsupportive federal commission.

The Small Collection is also rich in materials detailing the development of the city and government buildings well into the mid-19th century. One of the most informative features of the catalogue is the large collection of prints selected by Dr. Goode to show the progress of construction and the alterations made on the President's House and the Capitol between the 1790s and the outbreak of the Civil War.

Kenneth R. Bowling
Adjunct Professor of History
The George Washington University

This Northerne part of Virginia (the limitts whereof extend farther Southwards,)is heere inserted for the better description of the entrance into the Bay of Chesapeack.

Noua TERRÆ-MARIÆ, tabula

V I R G I N I Æ

Iames towne

Patowmeck.

Portobacke.

Cedar poynt.

St Clement Isle.

Heron Island.

Chares Ct.

Matapauian

Pascatonay

Patuxent

Point Comfort.

Iames flu.

Yorke flu.

Ri...

Criguack.

Patowmeck flu.

St Mat...

ries Ct.

St Ma...

Calverton

Calvert

Meruton

Anne-Arundell

C Henry

Michaell poynt

S. Gregories poynt

The Cliffs

P E A C K bay

Kent Ct.

C Charles

Accomack

Watkins Poynt

Dorchester Ct.

Talbot Ct.

Wicomese

C...

Smith Island

Sommerset Ct.

Wighto

Nantir...

Whorekill

Fetches Isle

Swansecutt Creeke

Matopongue flu.

Chingoteaq Isle.

Delaware Bay

OCEANVS ORIENTALIS.

Nou...

Pa...

Sea Leagues

5 10 15 20

Map, *Nova Terrae Mariae, Tabula*, published in John Ogilby, *Atlas America: Being the Latest, and Most Accurate Description of the New World.* London: John Ogilby, 1671. 15.5 × 18 in. Albert Small no. 707 (hereafter "AS").

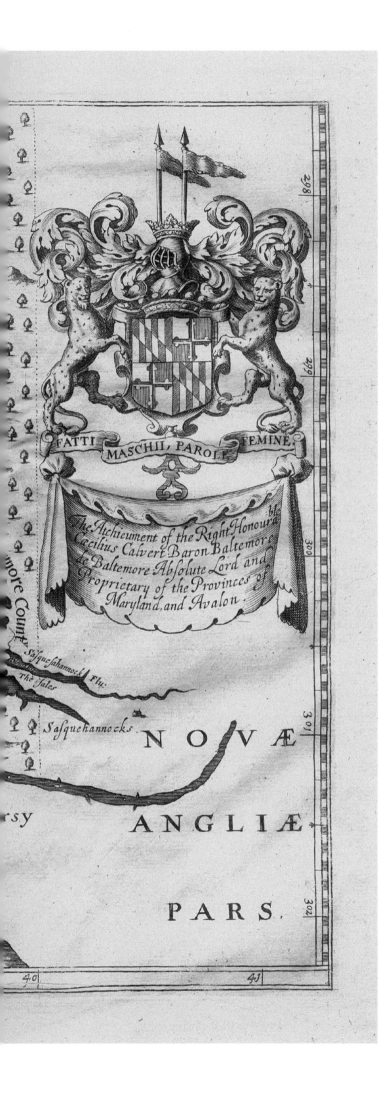

Second Published Map of Maryland, 1671

The history of Maryland began in 1632, when Charles I of England officially granted George Calvert the title of Lord Baltimore and gave him land to found a colony just north of Virginia. Calvert named the colony "Maryland" for the king's wife, Queen Henrietta Maria. Although George Calvert died in May 1632, his son, Cecil, the second Lord Baltimore, made plans to send settlers to the colony. Consequently, in 1633 he published a pamphlet promoting Maryland, *A Declaration of Lord Baltimore's Plantation in Maryland.* This encouraged the first settlers to leave England late that year on two small ships, the *Ark* and the *Dove.* They landed in Maryland in March 1634, established Saint Mary's City, and built a fort on the site. This remained the capital of Maryland until it was moved to Annapolis in 1689.

In 1635 Cecil, the second Lord Baltimore, published a second edition of Father Andrew White's 1634 pamphlet, *A Relation of the Successful Beginnings of the Lord Baltimore's Plantation in Maryland.* Sewn into the front of this later 1635 edition was a map, drawn by Jerome Hawley and John Lewger. It does not show any counties, since the first, Saint Mary's County, was not established until 1637. Located in the right margin are the coats of arms of Charles I and, below that, of Lord Baltimore.

A revised edition of this map, shown here, was published by Charles, the third Lord Baltimore, in 1671. It was the second published map of Maryland and appeared in John Ogilby's *Atlas America.* On the revised map Ogilby corrected the northern boundary of Maryland and added the names of its first 10 counties. Most were named for members of the Calvert family or their friends. These included Anne Arundel County (1650), named for the wife of Cecil Calvert, and Talbot County (1661), for Anne Arundel's sister, Lady Grace Talbot.

When this map was printed in 1671, there were only nine counties in Maryland. The 10th county, Cecil, was not established until 1674. Gov. Charles Calvert, the third Lord Baltimore, named it for his father. He told Ogilby that this 10th county would be added four years later. John Ogilby was born in Scotland in 1600 and became a printer in London. His notable early publications included an English translation of the *Fables of Aesop* and Homer's *Iliad.* By 1675 he had become printer to the king. The third published map of Maryland, drawn by Augustine Herrman at the request of Lord Baltimore, appeared in 1673. It was the first detailed and scholarly map of the colony and remained in use into well into the 18th century.

[15]

The Priggs "Alligator Map"

The Priggs "Alligator Map" is a period copy hand-drawn by Daniel Bell after the original by John Frederick Augustus Priggs in 1790, the year before L'Enfant arrived to lay out the Federal City. Priggs was a highly respected surveyor in Prince George's County, Maryland, who was commissioned in the 1760s to make several detailed technical maps of the county, as well as the town of Bladensburg, also depicted here at the top of the Anacostia River. Bell's map, in contrast, was drawn as a work of art with ink, watercolor, and ink washes. It was made as a decorative work, showing the names of the land owners on the Anacostia River. David Bell may have added the decorative cartouche and alligator-shaped scale, since there is little evidence that Priggs used them on his other maps preserved in the Library of Congress.

Priggs is best remembered for his work on a team of American surveyors hired by the British government to do preparatory work to establish the correct boundaries between the colonies of Virginia and Maryland and the colonies of Delaware and Pennsylvania. When the surveyors, Charles Mason and Jeremiah Dixon, arrived from England to survey the line officially, they found the preliminary work very well done. Thomas Cope, a cartographic historian, wrote of Priggs and the other surveyors:

They brought to their work neither the training nor the experience, nor the Instruments, nor the volume of scientific and technological counsel that Mason and Dixon brought with them ... but they did bring to their work integrity, sound technological instincts, and a goodly measure of genuine competence, as their Field Books show. They carried on and they did achieve results that stood up under scrutiny.

Congress voted in 1790 to create a new national capital on the banks of the Potomac River—then the center of the United States—and asked President George Washington to select the exact site. It is known that the landowners and officials in various towns on the upper Potomac presented maps of their areas to President Washington for consideration.

Probably the landowners around the new town of Carrollsburg on the Anacostia River, as well as those in Alexandria on the Potomac River in Virginia, made maps for President Washington to consider.

Landowners in and around Georgetown, to the west on Rock Creek, and citizens three miles east in Carrollsburg vied to have their towns designated the site of the new capital. A map of Georgetown was made at that time to promote its location as the capital. That map was described in a letter of November 18, 1790, from William Deakins Jr. to George Washington. Kenneth R. Bowling, a scholar on the founding of the Federal City, believes that a successful tobacco merchant of Georgetown, George Walker, promoted the extensive level land between Georgetown and Carrollsburg as the site of a very large and prominent capital city. Bowling also believes that Walker hired Priggs to make the map so that Walker could show it to George Washington.

George Walker emigrated from Scotland to Georgetown shortly after the end of the Revolutionary War in the 1780s. After George Washington selected this site for the District of Columbia, he directed L'Enfant to design the capital city in March 1791. Walker most likely showed the Priggs map to L'Enfant and encouraged him to plan a grand design for a city covering 6,000 acres, far larger than Philadelphia in the 1790s. Walker praised L'Enfant's design when it was published that year and invested $25,000 of his own money in a 383-acre tract of land near the Anacostia River. Unfortunately for Walker, the city moved westward in the 1790s toward the White House, leaving Walker's land undeveloped. In an effort to save his investment, Walker went to London and published a description of Washington, D.C., and praised its expansion potential. When this and other attempts failed to develop the Anacostia waterfront, Walker moved back to Scotland in 1800 and never returned to the United States.

Map, *The Priggs "Alligator Map,"* drawn by David Bell after the original by John Frederick Augustus Priggs, 1790. 21.5 × 16.5 in. AS 456.

Dunlap's American Daily Advertiser.

(Price Four-pence.) TUESDAY, APRIL 17, 1792. (No. 4126

Advertisement for Competition for the Design of the President's House

James Hoban played a key role in White House history, beginning with designing and supervising the construction of the building between 1792 and 1800.

President Washington met Hoban, an Irish architect who was designing and constructing both public and private buildings in Charleston, South Carolina, on the president's southern tour of the new country in April–May 1791. On the way back to Philadelphia, President Washington stopped in the Federal City and selected the site for the President's House, slightly north of where L'Enfant had planned it. Thomas Jefferson drafted the text for an advertisement for a competition for the design of both the President's House and the Capitol and gave it to George Washington for approval on March 13, 1792. It was then sent to all of the major newspapers in Philadelphia, New York, and Boston. The commissioners of the District of Columbia would select the design and award the winner $500 in cash or a gold medal of the same value.

James Hoban called on the president in Philadelphia in June 1792 and explained he was entering the competition. Then Hoban traveled to Washington, D.C., and met the commissioners, who showed him the site. Washington left Philadelphia for the Federal City to join the commissioners on July 16, 1792, to select the winning entry from among the nine submitted. Hoban adopted several elements from the Palladian design of Leinster House in Dublin, the residence of the Duke of Leinster. They selected Hoban's design for a three-story, stone rectangular building; the façade was designed with four engaged Ionic columns and a pediment framing the main entrance. The other three elevations were more elaborate, with Ionic pilasters set between all of the windows.

George Washington altered Hoban's design slightly, increasing the width and length by one-fifth and adding more carved stone embellishments to the front. Soon afterward, the house was reduced to two stories and a basement.

{ WASHINGTON, }
In the Territory of Columbia.

A PREMIUM,

OF 500 dollars, or a medal of that value, at the option of the party, will be given by the commissioners of the Federal Buildings, to the person, who, before the 15th day of July next, shall produce to them the most approved plan, if adopted by them, for a President's House to be erected in this city. The site of the Building, if the Artist will attend to it, will of course influence the aspect and outline of his plan, and its destination will point out to him the number, size and distribution of the apartments. It will be a recommendation of any plan, if the central part of it may be detached and erected for the present, with the appearance of a complete whole, and be capable of admitting the additional parts, in future, if they shall be wanting. Drawings will be expected of the ground plats, elevations of each front, and sections through the building in such directions as may be necessary to explain the internal structure; and an estimate of the cubic feet of brick work composing the whole mass of the walls.

The Commissioners.

March 14. 1792.

Opposite and above. Newspaper, *Dunlap's American Daily Advertiser,* Philadelphia, April 17, 1792. 20 × 12 in. AS 842.

[19]

The commissioners immediately hired Hoban to superintend the construction of the President's House, a project that took eight years, 1792–1800. Hoban moved his belongings from Charleston, South Carolina, to Washington, D.C., where he would live for the next 39 years of his life.

The Stranger, in America

The federal government did not move from Philadelphia to Washington until 1800. In June of that year, the 130 federal employees began to move their furniture and papers to the new capital. They occupied two new executive office buildings adjacent to the White House—the Treasury Building to the east and the War Department to the west. In November 1800 Congress convened in the half-completed Capitol, and President John Adams occupied the White House. John and Abigail Adams found their new residence uncomfortable because it too was unfinished—staircases were missing, the plaster was still wet, service rooms were lacking, and servants' bells had not been installed. After five months of residing in Washington, they could not wait to get back to Quincy, Massachusetts. When Thomas Jefferson entered the White House as the third president in March 1801, he immediately solved the problem of the lack of service rooms. He built low, one-story wings on the east and west, partly concealed on the north because they were cut into the hillside. The adjacent illustration on the title page of an 1807 London guidebook to the United States, *The Stranger, in America*, is the first published view of the White House.

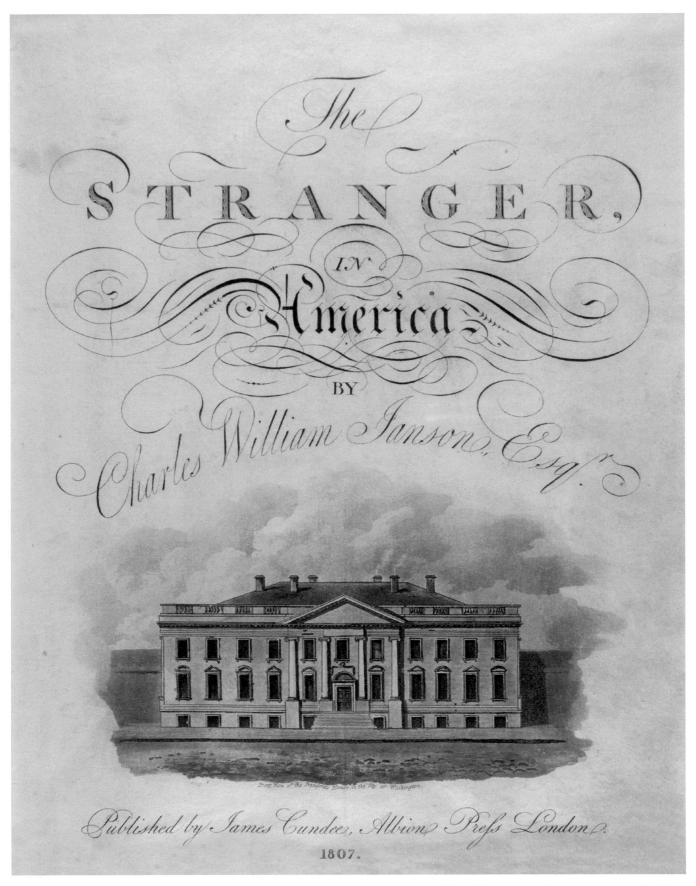

Title page of *The Stranger, in America*, engraving, published by James Cundee, Albian Press, London, 1807. 9.25 × 7.25 in. AS 36.

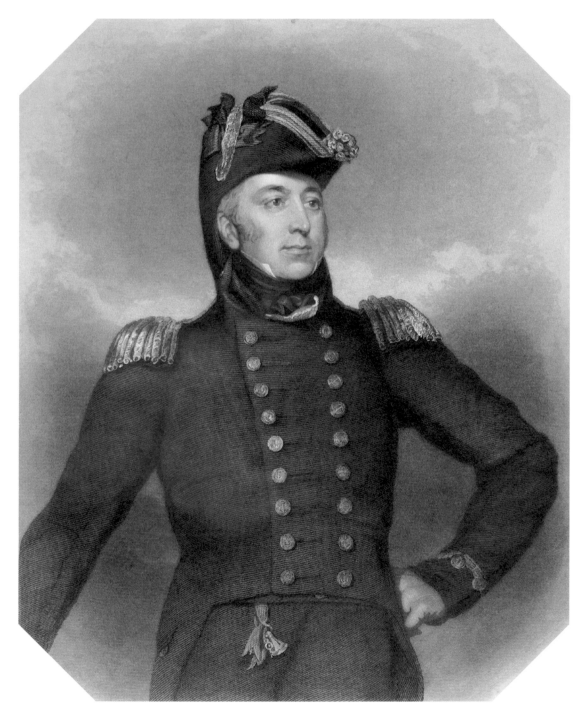

Engraving, *The Right Hon. Sir George Cockburn, G.C.B.*, Henry Robinson after painting
by John James Halls, published by George Virtue, London, ca. 1830. 9 × 7 in. AS 165.

The Right Hon. Sir George Cockburn, G.C.B.

Shortly after President Madison declared war on Britain in June 1812, towns along the Chesapeake Bay were pillaged by the British navy under the command of Rear Adm. Sir George Cockburn. After the British defeated Napoleon I in April 1814, they dispatched 4,000 troops to accelerate the harassment of the American coast. They proceeded up the Patuxent River, defeated the poorly trained American militia, who were commanded by inexperienced officers at Bladensburg, Maryland, and marched seven miles into Washington, D.C., arriving on Capitol Hill unopposed around dusk on August 24, 1814. The British military, commanded by Maj. Gen. Robert Ross, first burned the Capitol building and then marched on the President's House. After enjoying the dinner prepared for Madison and his cabinet, as well as the president's wine, they burned the White House and the adjacent Treasury Building. Accompanying Gen. Ross at the White House was Rear Adm. Cockburn, who had persuaded Ross to burn the government buildings. After spending the night on Capitol Hill, they returned to the White House on August 25 to burn the west executive office building. A severe storm that afternoon caused the British to depart for their ships on the Patuxent River, having spent only 24 hours in the city.

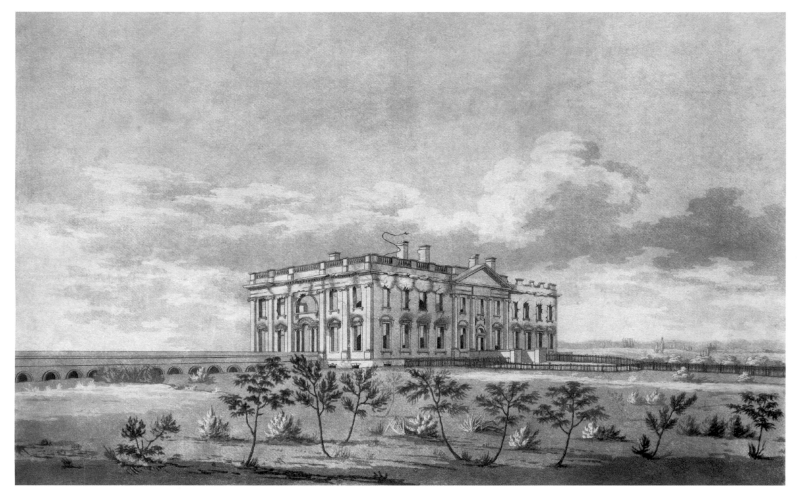

Engraving, *A View of the President's House in Washington, after the Conflagration of 24th August 1814*, William Strickland after a painting by G. Munger, 1825. 10.5 × 16.5 in. AS 164.

A View of the President's House in Washington, after the Conflagration of 24th August 1814

President James Monroe Asks Architect James Hoban to Finish Rebuilding the White House

After the British army burned the White House in August 1814, President James Madison called on James Hoban to rebuild. It took him three years, 1815–18. The south wall remained intact, but parts of the other three walls had to be pulled down and rebuilt with new stone. The Madisons took up temporary residence in the nearby Octagon House. The president wrote to Hoban in September 1817, asking him to work as hard as possible to finish rebuilding the interior so that he could have his New Year's Day reception there. The newly inaugurated President James Monroe was able to occupy the unfinished White House in October 1817, and his January 1818 reception took place on schedule.

Albemarle Sep. 26th 1817.

Dear Sir —

I arrived here on wednesday
& in the morning, the driver return'd
with the carriage to washington. He
will probably be there, on monday, &
at farthest on tuesday. I give him mo-
ny to bear his expenses back, & will
thank you to pay Mr Merril for
his hire, in coming & returning. I
shall not require him to come back
for me, having a carriage here, at
command. I found my family
in good health. I hope that you will
soon finish the Presidents house, &
that the Capitol, goes on, with more
despatch than heretofore —
with esteem yours
James Monroe

Autograph letter signed, President James Monroe to architect James Hoban,
Albemarle County, Virginia, September 26, 1817. 9.75 × 7.75 in. AS 753.

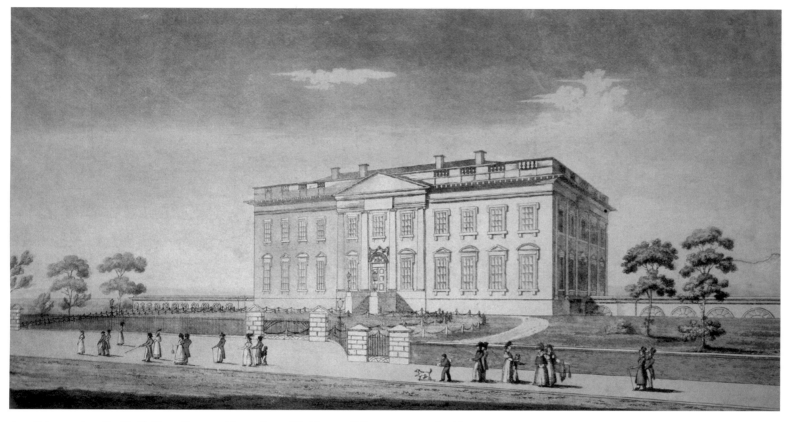

Aquatint engraving, *President's House*, Henry and James Stone, Washington, D.C., 1826. 7 × 11.5 in. AS 500.

President's House / The President's House, Washington

Architect James Hoban, at President Madison's request, drew plans for north and south porticos for the White House, but lack of congressional appropriations delayed their construction. President Monroe was finally able to build the south portico (*opposite, top*) in 1824. Hoban used dark red Seneca sandstone (concealed with white paint) for his half circle of six Ionic columns. They were mounted on the top of the high, basement-level, half-circular walls and extended two floors up to the entablature. The Ionic capitals of the columns matched the Ionic pilasters that circled the south, west, and east elevations. A set of winding stone steps swept down on each side to the lawn. The south portico's graceful curve added a new dignity to the façade.

In early 1829 Congress sent its Committee on Public Buildings to meet with Hoban and asked him to come out of retirement to build the north portico (*opposite, bottom*). Work started in the spring of 1829 and was finished the following year. The north portico was bold and large, and it helped lighten the heavy façade. It served as a porte cochere, sheltering people as they left their carriages or horses by the entrance steps. The image of the White House was then permanently established.

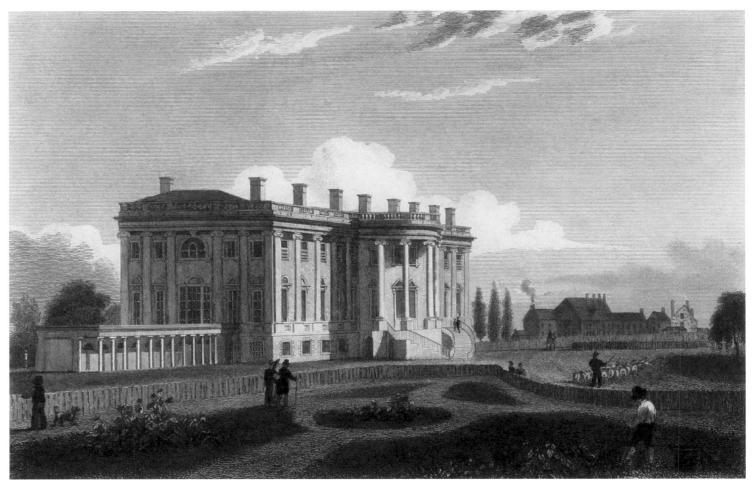

Print, *The President's House, Washington*, drawn by H. Brown, engraved by Fenner Sears, London: J. T. Hinton, 1831. 8 × 11 in. AS 66.

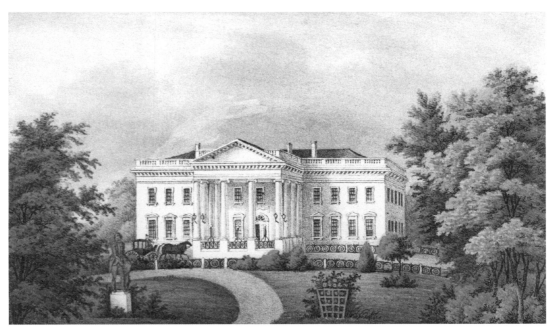

Colored lithograph, *President's House*, Edward Sachse, Baltimore, ca. 1860. 5.5 × 8 in. AS 422.

President George Washington Inquires about Designs for the Capitol

Since its inception in 1792, the U.S. Capitol building has undergone many physical changes to its design. These 10 images from the Albert H. Small Collection show the evolution of the façade and floor plan until the Capitol was finished in 1865. One of the earliest items in the collection relating to the Capitol is this letter from President George Washington in Philadelphia on November 30, 1792, to David Stuart, one of the three commissioners of the District of Columbia. The president asks whether a plan has been selected for the Capitol. Washington feels that L'Enfant is talented but too temperamental to work with. He suggests that someone be selected to supervise the construction of the federal buildings in the nation's capital; perhaps Stephen Hallet or Samuel Blodgett Jr. would be appropriate.

L'Enfant's failure to produce a plan for the Capitol caused President Washington to ask Secretary of State Thomas Jefferson to place advertisements in major American newspapers in April 1792, announcing a competition for designs of both the Capitol and the President's House. The deadline for submissions was July 15, 1792. The commissioners of the District of Columbia, working with George Washington, would select the winner the following day. But none of the designs submitted proved acceptable.

William Thornton, a physician and amateur architect, submitted his entry six months late in January 1793. The design was a combination of Neoclassical and Georgian elements, including a Corinthian portico with a pediment raised on a high basement. Washington and Jefferson, both of whom knew a great deal about architecture, liked it immediately.

Philadelphia Nov.^{th} 30^{th} 1792.

Dear Sir,

Knowing that tomorrow
is the time appointed for the monthly meeting
of the Commissioners at George Town, I had
intend. to have written you a line or two
on a particular subject by wednesday's
Post; but one thing or another put it out
of mind until it was too late. — I now set
down to do it, as the letter in the common
course of the Post will reach George Town
on Monday — probably, before you shall have
left that place. —

You will consider what I am now
about to say as a private communication;
— the object of which is only to express more
freely than I did in my last letter to the Com:
missioners, the idea that is entertained of
the necessity of appointing a Superintendant
of the execution of the plans & measures w.^{ch}
shall be resolved upon by the Commissioners
of the Federal City — one who shall always
reside there — and being a man of skill &
judgment — of industry & integrity, would,
from

Autographed letter signed, George Washington, Philadelphia,
to David Stuart, Washington, D.C., November 30, 1792. 11 × 8 in. AS 895.

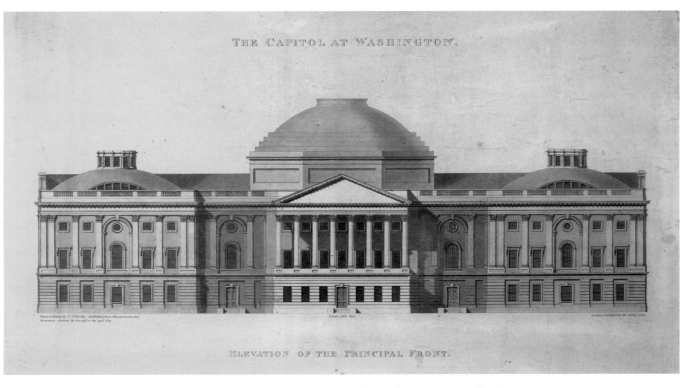

Engraving, *The Capitol at Washington—Elevation of the Principal Front*, C. A. Busby, London, 1823. 13 × 23 in. AS 194.

The Capitol at Washington—Elevation of the Principal Front

Thornton based his design on the Roman temple known as the Pantheon. Behind the portico was a low dome mounted on an octagonal base. The portico was flanked by two wings, which were embellished with ranges of pilasters mounted on a rusticated basement. The closest competitor to Thornton was Stephen Hallet. In July 1793, George Washington and the commissioners felt that Hallet's floor plan would be more efficient. It was adjusted to fit into Thornton's building, and Hallet was hired to manage construction. James Hoban, who was responsible for the construction of all government buildings in Washington in the 1790s, inspected Hallet's work periodically. Hallet left the job in 1794 and was replaced with George Hadfield. When Hadfield departed in 1797, James Hoban took over the construction management.

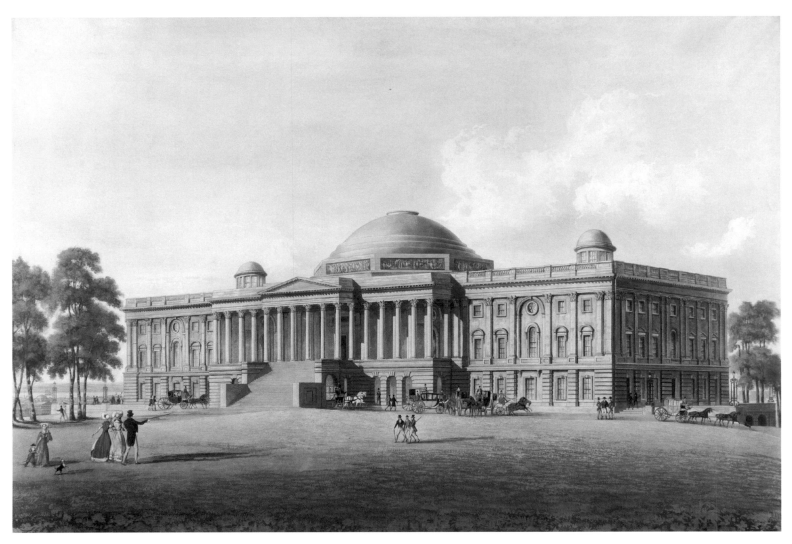

Colored aquatint of Latrobe's design for the Capitol, drawn by T. Sunderland, printed by R. Ackerman, London, ca. 1825. 17 × 25 in. AS 18.

Latrobe's Design for the Capitol

President Jefferson hired English architect Benjamin Latrobe in 1803 as superintendent of construction of public buildings. Latrobe arrived from England in 1795 and had just designed the Bank of Pennsylvania in Philadelphia in the Neoclassical style. On the Capitol, Latrobe changed both Thornton's exterior design and Hallet's interior plan. Latrobe raised both the House and Senate chambers from the ground level to the second floor and planned to build stairs on the east portico. He also planned to expand the colonnade on the central portico to cover the space leading to the wing on each side, giving the building a more monumental look. By 1808 Latrobe had perfected the floor plan for the House chamber (now Statuary Hall), the Senate, and the Supreme Court.

After the British burned the two wings of the Capitol on August 24, 1814, during the War of 1812, Latrobe returned to work on rebuilding the Capitol in March 1815. When Latrobe resigned in November 1817, President Monroe appointed Charles Bulfinch of Boston as the new Architect of the Capitol, a title still in use today. He began work in January 1818 and remained until 1829. Bulfinch was able to finish the Capitol in 1826.

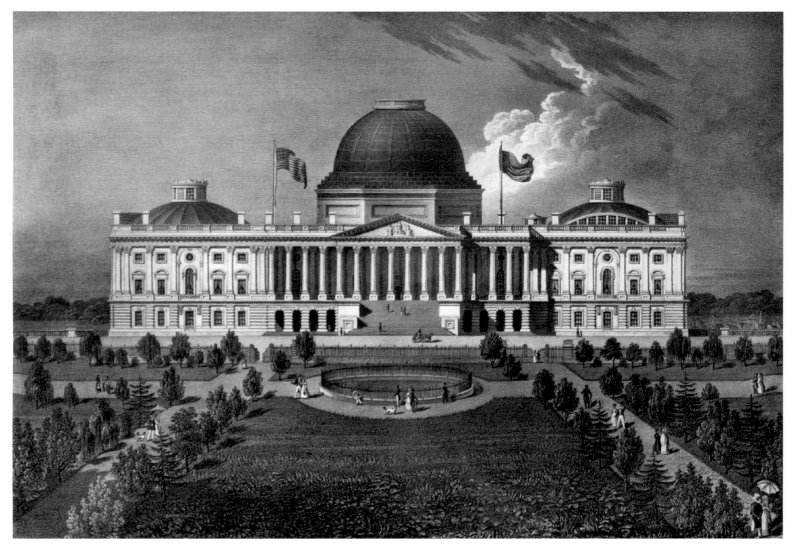

Drawing, *Elevation of the Eastern Front of the Capitol of the United States*, William A. Pratt, lithograph by P. S. Duval, Philadelphia, printed by William Fisher, Washington, D.C.; published by Charles Fenderich, Washington, D.C., 1839. 16 × 19.5 in. AS 5.

Elevation of the Eastern Front of the Capitol of the United States

Bulfinch felt strongly that a tall dome would be out of proportion with the building. He had two models of the Capitol made, one with a low dome and the other with a tall dome, to show to the president. Monroe and his cabinet, however, all thought the taller dome gave more prominence to the building and directed Bulfinch to build it. Bulfinch also followed Latrobe's plan to build steps on the east portico and to flank the east portico by a colonnade on each side, covering the recess between the center building and the wings.

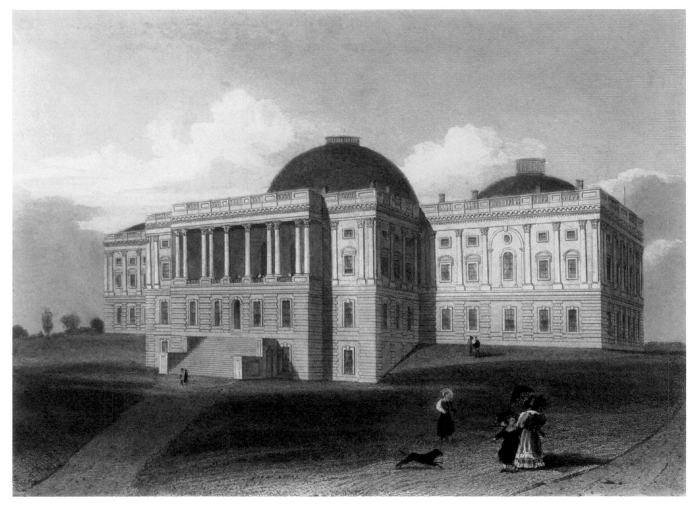

Colored engraving, *Capitol of the United States, Washington*, drawn by W. Goodacre Jr., engraved by Fenner Sears, printed by J. H. Hinton and Simpkin and Marshall, London, 1831. 9 × 11 in. AS 67.

Capitol of the United States, Washington

Bulfinch reduced the length of the west front in Latrobe's plan to provide for more committee rooms. He also made it four stories rather than three. The arrangement of the columns on the west portico was unusual; Bulfinch placed two single columns in the center and two pairs of adjoining columns on each side. He had used this arrangement for the front portico of the Massachusetts State House. This architect also was responsible for adding the west terrace to the building.

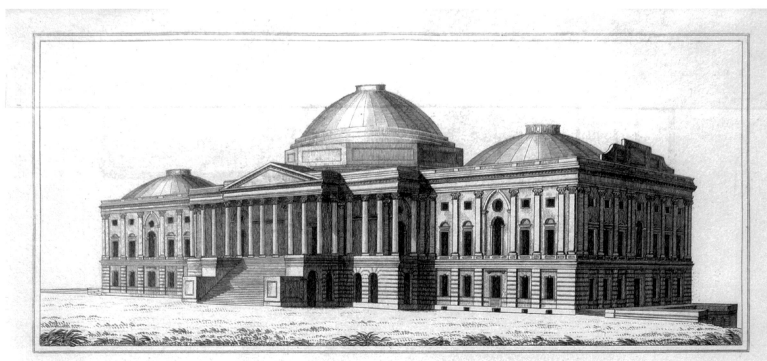

OESTLICHE FRONTE DES CAPITOLS VON WASHINGTON.

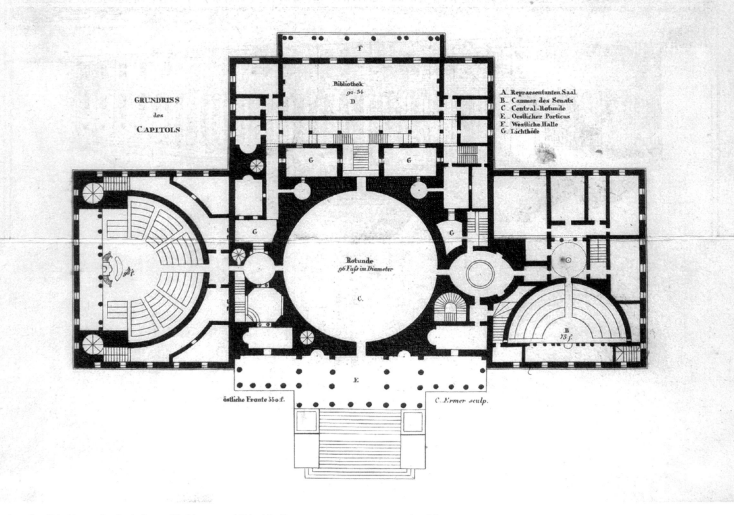

GRUNDRISS
des
CAPITOLS

Bibliothek
92·34
D

f

G G

G

Rotunde
96 Fuſs im Diameter

C.

G

G

A. Repraesentanten Saal
B. Cammer des Senats
C. Central-Rotunde
E. Oestlicher Porticus
F. Westliche Halle
G. Lichthöfe

B
15 f.

E

östliche Fronte 55 o f. C. Ermer sculp.

Engraving, *Oestliche Fronte des Capitols von Washington*, published in Germany, ca. 1840. 10.5 × 8.5 in. AS 260.

Oestliche Fronte des Capitols von Washington

During the 1830s and 1840s, more states were added to the Union, resulting in crowded conditions in both the House and Senate chambers. During this time, the slavery controversy continued in both houses, as northern abolitionists were determined to limit its spread into the western territories. In 1850 Sen. Henry Clay of Kentucky proposed a series of laws that became known as the Compromise of 1850; civil war was avoided and the Union preserved. Congress then voted for an extension of the U.S. Capitol, adding new and larger House and Senate wings. The architectural competition for this project in 1850 awarded the design to Philadelphia architect Thomas U. Walter.

Thomas U. Walter's Winning Design for the Capitol Extension (overleaf)

Walter's design consisted of House and Senate wings, south and north respectively, with porticos and steps on their east fronts. Each chamber would have outside windows opening under colonnades. Appropriations for the construction at this time did not include a new dome. Capt. Montgomery C. Meigs, an army engineer, was put in charge of supervising the construction following Walter's design. He wanted to make the Capitol a repository of art and a place to display the latest technological advances. Walter altered his original designs to accommodate Meigs, adding pediments to the two new porticos to provide room for sculpture. Walter moved the two chambers into the center of each wing to allow for committee rooms and corridors on all four sides. They were lighted by skylights and heated by steam. As the wings were nearing completion, Congress voted to build a new iron dome to provide better balance and commissioned Walter to design it. Meigs then designed a large crane inside the rotunda to hoist building materials upward for the new dome.

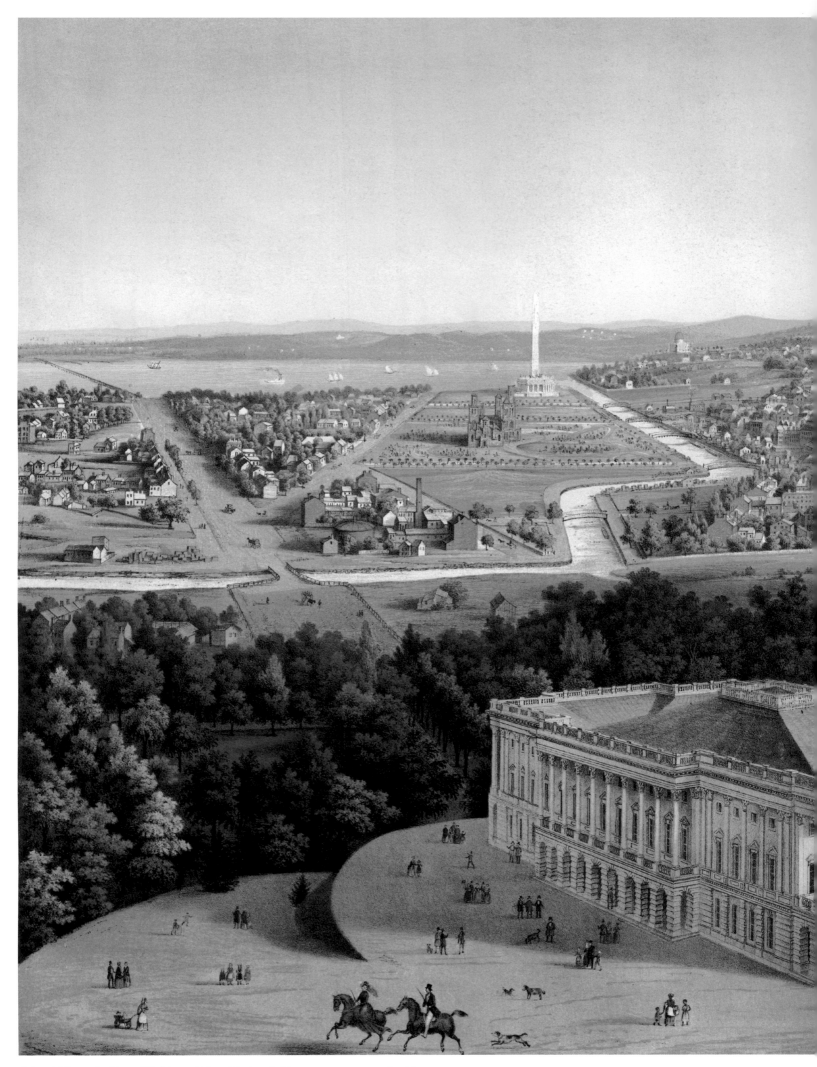

Colored lithograph, *View of Washington*, Edward Sachse, Baltimore, 1852. 20.5 × 28 in. AS 411.

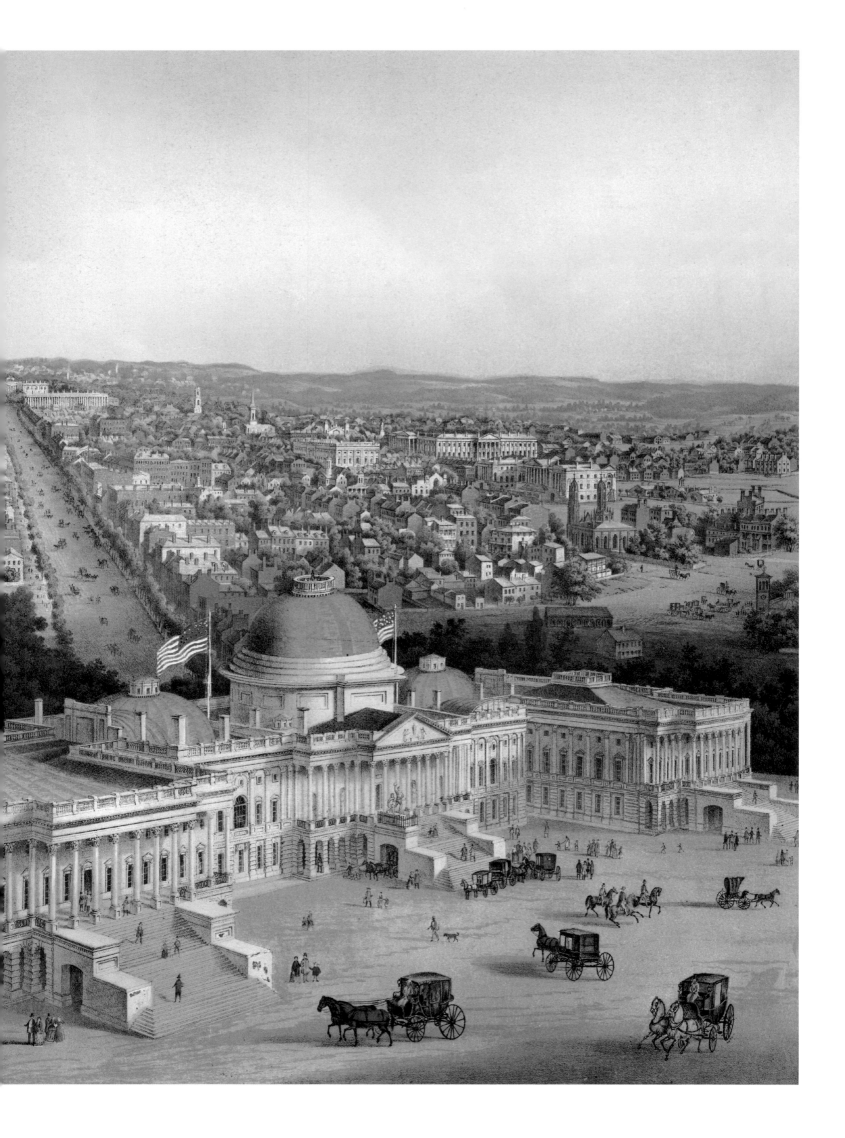

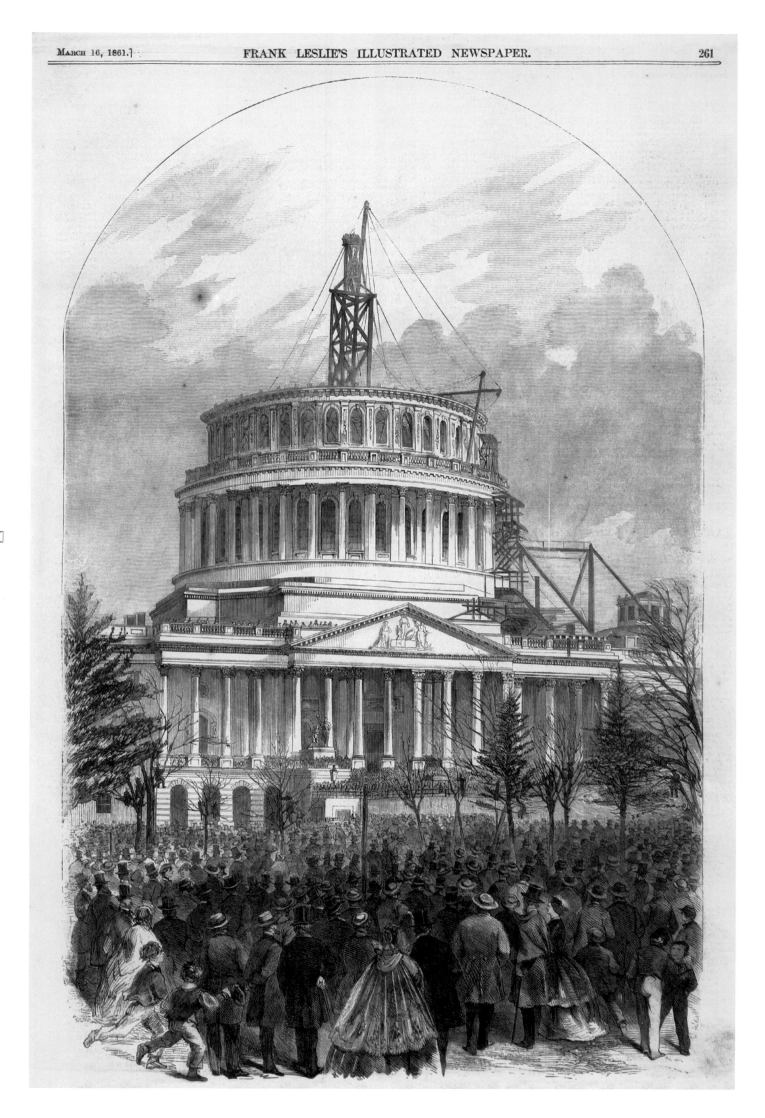

*View of the Capitol, Showing
the Present State of the Dome Taken
during the Inauguration of Lincoln,
Monday, March 4, 1861*

This 1861 view of the east façade of the Capitol shows Abraham Lincoln's inaugural stand erected on the steps of the portico and the dome half finished. By 1865 the new Capitol was essentially completed. It had a profound influence on the design of state capitol buildings during the next 50 years—half were modeled on its design.

Woodcut, *View of the Capitol, Showing the Present State of the Dome Taken during the Inauguration of Lincoln, Monday, March 4, 1861*, after photograph by Stacy, *Frank Leslie's Illustrated Newspaper*, March 16, 1861. 15 × 9.75 in. AS 216.

Cross Section of the Dome with
Floor Plan of U.S. Capitol Showing
the New House and Senate Wings

View of Washington City (overleaf)

When the Civil War broke out in April 1861, Congress adjourned and the Capitol was filled with hundreds of Union soldiers—there was no other place to put them. Some rationalized that they would protect the building from possible Confederate attack. Although not authorized by Congress, the dome's construction continued. The Beebe Iron Works of Brooklyn, New York, had over $100,000 worth of iron beams and panels stacked on the Capitol grounds. They were afraid that if they stopped work and abandoned the site their iron would be stolen. When the iron dome was topped out in December 1863, the Statue of Freedom was hoisted into place amid great fanfare.

The illustration on pages 42–43 shows the east façade of the Capitol as it appeared when construction was completed in 1865.

Colored woodcut, Cross Section of the Dome with Floor Plan of U.S. Capitol Showing the New House and Senate Wings, by *Frank Leslie's Illustrated Newspaper*, January 19, 1861. 18 × 13 in. AS 123.

and Mr. Rarey pulled the second strap, and the animal was on his knees to his master, who fell beside him. He then rose and began pulling the horse's head backwards and forwards. Up jumped Cruiser, and quick as a flash Mr. Rarey, and before the frightened stable-boys could escape Rarey had the horse again at the footlights, and pointing to a graze on Cruiser's hip, said, "In coming over in the ship the horse wounded his hip as you see, and is consequently very restive. The consequence is he will not allow himself to be dragged about as usual. I think it right to add that I have not laid hands on him before this afternoon since he was in England."

Mr. Rarey conquers a Nervous, Hard-pulling Horse.

When Cruiser had withdrawn, which he did amid considerable applause, a horse was introduced to Mr. Rarey, which his owner said was so fearfully nervous and such a hard puller at the mouth, that it was not possible to drive it. The equine tamer said that the horse was the creature of impressions—if he fears you he will run away, if he is angry with you he attacks you—he is like a child in intellect, and must be treated like one. Brute force can never tame a horse completely—there is always a sore spot left, which will break out at the first opportunity. The horse must be convinced by humane treatment and undeviating firmness that man is his natural master. In saddling and harnessing a horse for the first time, the objects must be made familiar to him. He should be permitted to rub them with his nose. Above all, deception should be never used—blinding a horse on these occasions is most injurious. Deception and brute force are both failures. Mr. Rarey then went through the various stages of his process, as illustrated by our artist, and in the course of ten minutes the nervous, trembling, jibbing, hard-mouthed horse, whose jaws were impervious to the fiercest tugging, stood as quiet and docile as a lamb, while a great drum was placed at his side and beaten with violence.

The Wild South American Pony.

The next subject on which Mr. Rarey showed his power was a South American pony which had just arrived. It had only been broken to bear a halter, and was as untamable a bit of horseflesh as ever threw its rider or bit its groom. Rarey made numerous attempts to catch the creature's foot, which it very cleverly avoided. At length the pony became enraged, and struck Mr. Rarey with one of its fore feet. He then took hold of the right rein, and drawing the animal's head close to the shoulder, made it go round and round as though it were in a small mill. He next lifted her near foot, and in another instant the inevitable strap was on and the quadruped was reduced to a tripod. The poor dumb animal's astonishment and annoyance were evident. At last, as though disgusted with the quiet persistence of its conqueror, it rolled on the ground. After playing with her a little longer to show how completely he had overcome her wildness, he let her rise. He then mounted her, and dismounted her, repeatedly, put her unshod feet upon his head,

patted her, spoke to her, then threw his leg over her head, and in a quarter of an hour the wild steed of the Pampas was as docile as a dog. At this remarkable result the cheers of the audience reverberated through the building, and the tamer led the conquered or converted animal off the stage.

The Fourth and Last Triumph of Rarey.

The last feat was undoubtedly the greatest attraction of the evening. It was the well-known Joe Anderson, Mr. Luff, of Harlem, gray stallion. The approach of this savage was heralded by the noise the creature made before it came upon the scene, for while Mr. Rarey was reading the following letter from its owner, it plunged, snorted and kicked as though it were going to break down the partition:

HARLEM LANE, January 3, 1861.

J. S. RAREY, ESQ —Dear Sir—Having heard that you are in want of vicious horses, I beg to inform you that I have a very fine stallion that has cost me $2,500, but so vicious that I have not been able to do anything with him for the last four years. He is the worst horse I have ever seen, and I believe one of the worst in the world. During this time I have not been able to put a harness on his back or a shoe on his foot, or even to take him out of the stable. He has bitten several men severely to my certain knowledge, and is said to have killed two. I believe him to be a dangerous animal in every respect, either by kicking, striking or biting. I can hardly believe that any man will ever be able to manage him, but if you will make the attempt, you are welcome to try him.

Yours truly,
E. LUFF.

Mr. Rarey had just finished reading the letter which conveyed such a very unfavorable opinion of Joe Anderson, when the monster himself was led on the stage, muzzled, and led by two grooms, with ropes and a leading-pole. He came in snorting and plunging, dragging his grooms after him. The shouts of the audience and the lights made him start with rage and agitation. His first rational act was an attempt to seize Mr. Rarey by the arm, but as the savage was muzzled, the amiable intention was a failure. Mr. Rarey then went to work, and in about ten minutes he had, by his simple but mesmerising plan of the strap, so completely convinced the hitherto indomitable Joe Anderson that submission was at once his pleasure and his duty, that Mr. Rarey removed the muzzle, freed his limbs from the strap, and restored to the amazed brute the liberty he had been deprived of for four years. As a proof of how completely he had changed the whole instincts of the horse, Mr. Rarey put his arm into the horse's mouth, took up his hoofs, sprang violently upon his back, and acted as though he had the mental as will as physical control of the creature. Amid a Niagara of applause and wonder, Joe Anderson was led off the stage, on which he may be said to have become an altered being. If any Rarey could be found to convert our rowdies into useful members of society, the world would be a far happier sphere than it is at present.

Mr. Rarey's Shetland Ponies.

As a curiosity, Mr. Rarey then had his two

[41]

1. SECTIONAL VIEW OF THE CAPITOL AT WASHINGTON.
2. GROUND PLAN OF THE CAPITOL AT WASHINGTON, SHOWING THE RECENT ADDITIONS.—SEE PAGE 134.

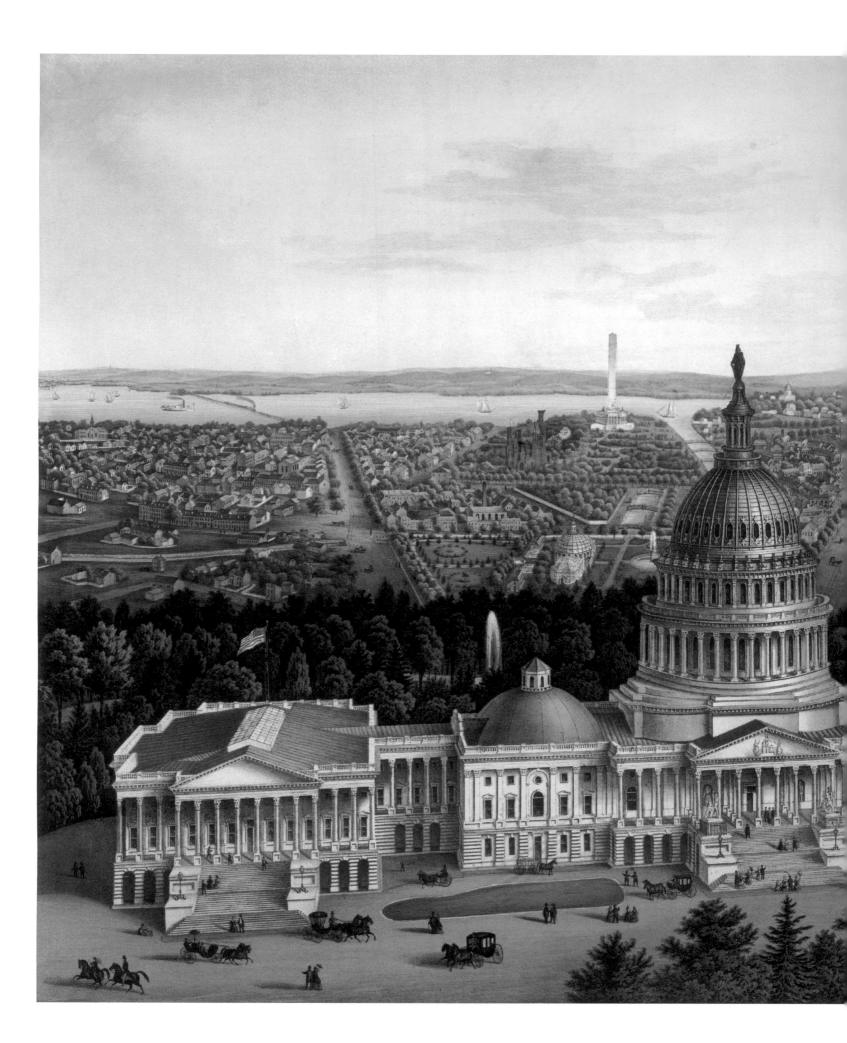

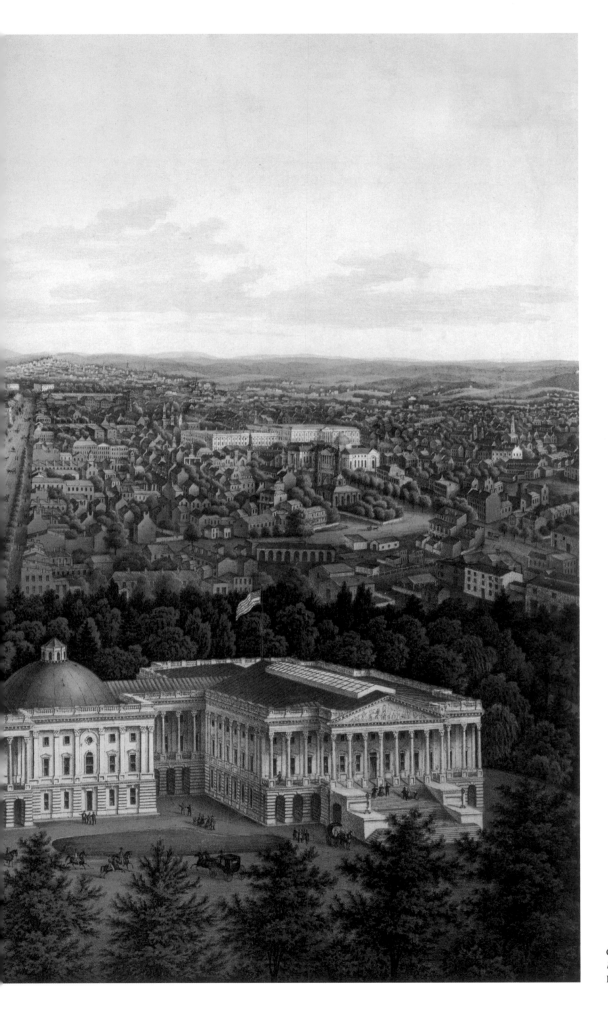

Colored lithograph, *View of Washington City*, Edward Sachse, Baltimore, 1871. 20 × 29 in. AS 2.

Letter, Harry S Truman to
Walter Neil Letson, October 9, 1963,
Regarding the East Front Extension

In this 1963 letter, Harry S Truman recalled that, in the 1930s, he was on a committee that recommended extending the central portico of the Capitol to conform to the two wings. Construction was probably delayed because of the Great Depression but was finally done in 1959–61 at a far greater expense.

HARRY S TRUMAN
INDEPENDENCE, MISSOURI

October 9, 1963

Dear Mr. Letson:

I appreciated very much yours of September 4th.

Regarding the extension of the middle section of the Capitol
Building, when I was a member of the Senate and Vice Chairman
of the Public Buildings and Grounds Committee, Senator Tom
Connally of Texas was Chairman, I held a series of hearings
on that project, to develop a plan in harmony with the other
two wings of the Capitol.

In our report on it we made the suggestion that the government
appropriate five and one-half million dollars for this extension.
Had that been done at that time a great deal of money would
have been saved.

On the basis of the plans we had made back in the 1930's, I
think the final cost was about fourteen million dollars to make
the East Front of the Capitol conform with the two wings. This
was somewhat reminiscent of the balcony situation in the
White House.

The original plans in both instances were drawn up by Jefferson
and his associates. In the basement of the Capitol you will find
these in the records as they are a part of the archives.

Sincerely yours,

Harry Truman

Mr. Walter Neil Letson, Editorial Assistant
Office of the Architect of the Capitol
601 Nineteenth Street, N. W.
Washington 6, D. C.

[45]

Letter, Harry S Truman to Walter Neil Letson, October 9, 1963. 10.5 × 7.25 in. AS 934.

Letter, William Thornton to George Washington, Regarding Construction of Two Rental Houses on Capitol Hill, Washington, D.C., 1798

City of Washington Dec.r 21.th 1798

Dear Sir

I had this Moment the honor of your Letter of yesterday's Date, inclosing a Check for five hundred Dollars, on the Bank of Alexandria, w.ch shall be duly appropriated to the prosecution of your two Houses in the City of Washington:—

I will make the necessary Enquiries of M.r Blag=din relative to any Alteration you may be pleased to direct.— It is a Desideratum in Architecture to hide as much as possible the Roof— for which reason, in London, there is generally a parapet to hide the Dormant Windows.— The Pediment may with propriety be introduced, but I have some Doubts with respect to its adding any beauty. It may however give some additional Convenience.— Every thing shall be

George Washington endorsed L'Enfant's proposal to design a large capital city for the United States, larger even than Philadelphia, with property reserved for the future development of a national cathedral, national university, banks, churches, fountains, and monuments. He also was personally involved in promoting the well-being of the infant Federal City during the 1790s. Washington met with the three District of Columbia commissioners to discuss the competitions for the design of the President's House and the Capitol and actually selected the final designs. L'Enfant proved his unreliability when he failed to produce his map of the city in time for the first auction of lots in late 1791. The president then recommended that the surveyor who had worked with L'Enfant, Andrew Ellicott, prepare the map and publish it as soon as possible. Washington approved the design and presented the large map engraved by Thackara and Vallance of Philadelphia to Congress in November 1792.

Opposite and above. Letter, William Thornton to George Washington, Regarding Construction of Two Rental Houses on Capitol Hill, autograph letter signed, Washington, D.C., 1798. 8.5 × 7 in. AS 328-B.

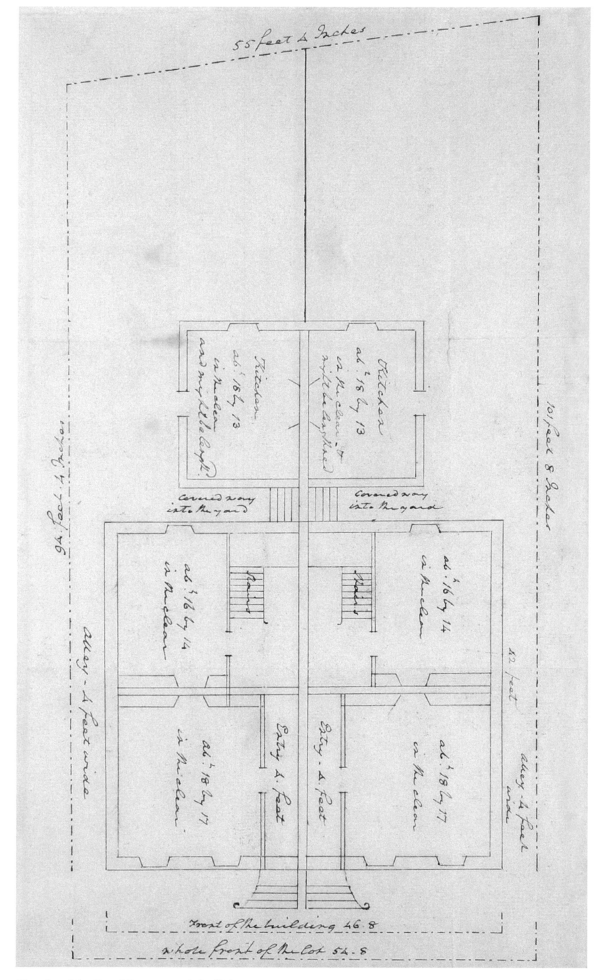

Floorplan of Two Rental Houses on Capitol Hill, drawn by George Washington, 1798. 10.5 × 6 in. AS 328-A.

Left and above. Check, George Washington to William Thornton, for partial payment for designing and supervising construction of the Capitol Hill rental houses, 1799. 3 × 6.5 in. AS 670.

Floor Plan of Two Rental Houses on Capitol Hill, 1798

George Washington purchased lots in the Federal City as a personal investment in three locations. The first were two lots on North Capitol and C Streets on Capitol Hill for the construction of two attached houses, which he planned to rent to members of Congress. On a trip to Philadelphia in the fall of 1798, Washington saw a house that influenced him in his Capitol Hill design and discussed the layout of the three-story houses in a letter to his architect, William Thornton. He also enclosed a floor plan with the rooms designated. The builder George Blagden undertook the construction under the supervision of William Thornton.

Check, George Washington to William Thornton

The Small Collection includes a check for $272 that Washington wrote to William Thornton on May 31, 1799, in partial payment for his work on the two houses. Construction was completed in 1800, shortly after the death of Washington.

In addition, Washington purchased four lots on the waterfront of the Anacostia River for the future construction of commercial buildings. He believed that a port for the city of Washington would soon develop at that location. Washington also purchased almost all of Square 21, now the site of the John F. Kennedy Center for the Performing Arts, for future use as a botanical garden. This would abut the proposed national university, which would be located along 23rd Street, where the Old Naval Observatory is now situated. He even left the stock owned in the Potomac Canal Company to endow the national university, which never developed. It is appropriate that the George Washington University now occupies much of Foggy Bottom, close to the original site for a national university.

Mezzotint engraving, *George Washington, President of the United States of America*, Edward Savage, London, 1793. 22 × 16 in. AS 497.

George Washington, President of the United States of America

This mezzotint portrait of George Washington dressed in a black velvet suit was produced by Edward Savage, an American working in London, in 1793. It was based on an oil portrait that Savage had painted of George Washington from life in 1789 for Harvard University. Savage produced two different prints of the portrait, a stipple engraving in 1792 and a mezzotint engraving in 1793. Although Savage lists himself as the printmaker for both prints as well as others, he relied heavily on other, more experienced engravers—especially David Edwin and John Wesley Jarvis. Both complained that Savage had given them insufficient credit on the prints. For the two prints, Savage added a map of the Federal City drawn by L'Enfant in 1791 and a classical column in the background to allude to ancient Rome and to the Society of the Cincinnati, of which George Washington was president. Members of the Washington family sat for Edward Savage on a number of occasions. Another print he made in 1798, *The Washington Family*, became equally popular.

Edward Savage (1761–1817) was a native of Massachusetts and a self-taught painter. He began his career by copying portraits of well-known Bostonians painted by the celebrated John Singleton Copley. After Savage had worked in London, 1791–94, he returned to the United States and settled in Philadelphia where he married Sarah Seaver. Savage was also an enterprising businessman, opening early art galleries not only in Philadelphia but also in New York and Boston, where he sold his own work as well as European masters and natural history paintings.

Washington and His Family

Washington and His Family was engraved and printed in 1864. The Philadelphia firm of Bradley and Co. commissioned a French painter living there, Christian Schussele, to paint the scene. When that was completed the company gave the job of engraving the print to William Sartain (1843–1924), the son of the leading engraver in Philadelphia, John Sartain. After completing one year of service in the Union army during the Civil War, William trained as an engraver with his father and his brother, Samuel. This was his first important commission.

The Schussele painting and the resulting Sartain engraving, *Washington and His Family*, were based on Savage's 1798 print, *The Washington Family*. They are very similar except that the figures are reversed. In the Sartain print Martha is seated at the left end of the table and George Washington at the right end. Martha Washington's grandchildren, George Washington Parke Custis ("Wash" or "Washy") and Eleanor Parke Custis (Nellie), also appear in the Sartain print, but at opposite ends of the room. They were adopted by George Washington when their father, John Parke Custis, died of camp fever (typhus) at Yorktown in 1781. The fifth person in the print, who is entering the room through a doorway on the right, is Christopher Sheels, a slave who served as George Washington's valet after the Revolutionary War. Sheels's uncle, Billy Lee, also a slave, served as Washington's valet before and during the war. In both prints, George Washington is not wearing his sword—it is lying on the table in one and on a chair in the other. The sword's position symbolizes Washington's resignation as general and his return to peace at Mount Vernon.

[52]

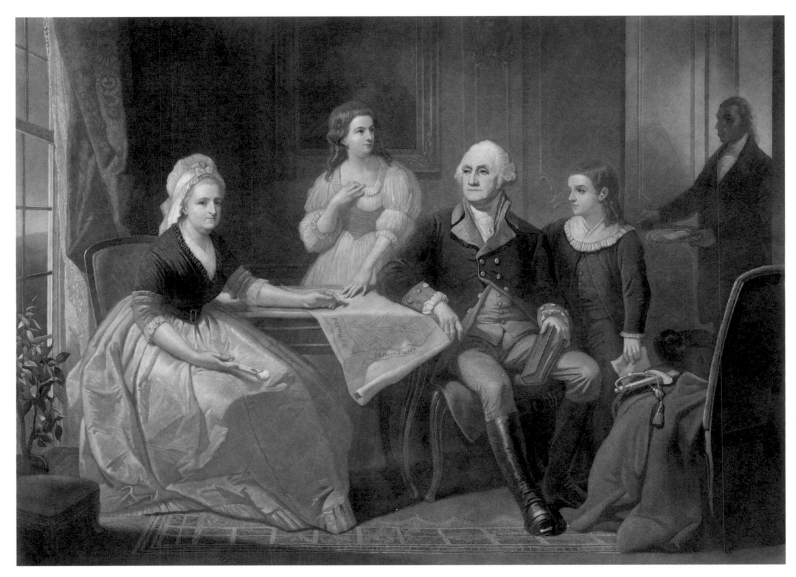

Mezzotint engraving, *Washington and His Family*, William Sartain, 1864. 22 × 28 in. AS 918.

The Seat of the Late Lieut. General George Washington, Commander in Chief of the Armies of the United States

This early 1800 print of Mount Vernon shows the famous piazza, supported by eight square pillars, facing the Potomac River. The land where the house is located had been in the family for three generations before George Washington leased it in 1754 and inherited it in 1761. His great-grandfather, John Washington, had emigrated to Virginia in 1657 and during his lifetime acquired more than 5,000 acres of land along the Potomac River. George Washington's father, Augustine, built the house that is the core of Mount Vernon in 1735. He left it to his eldest son from his first marriage, Lawrence, the half-brother of George Washington. Lawrence named it Mount Vernon after his former naval commander, Adm. Edward Vernon. It consisted of four rooms on the first floor and two rooms on the second floor—at the time, a substantial house for a Virginia planter.

Mount Vernon was enlarged by George Washington in two periods. In the first, 1757–59, he increased the height from one and a half to two and a half stories. In the second period, extending over 12 years from 1774 to 1787, he added a piazza on the river front, a cupola on the roof, a pediment on the land front, and additions at each end. A large, two-story reception room, which Washington called the "new room," was added on the north end while he installed his study and additional bedrooms on the south end. Funds from his wife's extensive Custis estate helped pay for the construction. The river front remained the principal façade, but during Washington's time most visitors arrived by carriage and entered the house through the west or "rear" entrance.

Aquatint, *The Seat of the Late Lieut. General George Washington, Commander in Chief of the Armies of the United States*, drawn by Alexander Robertson, colored by Francis Jackson, published by Francis Jackson, London, and by Alexander Robertson, New York, 1800. 12 × 15 in. AS 914.

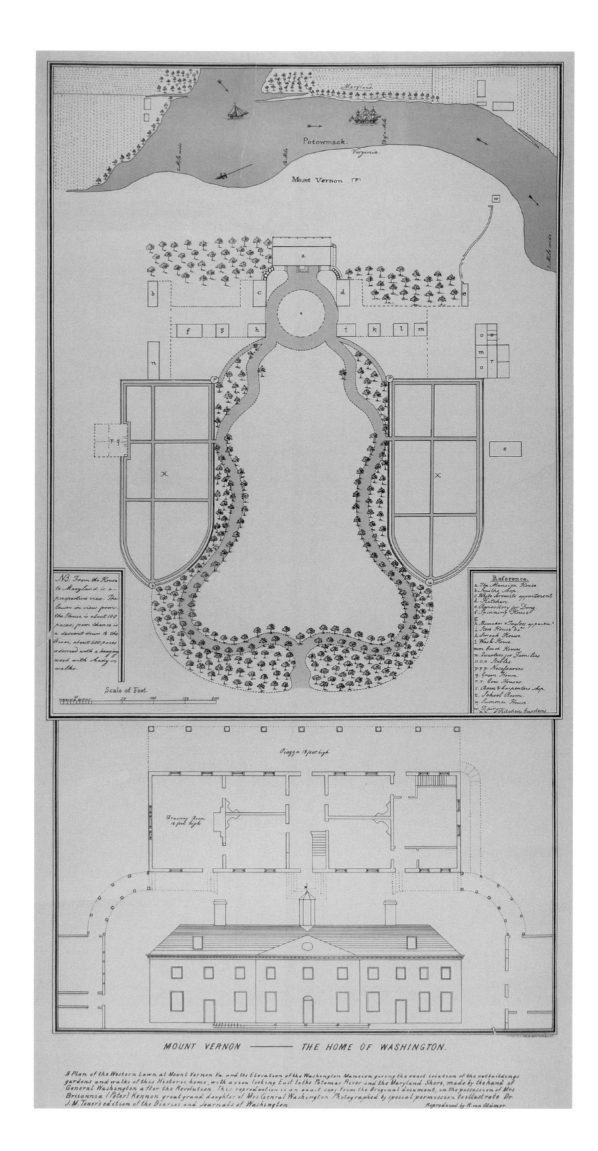

MOUNT VERNON ——— THE HOME OF WASHINGTON.

Mount Vernon— The Home of Washington

In this image, circa 1895, the bottom includes a drawing of the façade of Mount Vernon facing west and its first floor plan. The upper section is a site plan showing the relationship of Mount Vernon with the Potomac River and the circular driveway leading to the main west entrance. A legend on the right identifies more than a dozen outbuildings, including the two coach houses, the greenhouse, and the kitchen garden. The broadside was based on a drawing made by George Washington, which had come into the possession of Mrs. Britannia Peter Kennon of Tudor Place, the great-great-granddaughter of Martha Washington.

Lithograph, *Mount Vernon—The Home of Washington*, site plan drawn by R. von Glümer, published by J. M. Toner, ca. 1895. 35 × 18 in. AS 483.

The Old Brick Capitol

The Old Brick Capitol occupied the southeast corner of 1st and A Streets N.E., now the location of the U.S. Supreme Court. This site was first used for Tunnicliff's Tavern, built in 1795. After the capital moved to Washington from Philadelphia in 1800, the tavern provided food, drink, and lodging for congressional members and diplomats. In the rear were stables and sheds to accommodate the coaches that arrived daily from Baltimore.

This 18th-century building was pulled down in 1815 to make way for a temporary meeting place for Congress, after the British troops burned the Capitol on August 24, 1814. The Congress next met on September 19, 1814, in the only large, available building in the city—Blodgett's Hotel—located at 8th and E Streets N.W., the site now occupied by the old Post Office Building.

At the time, some congressional members favored moving the capital back to Philadelphia, then the largest city in the United States. In response, 32 of Washington's business leaders, who had invested heavily in local real estate, privately raised the funds to build a temporary home for Congress until the Capitol could be rebuilt.

This temporary brick capitol building, later known as the Old Brick Capitol, was rushed to completion between July and December 1815. Congress met here for four years. Architect of the Capitol Charles Bulfinch worked to have the original Capitol building restored and furnished for the return of Congress in December 1819.

Beginning in 1820 the Old Brick Capitol was used as a school and then as a boarding house for congressional members. The building was purchased by the federal government in early 1861 and converted to a prison for Confederate soldiers and southern sympathizers. After the war the government sold the badly damaged structure to George T. Brown, who razed the large rear wing and converted the main building into three imposing row houses. These were torn down in the early 1930s for the new U.S. Supreme Court building.

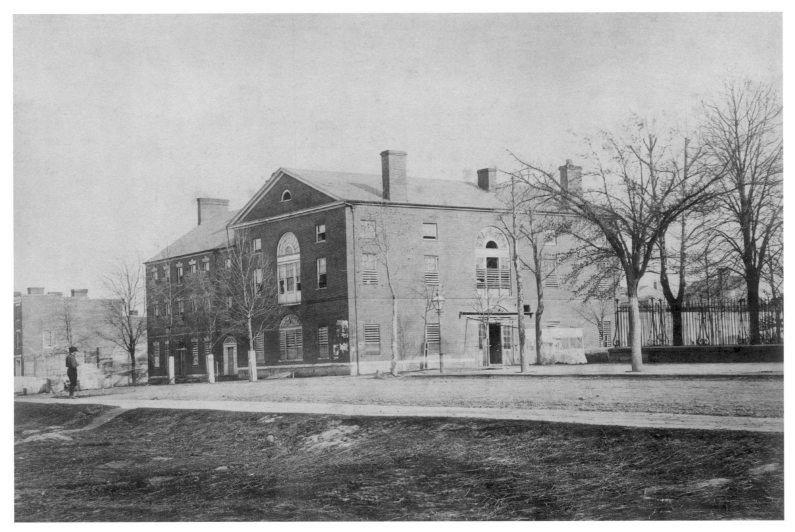

Photograph, *The Old Brick Capitol*, unknown photographer, ca. 1863. 9.25 × 14 in. AS 508.

Peter Force's Office Ledger

This rare surviving fragment from a pre–Civil War printing office sheds light on the history of business practices in Washington, D.C. The owner of the printing firm, Peter Force (1790–1868), was well known in the nation's capital as a journalist, printer, and historian.

Peter Force grew up in New York City, where he worked as an apprentice in the printing office of William A. Davis and eventually rose to the position of Davis's partner. He soon was elected president of the New York Typographical Society, a union of printers who agitated for higher wages.

After serving as sergeant majors in the War of 1812, Force and Davis moved their printing firm to Washington in 1815 when they acquired a major printing contract with Congress. Their new office was located on Pennsylvania Avenue next to Brown's Hotel, near the intersection of 7th Street. Force was then only 25 years old.

Soon Peter Force became the sole owner of the Washington printing office. He began publishing his own almanac, *The National Calendar and Annals of the United States*, in 1820. Four years later he founded a daily newspaper, the *National Journal*, which supported President John Quincy Adams, Henry Clay, and the Whig Party in general.

This printing ledger records over 100 printing orders between 1826 and 1832. Orders came from many members of Congress, including Rep. David Crockett of Tennessee and Rep. (later Sen.) Daniel Webster of Massachusetts. Force even printed Henry Lee's memoirs of the Revolutionary War in 1827.

Force was very civic minded, serving on the Washington City Council, as mayor from 1836 to 1840, trustee of the Columbian College (now the George Washington University), board member of the Washington National Monument Society, and president of the National Institute for the Promotion of Science. The last group was absorbed into the Smithsonian Institution.

He was known throughout the United States for his lifetime of collecting and preserving books, pamphlets, newspapers, diaries, and letters relating to the history of the American Revolution. The Force Collection became the largest in the country—60,000 items by 1867. Several American libraries tried to buy the collection, including the New-York Historical Society, but Congress purchased it in 1867 for $100,000. The Force collection became the basis for three divisions in the Library of Congress—Rare Book Division, Newspaper Division, and Manuscripts Division. Peter Force died in 1868 at his Washington house at the age of 78.

April 25, 1826

No. 17 ✓ Hon. Mr. Bouligny.
200 Letters of Invitation, 8vo.

Paymaster General
No. 18 ✓ 50 Bonds folio post.
May 1. ✓

Marine Corps
No. 19 ✓ 500 Blank Accounts. ✓

Navy Department
No. 20 ✓ 1 ream Letters of Appointment

State Department.
No. 21 ✓ 1 ream Certificates

Pishey Thompson
No. 22 ✓ The ——— No. 6, 7 & @ 2. 2 9 2.

Daniel Webster
No. 23 ✓ 2000 Speech, fine Medium 64 pages
18 reams ½ paper @ 6.00 112.00
 26.00
 32.00

Hon. Mr. Rowan
No. 24 ✓ 1000 Speech 44 pages

Pishey Thompson
No. 25 ✓ The ——— No. 7,
 do. No. 8.
 13

Wm. Brent
No. 26 3 qrs. Summons

4th Auditor
No. 27 ✓ 1 ream Reports ✓

1st Legion
No. 28 3 qrs. Inspection Returns 4 pages ✓

Marine Corps
No. 29 Morning Report Marine Guard 1 ream ✓
 20

D. Trimble
No. 30 6000 Speech 20 pages ✓

Wm. L. Brent
No. 31 ✓ 300 Circular. English
No. 32 250 do. French

May 20, 1826

Ordnance Department
No. 33 ✓ ½ ream Instruction 4 pages ✓ 6.00

Hon. Mr. Worthington
No. 35 200 Speech 24 pages ✓ 25.00

Hon. Mr. Reed.
No. 36 500 Speech 32 pages 25.00

Hon. Mr. Whipple
No. 37 1000 Speech 24 pages 60.00

Navy Store
No. 34 2 ream Requisitions 5.00

Hon. Mr. Bartlett
No. 38 500 Speech 28 pages 30.00
 22

2d. Legion
No. 39 ✓ 3 qrs. Notices Capt. Ingle 1.50
No. 40 ✓ 1 do. Capt. Woodward ✓ .75

Ordnance Office
No. 41 3½ qrs. Bonds 3 pages ✓ 5.00

Indian Office
No. 43 ✓ 1000 Vocabulary No. 1.
No. 44 ✓ 500 do. 2.
No. 45 ✓ 500 Tables of Tribes ✓ 75.00

Col. White. (Florida.)
No. 46 1000 Circular 12 pages ✓
 31

Yates & McIntire
No. 48 300 Lottery Tickets ✓

N. Jewett
No. 49 ✓ 1000 Labels for Todd,
June 1

Marine Corps
No. 50 4 qrs. Imperial Blank Leading
 Settlement Accounts 16.00

Treasury Department
No. 51 ✓ 180 Circular to Receivers of
 Public Moneys 6 pages ✓ 6.00

Opposite and above. Printing orders in Peter Force's Office Ledger, 1826–32. 6 × 17 in. AS 837.

Georgetown College / Columbia(n) College

This small, rare lithograph shows the main buildings of the first two colleges in Washington, D.C.—Georgetown College and Columbian College. Georgetown College was founded by Bishop John Carroll in 1789 at 37th and O Streets N.W. as the first Catholic—and first Jesuit—institution of higher learning in the United States. In addition to the general liberal arts department, the college trained candidates for the priesthood.

The first building erected at Georgetown College, "Old South," opened in 1794 with 40 students and immediately proved to be too small. The much larger "Old North" building, designed to accommodate 100 students, was begun in 1794 and completed in 1808. It was based on the design of Nassau Hall at Princeton University (then the College of New Jersey). The building, measuring 154 by 40 feet, opened for use in 1797 before it was completed. The four-story brick building included classrooms, a library, chapel, natural history museum, auditorium, offices, and dormitory rooms. One of the first prominent visitors was President Washington, who came in 1797 to see his two grand-nephews. At the time, Old North was the second largest building in the District of Columbia, after the Capitol. Old North remained the principal building on campus until Healy Hall opened in 1881.

By the outbreak of the Civil War in 1861, the campus comprised five buildings—Old North, Old South, Gervase Hall, Mulledy Hall, and Maguire Hall. After the First Battle of Bull Run in July 1861, several hundred Union troops occupied the campus in their rows of pitched tents—the 69th New York "Irish" Regiment and the 79th New York "Highlander" Regiment. Four of the five buildings were taken for Union hospitals, but Georgetown College continued to function in the Old North building because of the intervention of Gen. S. W. Whipple, whose two sons were students. After Old South was razed in 1904, Old North became the oldest surviving building on campus.

The image shown at the bottom of this print is the Columbian College building, built just beyond the city limits of Washington, D.C.—north of Florida Avenue between 14th and 15th Streets N.W. near the present Euclid Street. Columbian College was founded in 1821, and its original, large brick building was completed in 1822. It was nearly the same size as Old North at Georgetown College—117 by 47 feet with five stories. All of the activities of the college

were contained here—classrooms, dormitory, library, and a laboratory in the attic. The large basement housed the kitchen, dining room, and chapel. It was founded by local leaders of the Baptist church, including Luther Rice and Obadiah B. Brown, who purchased 47 acres from George Peter for $7,000 for the campus. The college lost its religious affiliation in 1846, when the American Baptist Missionary Union decided to withdraw financial support for the school.

The Civil War affected Columbian College as seriously as it did Georgetown College. Even though two-thirds of its students left to join either the Union or Confederate army, the Columbian College continued in operation. The Union army appropriated the vacant space in the building by installing the Columbian General Hospital, which housed 844 patients during the war. Also located on the campus was a second hospital, the Carver General Hospital, housed in wooden wards and large tents. Students from the college medical department helped care for patients on the grounds.

After the war the trustees of Columbian College in 1873 changed its name to Columbian University. In 1881 they voted to move the institution downtown. The medical school and law school were already located at 15th and H Streets N.W., so the college moved there. Because of the rapid residential development of Columbia Heights, the value of the campus land escalated. In 1881 the college sold the campus in three sections. The north and south portions went to real estate investors for $136,000—enough funds to allow the college to build its new main building downtown. By 1884 the old main building was demolished to provide building lots for row houses. The west portion was later sold to the government and became part of Meridian Hill Park. Originally six streets ran through the old campus, named for college presidents and professors. Only two of the original names survive today—Chapin Street, named for the second president, and Euclid Street, for the ancient Greek philosopher who is referred to as the "father of geometry." These two remaining streets are the only reminder that the college was located there.

While at the 15th and H Streets location, Columbian University changed its name. It made an agreement with the George Washington Memorial Association to take the name "The George Washington University" in 1904. After remaining there for 30 years, the George Washington University moved in 1912 to 2023–24 G Street N.W.—its present location in Foggy Bottom.

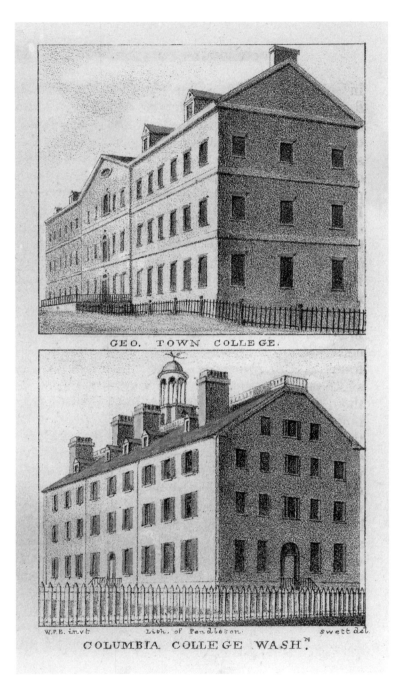

GEO. TOWN COLLEGE.

W.P.E. invt. Lith. of Pendleton. swett del.

COLUMBIA COLLEGE WASH.ᴺ

Lithograph, *Georgetown College/Columbia(n) College*,
by unknown publisher, ca. 1830. 5 × 3 in. AS 913.

Phoenix Line, "Safety Coaches"

Four years after Washington was laid out by L'Enfant in
1791, regular stagecoach service was established between
Baltimore and Washington to deliver mail and accommo-
date passengers between the two cities. The trips were
unpleasant because of the dust coming through open win-
dows, the swaying motion, and crowded conditions. This
1831 colored lithograph by Moses Swett of Baltimore shows
a yellow and black Phoenix Line stagecoach traveling from
Baltimore to Washington. Newspaper advertisements for
the Phoenix Line were placed by the owner, George
Beltzhoover, a native of Hagerstown. He sold tickets for $3
to passengers who would be picked up from the three Bal-
timore hotels that he also owned—the Fountain Inn, Indian
Queen, and Barnum's Hotel. At the end of the five-hour
trip they would be delivered to two Washington hotels on
Pennsylvania Avenue—the National and the Metropolitan.
By that time, several stagecoach lines operated daily
between Baltimore and Washington. In 1835 the Baltimore
and Ohio Railroad reached Washington and provided seri-
ous competition to the stagecoach lines. Most travelers pre-
ferred the railroad because the trains were faster, the travel
was smoother, and the cars were cleaner. It is assumed that
the railroad put the Phoenix Line out of business in 1835,
because no advertisements appear after that date.

This elegant print shows a small stagecoach pulled by
four horses. The vehicle's design and size became known as
a "Troy coach" after the city of Troy, New York, where a
number of companies made light, almost egg-shaped
coaches for use on the East Coast. By the 1820s, the roads in
the east were greatly improved by turnpikes, as well as by
the first national highway between Baltimore, Maryland,
and Wheeling, Virginia. In 1831 one Troy firm, Eaton and
Co., produced 50 Troy stagecoaches for use in Pennsylvania.
Concord, Massachusetts, became the center for the manu-
facture of much boxier and larger coaches, which were
pulled by six horses. These "Concord coaches" were used
almost exclusively in the West, where they traveled over
rougher terrain for longer periods.

Usually a stagecoach could travel as far as 50 miles in one
day until it stopped for the passengers to spend the night in
a tavern or inn. The standard practice was for the stage-
coach to stop every 10 miles for the horses to be changed.
The town of Middleburg, Virginia, for instance, derived its
name from being the middle point on the stagecoach line
between Washington, D.C., and Winchester, Virginia. Pas-
sengers spent the night there at the tavern before continu-
ing the next stage of the trip the following morning.

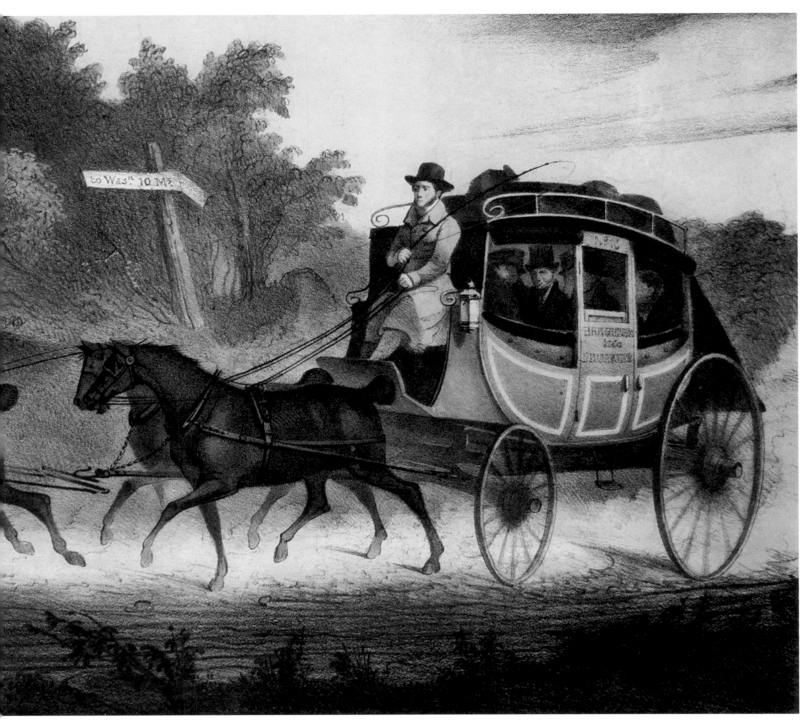

Colored lithograph, *Phoenix Line,* "*Safety Coaches,*" Endicott and Swett, Baltimore and New York, 1831. 12 × 18.5 in. AS 257.

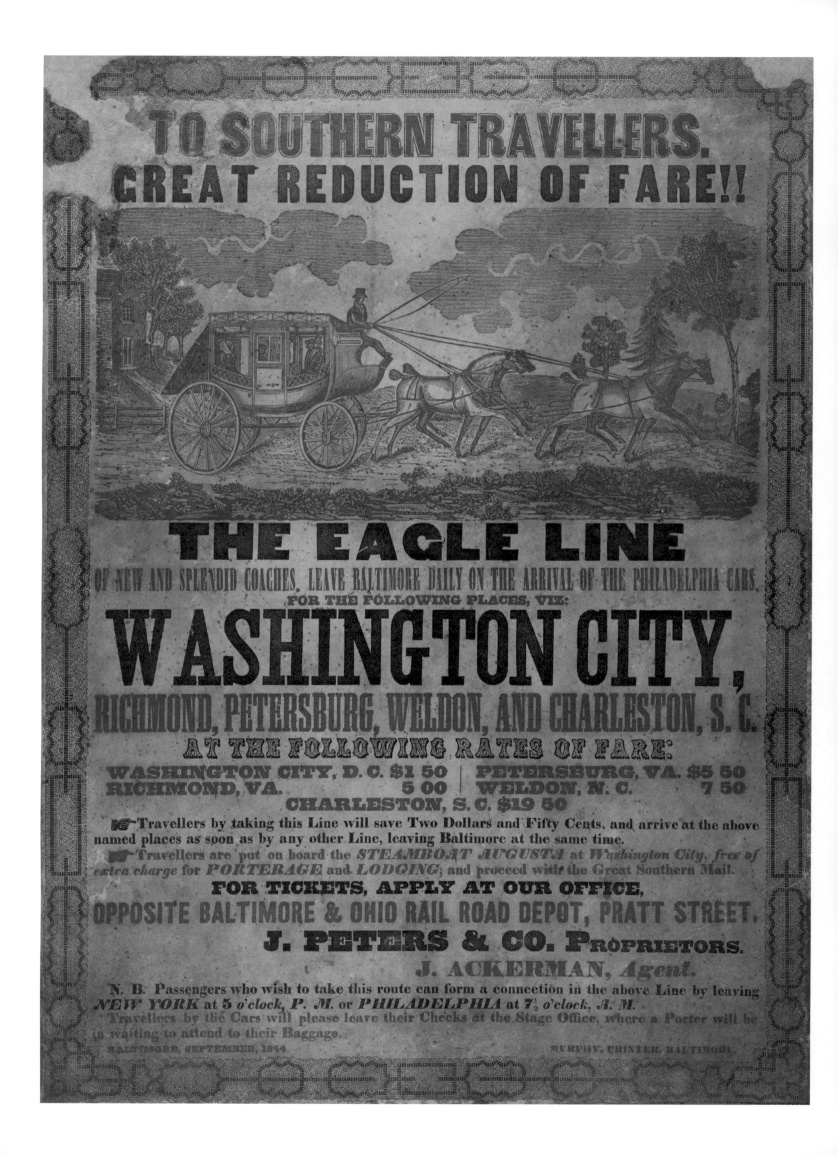

To Southern Travellers, Great Reduction of Fare!!

In 1844 another stagecoach company, the Eagle Line, went daily from Baltimore to Washington, carrying passengers and possibly illegal mail at rates lower than those charged by the Post Office. The fare between the two cities was reduced to $1.50 in an effort to compete with the Baltimore and Ohio Railroad. The Eagle Line traveled along the Great Southern Mail railroad route, which began in Philadelphia and continued south through Baltimore. When the stagecoach arrived in Washington, the passengers boarded the steamship *Augusta*, which sailed 55 miles down the Potomac River to Aquia Creek, a major steamboat hub in Stafford, Virginia. Here the travelers transferred to the Richmond, Fredericksburg, and Potomac Railroad line. After arriving in Richmond the passengers had to cross the city by omnibus to the depot of the Richmond and Petersburg Railroad.

They continued on this railroad to Petersburg, Virginia, until the railroad terminated in Weldon, North Carolina. Here they transferred to the Wilmington and Raleigh Railroad, which carried the passengers and mail to four stops before reaching Wilmington—North Carolina's major port city. They continued by a second steamer on the trip that terminated in Charleston, South Carolina. It would not be until 1854 that these two port cities would be connected by the Wilmington and Manchester Railroad.

The Eagle Line failed in its attempt to compete with the railroads and closed after two years' operation. The same pattern followed throughout the East Coast in the years before the Civil War. In the western territories and states, which lacked railroads until the late 19th century, stagecoach travel continued much longer.

Broadside, *To Southern Travellers, Great Reduction of Fare!!*
printed by Spittall and Murphy, Baltimore, 1844. 23 × 16.75 in. AS 924.

The Slave Market of America

In about 1830, the center of the American slave trade in the upper South shifted from Baltimore, Maryland, to the District of Columbia, because its location made shipment of slaves to the deep South much easier. Changes in agricultural production caused a surplus of slaves in the upper South, and they were sold to the owners of expanding cotton plantations in Georgia, Alabama, Mississippi, and Louisiana. In Washington, slave auctions were held by John Gadsby at his house on Lafayette Park, while Joseph W. Neal and Co. maintained its office and slave pen near the intersection of 7th Street and Pennsylvania Avenue N.W. The largest dealer, however, was Franklin and Armfield, which had its holding pen and auction rooms on Duke Street in Alexandria, D.C. This firm owned three ships that could each take 180 slaves to the deep South. In 1834 alone, it shipped 1,000 slaves to auction houses in New Orleans, Louisiana, and Natchez, Mississippi.

This broadside includes nine images that record the slave trade in the District of Columbia. It contrasts the ideals of liberty and independence fostered by the American Revolution versus the legality of slavery in the District of Columbia—images of slaves in prison, slaves being auctioned, and slaves sailing down the Potomac River for Southern ports. One unsettling image on the broadside shows a coffle, or column of chained slaves, on Pennsylvania Avenue. A witness described the scene:

In May 1834, a gentleman visited it (Joseph W. Neal & Co.) and fell into conversation with the overseer of the pen. He heard the clanking of chains within the pen. "O," said the Overseer—himself a Slave, "I have seen fifty or seventy Slaves taken out of the pen, and the males chained together in pairs, and drove off to the South—and how they would cry, and groan, and take on, and wring their hands, but the driver would put on the whip and tell them to shut up—so they would go off and bear it as well as they could.

The broadside also quotes the Bible, the Declaration of Independence, and the Constitution to condemn slavery. A major tactic of William Lloyd Garrison, who founded the American Anti-Slavery Society in Philadelphia in 1833, was to convince preachers in evangelical white churches to attack slavery as a moral wrong before their congregations. Garrison further called for an immediate, uncompensated abolition of slavery, as well as an end to the colonization of American slaves to Africa.

Not surprisingly, slavery was a contentious issue in Congress. The abolition of slavery in Washington—the nation's capital and the center of democracy—would be a strategic victory for the abolition cause. Congress had enough Southern members to pass an act that retroceded Alexandria, D.C., back to Virginia in 1846. This guaranteed that the slave trade in Alexandria would survive under Virginia law. Only four years later, in 1850, the abolitionists in Congress were able to pass a bill that outlawed the slave trade, but not slavery, in Washington, D.C.

Slavery came to an end in the District of Columbia in 1862, and the owners of 3,000 slaves were compensated. Eight more months passed before Lincoln issued the Emancipation Proclamation in early 1863, freeing slaves in the Confederate states. The 13th Amendment to the Constitution was passed in 1865, prohibiting slavery throughout the United States.

Printed broadside, *The Slave Market of America*, American Anti-Slavery Society, Philadelphia, 1836. 26.5 × 17.2 in. AS 13.

THE SLAVE MARKET OF AMERICA.

THE WORD OF GOD.

"ALL THINGS WHATSOEVER YE WOULD THAT MEN SHOULD DO TO YOU, DO YE EVEN SO TO THEM, FOR THIS IS THE LAW AND THE PROPHETS."
"AND THEY SIGHED BY REASON OF THE BONDAGE, AND THEY CRIED, AND THEIR CRY CAME UP UNTO GOD BY REASON OF THE BONDAGE, AND GOD HEARD THEIR GROANING."
"THUS SAITH THE LORD, EXECUTE JUDGMENT IN THE MORNING, AND DELIVER HIM THAT IS SPOILED OUT OF THE HANDS OF THE OPPRESSOR, LEST MY FURY GO OUT LIKE FIRE, AND BURN THAT NONE CAN QUENCH IT, BECAUSE OF THE EVIL OF YOUR DOINGS."

THE DECLARATION OF AMERICAN INDEPENDENCE.

"WE HOLD THESE TRUTHS TO BE SELF-EVIDENT.—THAT ALL MEN ARE CREATED EQUAL, THAT THEY ARE ENDOWED BY THEIR CREATOR WITH CERTAIN UNALIENABLE RIGHTS; THAT AMONG THESE ARE LIFE, LIBERTY, AND THE PURSUIT OF HAPPINESS."

THE CONSTITUTION OF THE UNITED STATES.

"THE CITIZENS OF EACH STATE SHALL BE ENTITLED TO ALL THE PRIVILEGES AND IMMUNITIES OF CITIZENS OF THE SEVERAL STATES." Article 4, Section 2.
"CONGRESS SHALL MAKE NO LAW ABRIDGING THE FREEDOM OF SPEECH OR OF THE PRESS; OR OF THE RIGHT OF THE PEOPLE PEACEABLY TO ASSEMBLE, AND TO PETITION THE GOVERNMENT FOR A REDRESS OF GRIEVANCES."—Article 1, Amendment.
"CONGRESS SHALL HAVE POWER TO EXERCISE EXCLUSIVE LEGISLATION, IN ALL CASES WHATSOEVER, OVER SUCH DISTRICT NOT EXCEEDING TEN MILES SQUARE) AS MAY, BY CESSION OF PARTICULAR STATES AND THE ACCEPTANCE OF CONGRESS, BECOME THE SEAT OF GOVERNMENT OF THE UNITED STATES."—Article 1, Section 8.

CONSTITUTIONS OF THE STATES.

"EVERY CITIZEN MAY FREELY SPEAK, WRITE, AND PUBLISH HIS SENTIMENTS ON ALL SUBJECTS, BEING RESPONSIBLE FOR THE ABUSE OF THAT LIBERTY." Constitutions of Maine, Connecticut, New-York, Pennsylvania, Delaware, Ohio, Indiana, Illinois, Tennessee, Louisiana, Alabama, Mississippi, and Missouri.
"THE FREEDOM OF THE PRESS IS ONE OF THE GREAT BULWARKS OF LIBERTY, AND THEREFORE OUGHT NEVER TO BE RESTRAINED."—North Carolina.
"THE LIBERTY OF THE PRESS OUGHT TO BE INVIOLABLY PRESERVED."—Maryland.
"THE FREEDOM OF THE PRESS IS ONE OF THE GREAT BULWARKS OF LIBERTY, AND CAN NEVER BE RESTRAINED BUT BY DESPOTIC GOVERNMENTS."—Virginia. Other States nearly the same.

DISTRICT OF COLUMBIA.

"THE LAND OF THE FREE." THE RESIDENCE OF 7000 SLAVES "THE HOME OF THE OPPRESSED."

READING OF THE DECLARATION OF INDEPENDENCE.

PART OF WASHINGTON CITY.

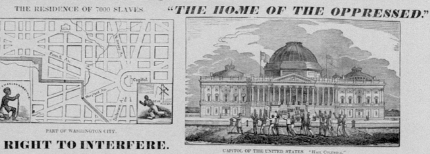

CAPITOL OF THE UNITED STATES. "Hail Columbia."

RIGHT TO INTERFERE.

People sometimes say we have no right to interfere for the abolition of Slavery in the District of Columbia. Now what are the facts in the case? Article 1, Sec. 8, of the Constitution (see above) gives Congress "power to exercise exclusive legislation in all cases whatsoever, over such district."

PUBLIC PRISONS IN THE DISTRICT.

Built by Congress with $15,000 of the People's money; perverted from the purposes for which they were built, and used by Slaveholders for the confinement of refractory Slaves, by licensed Slave-dealers as depots for their victims, and by kidnappers for the imprisonment of Free Americans, seized and sold to pay their jail fees!

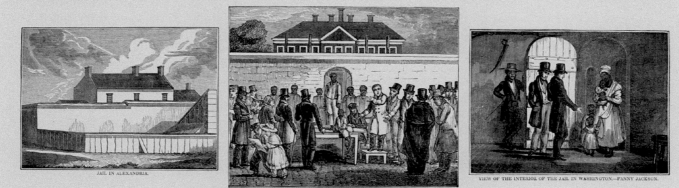

JAIL IN ALEXANDRIA.

JAIL IN WASHINGTON.—SALE OF A FREE CITIZEN TO PAY HIS JAIL FEES!

VIEW OF THE INTERIOR OF THE JAIL IN WASHINGTON.—FANNY JACKSON.

FACTS.

PRIVATE PRISONS IN THE DISTRICT, LICENSED AS SOURCES OF PUBLIC REVENUE.

"For a license to trade or traffic in slaves for profit, whether as agent or otherwise, four hundred dollars,"—the Register to "deposit all monies received from taxes imposed by this act to the credit of the Canal Fund." Act to provide a revenue for the Canal Fund, approved July 28, 1831. City Laws, p. 249.

SLAVE HOUSE OF J. W. NEAL & CO.

"CASH FOR 200 NEGROES."

"We will give cash for two hundred likely young negroes, of both sexes, families included. Persons wishing to dispose of their slaves, will do well to give us a call, as we will give higher price in cash than any other purchasers who are now, or may hereafter come into this market. All communications will meet attention. We can at all times be found at our residence on 7th street, immediately South of the Centre Market House, Washington, D. C."
"JOSEPH W. NEAL & CO."
September 13, 1834.

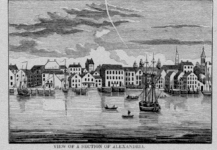

VIEW OF A SECTION OF ALEXANDRIA.

"ALEXANDRIA AND NEW-ORLEANS PACKETS."

"Brig TRIBUNE, Captain Smith, and Brig UNCAS, Captain Boush, will resume their regular trips on the 20th October, one of which will leave this port every thirty days thereafter the shipping season. They are vessels of the first class, commanded by experienced officers, and will at all times go up the Mississippi by steam, and every exertion used to promote the interest of shippers and comfort of passengers. Apply to the Captains on board, or to
"FRANKLIN & ARMFIELD."
"Alexandria, September 1, 1834."

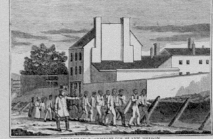

FRANKLIN & ARMFIELD'S SLAVE PRISON.

"CASH FOR 400 NEGROES."

"Including both sexes, from 12 to 25 years of age. Persons having likely servants to dispose of, will find it to their interest to give us a call, as we will give higher prices in cash than any other purchaser who is now, or may hereafter come into this market."
"FRANKLIN & ARMFIELD."
"Alexandria, September 1, 1834."

Published by the Am. Anti-Slavery Society, 144 Nassau-st., New-York, 1836.

WILLIAM'S DORR, Pr.

$100
REWARD

Ran away from the subscriber, living near the Anacostia Bridge, on or about the 17th November, negro girl ELIZA. She calls herself Eliza Coursy. She is of the ordinary size, from 18 to 20 years old, of a chestnut or copper color. Eliza has some scars about her face, has been hired in Washington, and has acquaintances in Georgetown.

I will give fifty dollars if taken in the District or Maryland, and one hundred dollars if taken in any free State; but in either case she must be secured in jail so that I get her again.

JOHN. P. WARING.

Nov. 28, 1857.

H. Polkinhorn's Steam Job Printing Office, D street, bet. 6th & 7th sts., Washington, D. C.

Broadside, *$100 Reward*, 1857. 11 × 9 in. AS 651.

$100 Reward

This broadside advertised a reward for the apprehension of a runaway slave named Eliza Coursy. It was printed in Washington, D.C., in 1857 for the owner, John P. Waring, a planter from the adjacent Montgomery County, Maryland. By the 1830s a majority of Maryland and Virginia planters had switched from growing tobacco to wheat because tobacco was too labor intensive and ruined the soil. Because of the resulting surplus of slaves, planters from the upper South began to sell or hire out many of their slaves to work for wages in the cities of Washington and Baltimore. The owners took a percentage of their earnings, but often these hired-out slaves were allowed to buy their freedom with the earnings they were allowed to keep.

Washington developed a large population of free blacks—more than 3,000 when the Civil War began in 1861. At that time only three American cities had populations of free blacks that outnumbered enslaved blacks—Washington, Baltimore, and Saint Louis. This demographic feature proved influential on slaves who had been hired out to work in Washington, for they often intermingled with the free blacks and learned of the abolition movement and the Underground Railroad. Some ran away. This may have happened to Eliza—it is not known whether she was ever captured.

Henry Polkinhorn's printing company, located downtown at 6th and D Streets N.W., produced the broadside. He specialized in "job" printing—that is, printing broadsides and related items such as tickets, invoices, timetables, and other ephemera, rather than books. He is most famous for printing the 1865 playbill, *Our American Cousin*—the play Lincoln was attending at Ford's Theatre the night he was assassinated by John Wilkes Booth. Polkinhorn printed broadsides for local runaway slaves, all in the same template. They listed the reward amount, the owner's name, the slave's name, and his or her physical description, mannerisms, or personality traits. These helped professional slave catchers spot runaways. Once apprehended, the runaway would be placed in a local jail. The jail keeper would then advertise in a local newspaper for the owner to come and get his slave and pay the expenses and the reward. Often the owner would then sell the captured slave to the New Orleans or Natchez auction houses, where there was a strong demand from the growing number of sugarcane and cotton plantations in the Gulf states.

National Hotel Bill

This bill was made out to Francis Scott Key, a Washington lawyer and the famous author of the "Star Spangled Banner", for his brief stay at the National Hotel in May 1837. The top of the bill includes an engraving of the four-story hotel located on the northeast corner of Pennsylvania Avenue and 6th Street N.W. The total charge of $5.62 included one night's lodging, dinner, and miscellaneous supplies, including paper. It is not known why Key stayed at the hotel, since his home was then only two blocks away at 3rd and C Streets (now the site of the Municipal Building).

The National Hotel originated in 1816, when Roger Weightman of Alexandria, Virginia, built six adjoining row houses on this site. A decade later, John Gadsby bought the hotel and enlarged it to a four-story building. In the 1830s and 1840s, it was the largest and most fashionable hotel in the capital, with 10 parlors and a rear courtyard. In the years before the Civil War, the National Hotel became especially popular with Southerners, while the Willard Hotel was occupied mainly by Northerners. Guests at the National Hotel included Andrew Jackson, James Buchanan, and Sen. Henry Clay, who died in his room there in 1852. John Wilkes Booth was staying at the hotel the day he assassinated Lincoln on April 14, 1865. The hotel received national attention in 1857, when more than 100 guests, many staying there to attend James Buchanan's inauguration, developed dysentery. This malady, known then as the National Hotel Disease, killed 36 people and was thought to have been caused by contaminated water. The former National Hotel site is now occupied by the Newseum.

Printed bill, *National Hotel Bill*, drawn by John Rubens Smith,
engraved by J. B. Longacre, 1837. 7.5 × 4.75 in. AS 25.

Government Hospital for the Insane/ Government Hospital for the Insane, Washington, D.C. *(overleaf)*

The Government Hospital for the Insane, commonly known as Saint Elizabeths Hospital, was established primarily through the lobbying efforts of Dorothea Dix, a school teacher from Massachusetts, who grew alarmed at the way mentally ill patients were treated. Most were housed in jails and almshouses. Because of her efforts, over two dozen state hospitals for the insane were founded between 1840 and 1870. She persuaded Rep. John G. Davis of Indiana to introduce a bill in Congress to establish a federally funded government hospital for the insane in Washington, D.C., to care for both locally ill patients and those from the army and navy. The bill passed, providing $100,000 for the construction of the main building, and was signed into law by Dix's friend, President Millard Fillmore, in 1852.

Dorothea Dix was responsible for selecting the site, on a steep hill in far Southeast Washington, overlooking the Anacostia River and downtown Washington in the distance. She coaxed Thomas Blagden to sell 185 acres of his farm for the hospital site. Dix felt that a rural environment would improve the condition of the mentally ill. In addition, she was responsible for hiring Dr. Charles Nichols, who had managed the Bloomingdale Asylum in New York, as the first superintendent. Nichols's design of the main building at Saint Elizabeths Hospital was influenced heavily by the writings of Dr. Thomas S. Kirkbride, who advocated that a main hospital building be built in a straight linear design to provide privacy for the 250 patients. Also included would be the superintendent's office and other administrative offices in the center. Nichols improved upon this design with setback wings from the center section of the hospital. Ventilation and views were both improved. Nichols persuaded Thomas U. Walter, Architect of the Capitol, to prepare the architectural drawings.

The center building was used as the residence of the superintendent and his family, administrative offices, a staff dining room, and an assembly room that served as a meeting place for lectures and church services, as well as a community center. The recessed wings on the east were used for white male patients and those on the west for white female patients. Each recessed wing had its own dining room and parlor.

Construction began in 1854 on the outer wings. The first patients—63 with dementia—were admitted in 1855 before the building was finished. During the Civil War the east wing was taken over by the military and used as the Saint Elizabeths General Hospital from 1861 to 1864. The military borrowed the term "Saint Elizabeth" from the original land-grant name from the late 17th century. After the war the name "Saint Elizabeths" was used for the entire complex of hospital buildings.

Upon the retirement of Dr. Nichols from the hospital in 1878, Dr. William Godding took over as superintendent. He expanded the hospital by adding dozens of small cottages for specialized care for the patients. By the early 20th century, the grounds had been enlarged to 500 acres and more than 50 buildings. As can be seen on the 1904 map of the hospital campus, it then included many specialized buildings—greenhouses, a home for nurses, buildings for epileptic patients, a prison, carpenter shop, and across Nichols Avenue (renamed Martin Luther King Jr. Avenue in 1971) on the east campus a barn, hen house, pig house, and horse stable for the hospital-operated farm. Male patients were encouraged to volunteer to work on the farm, and female patients to take up weaving in the craft shop—activities that were seen as beneficial to the mentally ill. By 1955 the number of the hospital's patients had increased to more than 7,500.

In 1963 a major change occurred, when President John F. Kennedy signed a law to reform mental hospitals by releasing long-term patients and placing them on drugs in small health care agencies within the community. In 1987 the U.S. government gave the operation of Saint Elizabeths Hospital to the D.C. government and provided the funds for one new hospital building on the east campus, with only 280 patients. Most are very serious cases who require long-term care. The large west campus, where most of the historic buildings are located, was given to the federal government's General Services Administration. That agency is working to transform the west campus into the new headquarters of the U.S. Department of Homeland Security, which includes the U.S. Coast Guard.

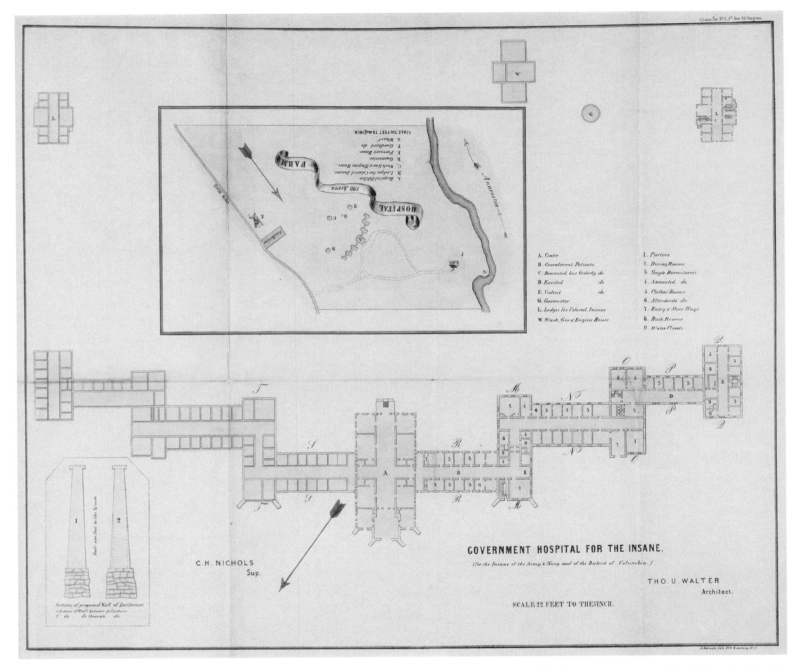

Lithograph, *Government Hospital for the Insane*, by Ackerman, New York, included in U.S. House Executive Document 1, First Session, 34th Congress, 1854. 16 × 18 in. AS 577.

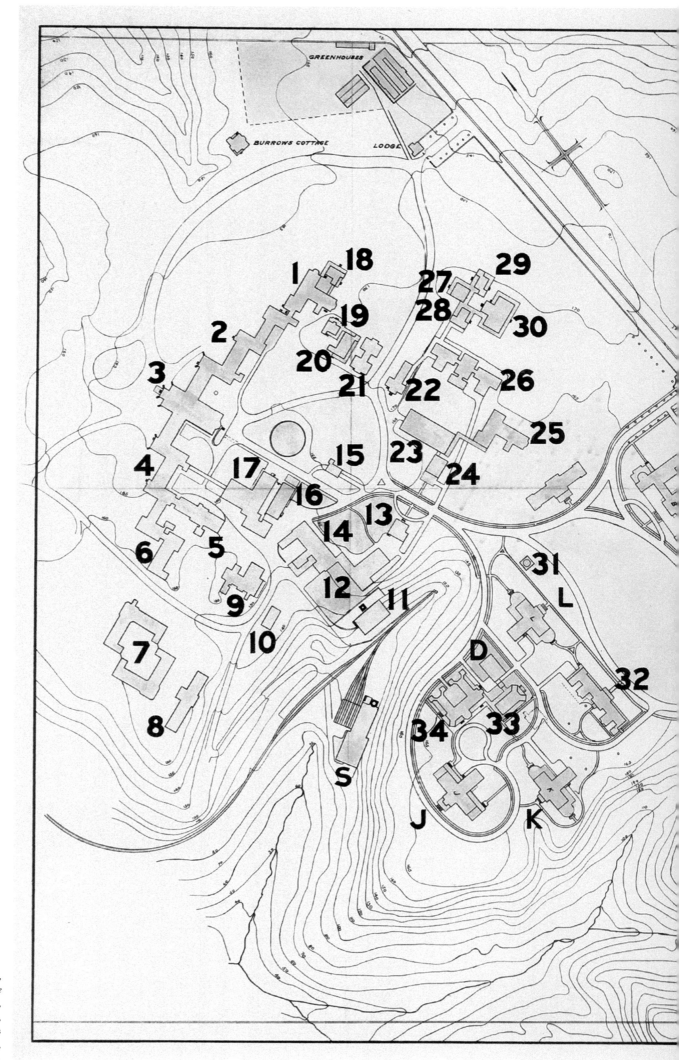

GREENHOUSES

BURROWS COTTAGE LODGE

Colored lithograph,
*Government Hospital for the
Insane, Washington, D.C.,*
drawn by James Berrall,
published by Norris Peters
Co., Washington, D.C.,
1904. 21 × 27 in. AS 614.

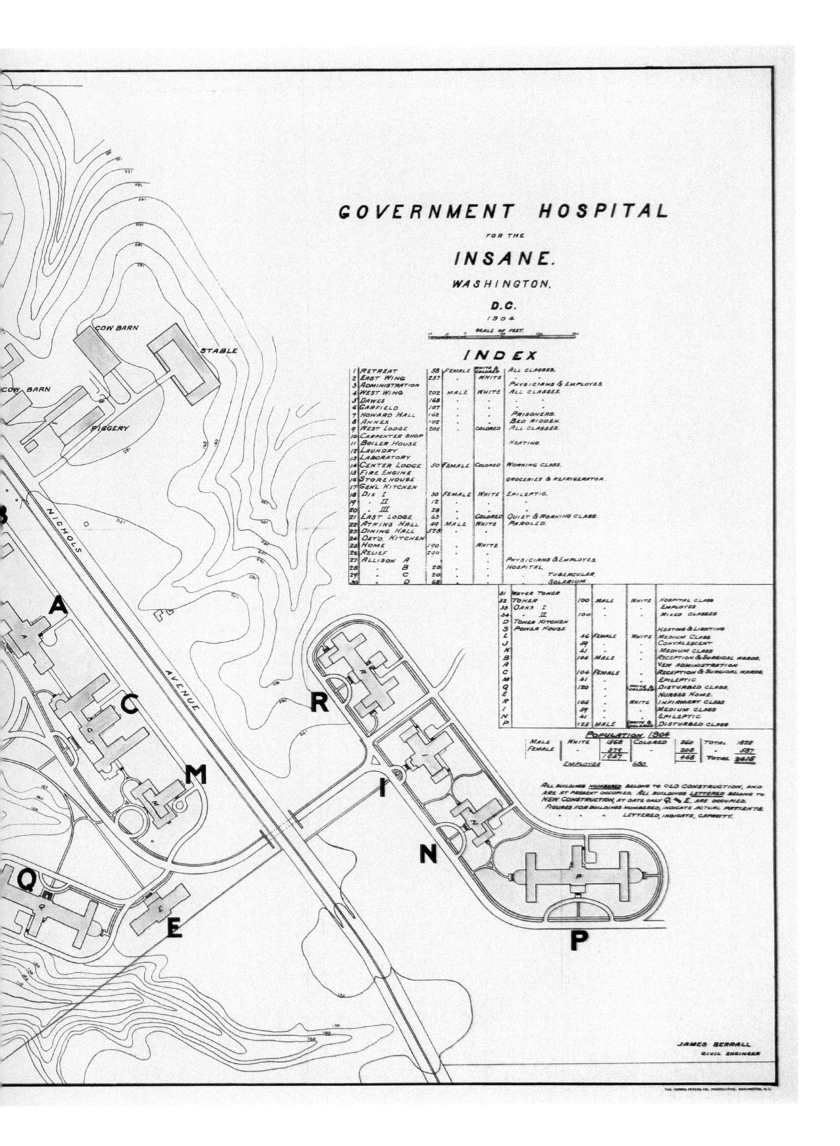

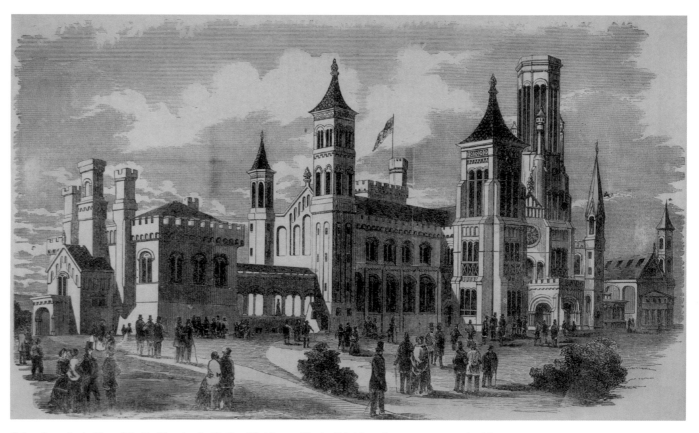

Colored woodcut, *View of the Smithsonian Institution, Washington City*, in *U.S. Magazine*, ca. 1855. 6 × 9 in. AS 51.

TWO SMITHSONIAN IMAGES (PAGES 78–79)

View of the Smithsonian Institution, Washington City

Within months after the Smithsonian Institution was chartered by Congress in 1846, plans were underway to build an ornate and picturesque red sandstone building on the National Mall at 10th Street S.W. The leading figure in proposing such a landmark was a member of the original Board of Regents and chairman of the Building Committee, Rep. Robert Dale Owen of Indiana. Owen wanted a Medieval Revival building with the basic design of a rectangular central block and two wings connected by ranges to the center. The building would be designed both for scientific research and for art exhibitions and would include a museum, lecture halls, art galleries, offices, and a library.

Washington architect Robert Mills helped Owen with the early designs. Owen and his fellow committee members toured the northeastern states to look at recent buildings designed in the Medieval style. The Board of Regents was impressed with a young New York architect, James Renwick Jr., and his Gothic Revival design for Grace Episcopal Church in Manhattan. Owen selected him as the architect for this major

building in late 1846. The first secretary of the Smithsonian, Joseph Henry, took office soon after the building's design was selected. Henry was alarmed over the expense of the Smithsonian Castle but he was unable to halt its construction because the Regents had approved it. Henry was able, however, to have the three stories of the central section reduced to two.

Renwick's final design was mainly Romanesque Revival, but he also included elements of the Gothic, Norman, and even Italianate. The extant landmark, with its eight towers of varying design, is best termed "Medieval Revival." The main entrance on the north, facing the National Mall, is through a porte cochere, while the main south entrance is surmounted by a large oriel window.

The building is picturesque because of its asymmetry. This early view from the northeast shows the East Wing attached to the body of the building by an open arcade. Secretary Henry and his family lived in the East Wing from 1855, when the building was finished, until his death there in 1878. Afterward it was converted to offices.

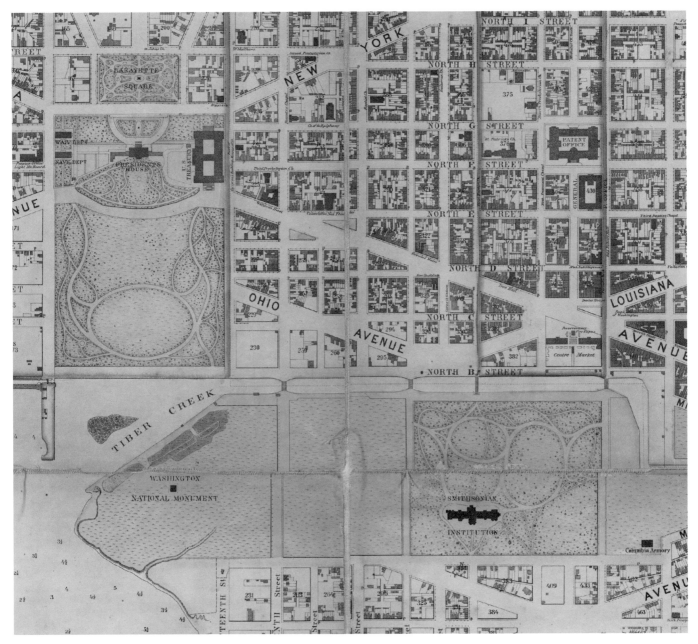

Map of Washington City, District of Columbia. Dawn by A. Boschke. Published by J. Bien, New York, 1857. Size: 5 × 5 feet. AS 295.

Map of Washington City, District of Columbia

In 1850 President Millard Fillmore commissioned Andrew Jackson Downing of Newburgh, New York to landscape the National Mall, White House grounds, and Lafayette Park. Although he finished his master plan in early 1851, only the landscaping of the Smithsonian grounds, north of the Castle between 7th and 12th Streets, was carried out by the outbreak of the Civil War. This detail from an 1857 map of Washington, D.C., by Albert Boschke, a German engineer then employed by the U.S. Coast Survey, shows the outline of the Castle with winding carriage drives landscaped with evergreen trees. The rest of Downing's master plan was completed in 1876. President Franklin D. Roosevelt removed Downing's Victorian design between 1934 and 1936 and restored the Mall to L'Enfant's original 1791 design of an open greensward between the Capitol and the Washington Monument.

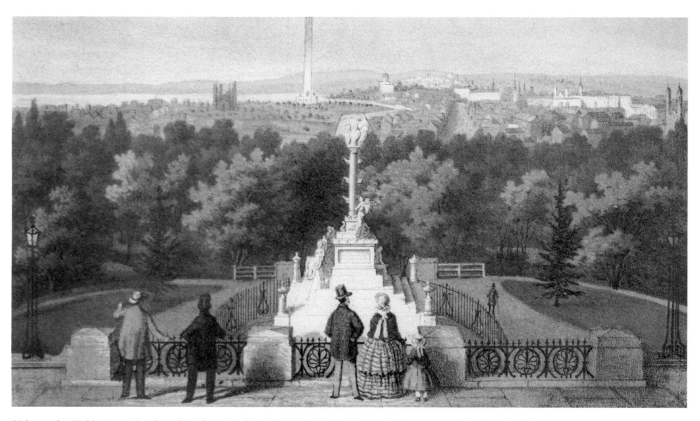

Lithograph, *Washington—View from the Balustrade of the Capitol*, by Edward Sachse, Baltimore, ca. 1855. 5.5 × 8 in. AS 423.

Washington—View from the Balustrade of the Capitol

This view from the west terrace of the Capitol (about 1855) shows tourists looking at the Tripoli Monument in the foreground with the National Mall and downtown Washington in the distance. Tourists could easily identify the Smithsonian Castle, Washington Monument, Naval Observatory, Pennsylvania Avenue, and Trinity Episcopal Church on the far right.

The Tripoli Monument was the earliest monument and the earliest outdoor sculpture erected in the capital. It commemorates American naval officers who lost their lives in the Tripolitan War of 1801–05, a war over tributes demanded by Tripoli to "safeguard" American vessels sailing in the Mediterranean Sea from being captured and pillaged.

In response, the United States sent ships to blockade the coasts of the Barbary States. In 1803 the American frigate USS *Philadelphia* was captured by Tripoli, and the officers and sailors were taken prisoner. To prevent the Tripolitans from using the USS *Philadelphia* against the American navy, a group of American naval officers and sailors entered the Tripoli harbor and burned the ship. The following year, the American navy attacked the port of Tripoli and caused major damage to the city. As a result, Tripoli surrendered and signed a peace treaty with the United States.

The surviving officers and sailors raised $3,000 to build this monument to the officers killed in the war. It was carved of white Italian marble in Leghorn, Italy, in 1807 by Carlo Giacinto Micali and transported on the USS *Constitution* to the Washington Navy Yard in 1808, where it was placed on display. The design consists of allegorical female figures standing at the base of a large naval column, which is surmounted by an American eagle. The names of the six American officers killed are inscribed along the base. Four torches, one at each corner of the base, add to the embellishment of the 15-foot-high sculpture.

In order that the sculpture could be seen and appreciated by more people, it was moved to the west terrace of the Capitol in 1831. But when the storage of hundreds of iron beams used in the construction of the Capitol's new iron dome threatened to damage the sculpture in November 1860, it was moved permanently to the U.S. Naval Academy in Annapolis.

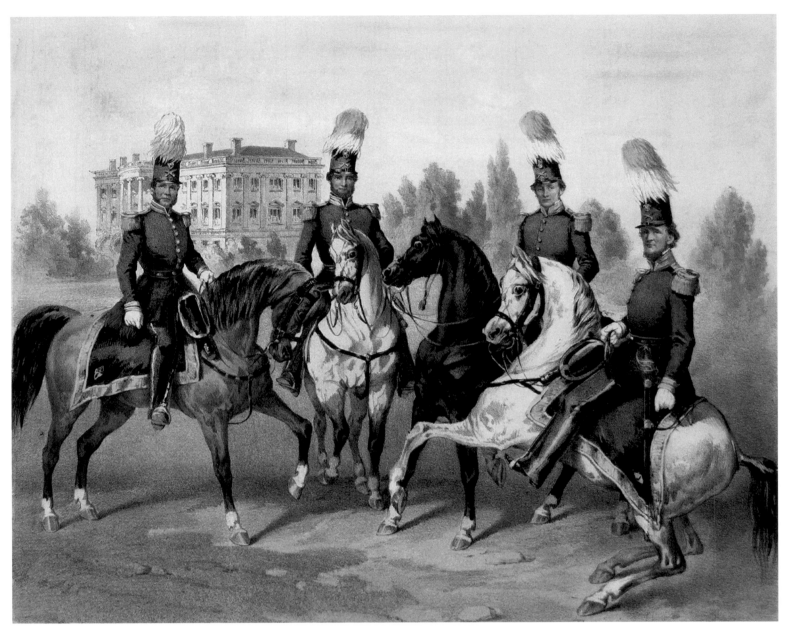

Colored lithograph, *To the Officers and Members of the President's Mounted Guard*, published by Hilbus and Hitz, Washington, D.C., 1855. 10 × 12 in. AS 430.

To the Officers and Members of the President's Mounted Guard

This print adorned the musical score of a polka called the "President's Mounted Guard Quickstep." It was written to honor the company that was founded in 1853 as part of Washington's 1,500 militiamen. However, the name of the unit on the music sheet and the elaborate uniforms the four men are wearing are purely imaginary. The real name of the unit was Capt. Samuel Owen's Independent Company of Cavalry. The unit saw three months of service at the beginning of the Civil War,

April to July 1861, guarding the U.S. Capitol building until enough reinforcements from the Northern states could get to Washington. The names of the four cavalrymen are listed on the print. The soldiers came from varied backgrounds. Joseph H. Peer, a native of Virginia and a farmer, appears on the far left. He later deserted and joined the Confederate army. Two of the others owned a tavern and a hardware store.

The moral of this story is: Don't believe everything you see.

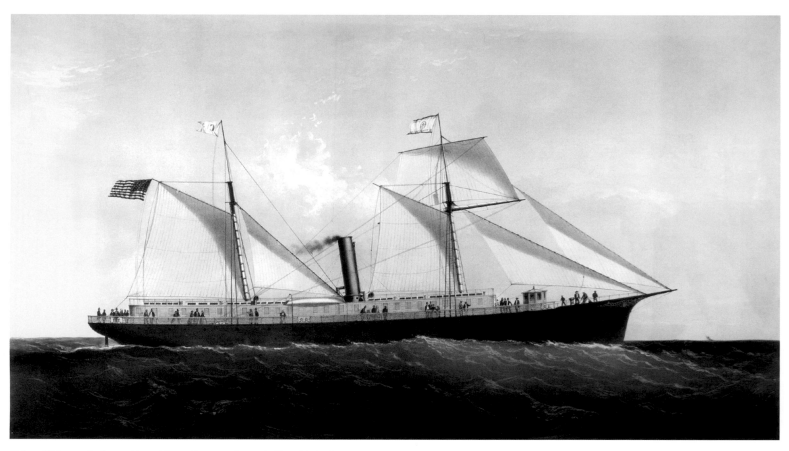

Colored lithograph, *Steamships—Mount Vernon and Monticello*, published by Endicott, New York, 1859. 20 × 30 in. AS 467.

Steamships—Mount Vernon and Monticello

The New York and Virginia Screw Steamship Company (SSC) operated five coastal steamships that transported passengers, cargo, and mail. The ships represented here, the *Mount Vernon* and the *Monticello*, traveled between Washington and New York City with stops in Georgetown and Alexandria. The company also had contracts with the state of New York and the U.S. government to deliver mail. The three other ships owned by the SSC, the *Yorktown*, *Roanoke*, and *Jamestown*, traveled between New York City and Richmond, Virginia. They could operate either by coal or by sailing masts. The ships shown here were both constructed in 1859—the *Mount Vernon* in Long Island, New York, and the *Monticello* in Mystic, Connecticut. They were each 175 feet long, 28 feet wide, and carried 650 tons.

One of the main strategies to a Union victory in the Civil War was the Anaconda Plan. It was recommended by Lt. Gen. Winfield Scott and put into place by Secretary of the Navy Gideon Welles. The Union navy would blockade the Confederate ports to hinder trade, principally the shipping of cotton to England in exchange for arms and supplies. Consequently the Union navy increased its supply of warships from 42 in 1861 to over 700 in 1865. Any vessel stable enough to mount cannon became a warship. The *Mount Vernon* and *Monticello* were each purchased by the federal government for $75,000. The other three SSC steamships owned by the SSC were captured by the Confederate navy and eventually sunk. In 1865, at the end of the Civil War, the *Mount Vernon* and *Monticello* were both badly damaged and were sold at auction by the Union navy.

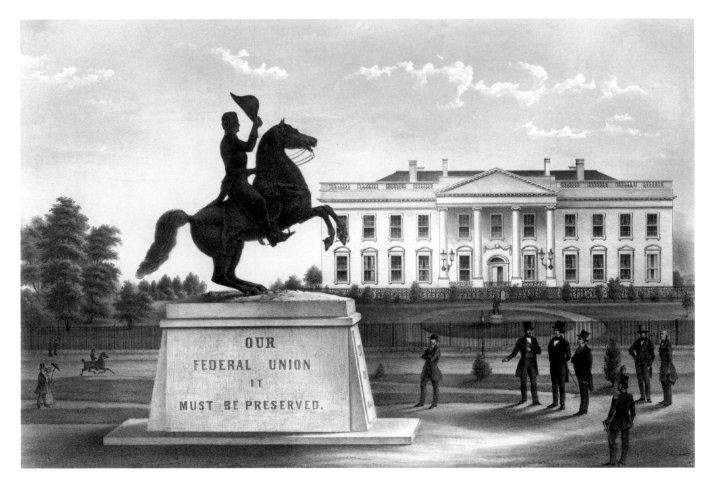

Lithograph, *Mills's Proposed Equestrian Statue of General Andrew Jackson, Dedicated to the American Army and the People of the United States*, T. Sinclair, published by Casimir Bohn, 1860. 15.5 × 20.5 in. AS 131.

Mills's Proposed Equestrian Statue of General Andrew Jackson, Dedicated to the American Army and the People of the United States

The Andrew Jackson equestrian statue in Lafayette Park is familiar to most of the world in its place in front of the White House in Washington, D.C. The original bronze sculpture was erected in 1853. Thereafter the sculptor, Clark Mills, made replicas for New Orleans in 1858 and for Nashville in 1880. A fourth copy was cast as recently as 1987 for outdoor display in Jacksonville, Florida. The Andrew Jackson statue for Washington was historically significant because it was the first statue in the country to be cast in bronze. Clark Mills gained additional fame because his Jackson statue was also the first equestrian statue in the world to be balanced solely on the horse's hind legs.

Jackson is portrayed here in the uniform of an American general. His military career began in 1791, when he joined the militia in Davidson County, Tennessee. He was popular and quickly rose in rank—in 1802 he was elected a major

general by his men. Jackson was successful in defeating the Creek Indians after they revolted against white settlers in Alabama in March 1814. It was at the Battle of New Orleans, however, on January 8, 1815, that Jackson achieved greater fame. His victory over the British was the last battle of the War of 1812, and it made him a national hero, paving his way to the presidency. Up until the Civil War, the 8th of January was celebrated as a national holiday in most states. Jackson was the seventh president and served two terms, from 1829 to 1837. On leaving the White House, Jackson retired to his plantation, the Hermitage, near Nashville, Tennessee, where he died at age 78 on June 8, 1845. To commemorate his memory, leaders of the Democratic Party began a campaign that year to raise the private funds needed for a statue in Washington, D.C. The inscription on the pedestal was actually placed on the west side in 1909, not on the north side as shown in the print.

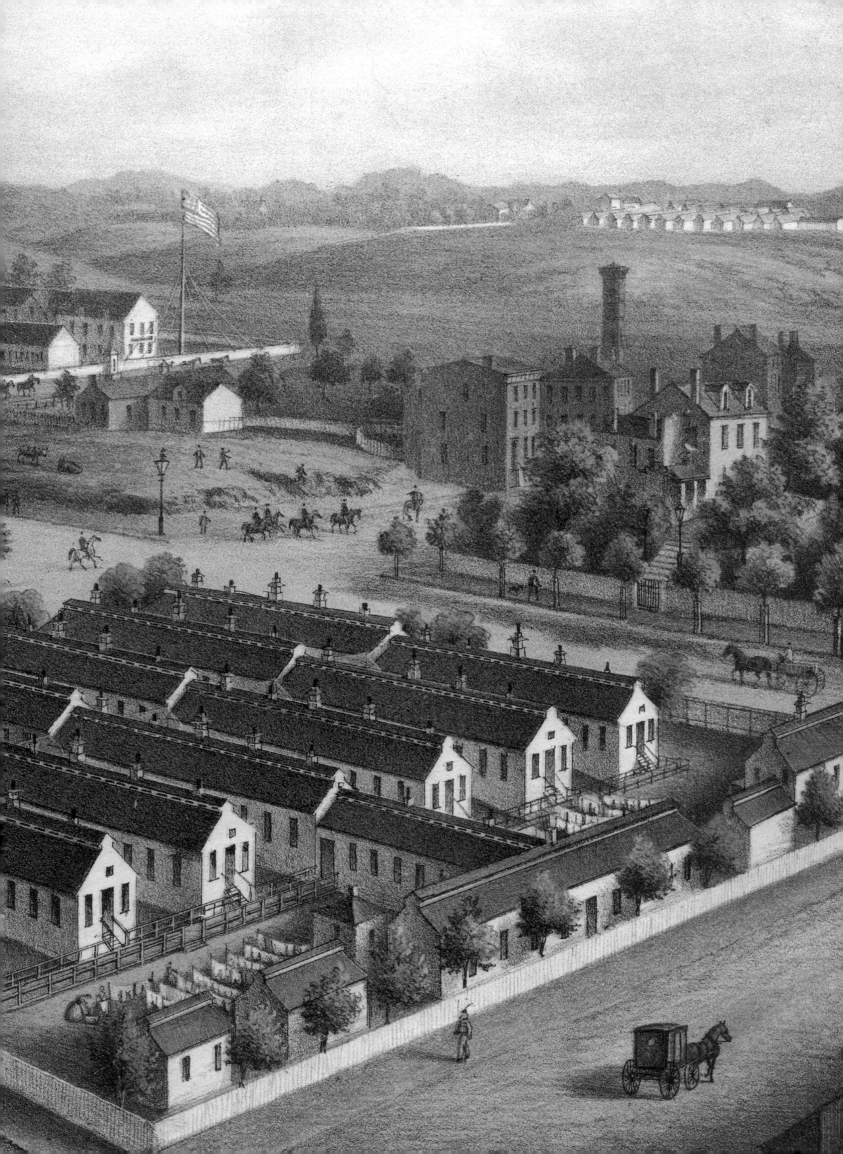

PART TWO

The Civil War Years

1861–1865

Overleaf. Like many wartime hospitals in Washington, Douglas Hospital occupied existing row houses, while Stanton Hospital operated in newly built wooden wards. See page 114.

The American Civil War was the first military conflict that Americans could see even if they were not present. Illustrated news magazines such as *Harper's Weekly* and lithographers like Currier and Ives brought images from the battlefield to Americans just days after the guns fell silent. Photographers, too, such as Mathew Brady, allowed Americans to see the grim reality of war in a manner never before possible.

The Albert Small Collection is one of the finest assemblages of these images in existence. One of the strengths of the collection is its wonderful variety. While other collectors have tended to focus their acquisitions on one medium or theme, Small assembled a truly catholic collection that includes photos, woodcuts, lithographs, posters, and oil paintings. The subject matter also spans the length and breadth of the war, comprising maps (some very rare), recruitment posters, hospital views, fortifications, and battlefield scenes. It includes both the good (a very early copy of the Emancipation Proclamation) and the bad (a wanted poster for the Lincoln assassins with photographs to allow for easy identification).

The Small Collection is an especially welcome addition to the George Washington University. Students learning about the Civil War, American print culture, and many more topics will now have an unparalleled opportunity to work hands-on with original documents that will bring these subjects to life. And with the Small Collection's arrival at the new George Washington University Museum, Washingtonians and the capital's millions of visitors will be able to experience the Civil War—the nation's defining crisis—in an immediate, intimate, and visually compelling way that until now has only been possible for a few collectors and curators.

Tyler Anbinder
Professor of History
The George Washington University

Sketch of the Seat of War in Alexandria & Fairfax Co.

This very early Civil War map was drawn and printed only a week after hostilities began, when Union army troops invaded and occupied Alexandria, present-day Arlington County, and part of Fairfax County. The map shows the roads, railroads, canals, bridges, and villages in this area of northern Virginia. Most important, it shows the location and names of the first U.S. army regiments to build earthen fortifications in northern Virginia to withstand a possible Confederate attack on Washington, D.C.

On May 23, 1861, Virginia officially ratified secession from the Union with a popular state-wide vote. Early on the following day, Col. Elmer Ellsworth took his 11th New York Regiment, dressed in colorful Zouave uniforms, on two steamers down the Potomac River to occupy the strategic port of Alexandria, Virginia. Ellsworth became the first officer casualty of the war when he was shot and killed while removing a Confederate flag on the roof of a hotel on King Street.

The highest point of land on the map was Arlington, the estate of Gen. and Mrs. Robert E. Lee. Because of its strategic importance, the now vacant house was immediately taken over by the first commander of Union troops in northern Virginia, Gen. Charles W. Sandford, who made it his headquarters. By June 2, Gen. Sandford had been replaced by Gen. Irvin McDowell, who also occupied Arlington. Gen. McDowell complained of the lack of up-to-date maps of northern Virginia, a factor that contributed to his losing the First Battle of Bull Run six weeks later.

New Union forts were built in a line outward from the Arlington estate—those extending to the north protected the Aqueduct Bridge and Chain Bridge, and those to the south protected the Long Bridge and the city of Alexandria. Collectively they were known as "The Arlington Line." These forts, placed roughly one-half mile apart, were built with earthen walls 12 to 18 feet thick. This map is so early that all of the forts shown were still under construction, and only one had been named—Fort Corcoran. It was named for the commanding officer of the 69th New York Militia, Col. Michael Corcoran, who had built it. Fort Corcoran was adjacent to the farm of William Ross, named "Rosslyn" (today's Rosslyn Circle), the Virginia terminus of the Aqueduct Bridge. Most of the other forts later were named for the officers of the regiments that built them—Forts Runyon, Haggerty, and Bennett. Exceptions were Fort Albany, named after the Seventh New York Militia's state capital, and Fort Ellsworth, named for the fallen colonel.

The cartographer of this map was Virgil P. Corbett, born in Corbettsville, New York, in 1829. He and his father, Cooper, and brothers Sewell and Frank, had migrated to Alexandria County, Virginia, in the late 1840s and 1850s and purchased adjacent farms. Their property is labeled on the map. Virgil Corbett made his map immediately after Virginia seceded. Only a few copies of this map were printed because it was soon out of date—a month later, for instance, most of the forts shown had been given names. Corbett did, however, publish two maps in October 1861 that were for sale in Washington, D.C. for 25 cents each. The first was *Map of the Seat of War, Showing the Battles of July 18th, July 21st, and October 21st, 1861.* The date of July 18 relates to the Battle of Blackburn's Ford near Centreville—a reconnaissance of Union forces who were defeated by Confederate Gen. James Longstreet. The date of July 21 refers to the First Battle of Bull Run, in which the Confederate army defeated Union forces in a one-day engagement. The third date, October 21, concerns the Battle of Ball's Bluff, which resulted in the defeat of Union forces on the banks of the Potomac River near Leesburg. The second was *Corbett's Large Map of Fairfax County, Virginia.* But Corbett did not stay in the cartography business for long. According to the 1870 census, Virgil Corbett had gone back to farming in Alexandria County, Virginia.

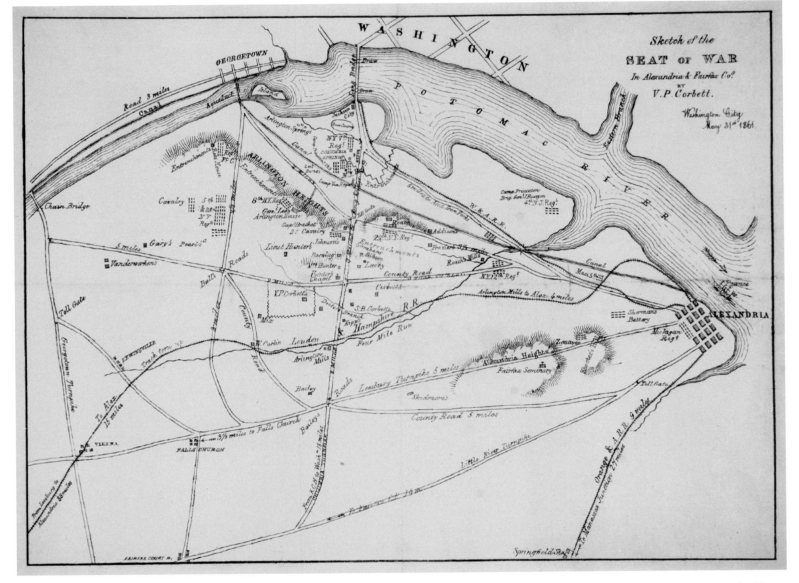

Map, *Sketch of the Seat of War in Alexandria & Fairfax Co.*, drawn and printed by V. P. Corbett, Washington, D.C., May 31, 1861. 11.5 × 15 in. AS 708.

Landing of Ellsworth's Zouaves at Alexandria, Va., on the Morning of May 24, 1861

The secession of Virginia by popular vote on May 23, 1861, galvanized Union troops to protect the city of Washington from possible Confederate attack. Early on the morning of May 24, one body of Union troops marched from Washington over the Long Bridge to seize the city of Alexandria, Virginia, a strategic railroad and shipping terminal only four miles from the capital. Simultaneously, another regiment, the 11th New York Volunteers, arrived by boat from Washington at the foot of King and Cameron Streets. As they entered the city they noticed a large Confederate flag flying from the roof of the Marshall House hotel on King Street. This flag was so prominent that it could be seen with binoculars from many points in Washington, D.C. Their Union commander, the 24-year-old Col. Elmer Ellsworth, shown on the print standing in the right foreground, climbed the stairs of the hotel and removed the flag. As he descended, the hotel owner, James W. Jackson, shot him, making Ellsworth the first Union officer killed in the war. Jackson was then shot and bayoneted by a corporal under Ellsworth's command.

The Ellsworth's Zouaves—soldiers wearing red, baggy uniforms modeled on those of French Emperor Napoleon III's precision infantry—threatened to burn the city of Alexandria in retaliation for the killing of their commander. The officer in charge of the steamboats at the foot of King Street prudently ordered Ellsworth's troops to embark on the steamers, which he then anchored in the middle of the Potomac River for 24 hours to allow the men to calm down.

Because of President Lincoln's friendship with Ellsworth, who had worked in Lincoln's law office in Springfield, Illinois, Ellsworth's body lay in state in the East Room of the White House before it was sent back for burial in his hometown in upstate New York.

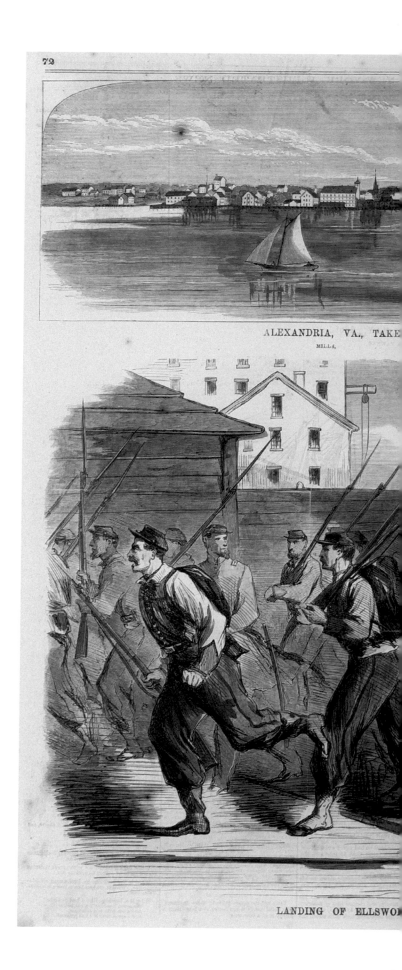

ALEXANDRIA, VA., TAKE

MILLS.

LANDING OF ELLSWO

COLONEL ELLSWORTH'S ZOUAVES ON THE MORNING OF THE 24TH OF MAY, 1861.. SEE PAGE 74.

MARSHALL HOUSE. GREEN'S HOTEL. STEAMER PAWNEE. GAS WORKS.

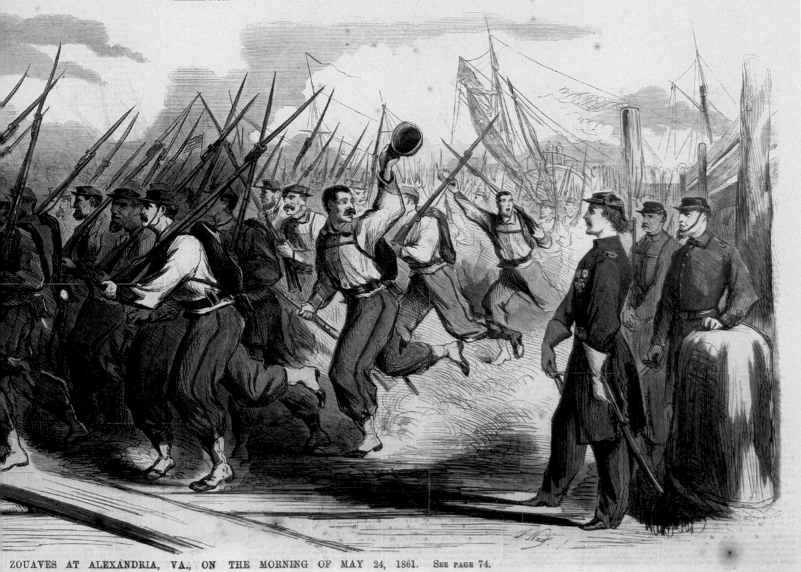

ZOUAVES AT ALEXANDRIA, VA., ON THE MORNING OF MAY 24, 1861. SEE PAGE 74.

Colored woodcut, *Landing of Ellsworth's Zouaves at Alexandria, Va., on the Morning of May 24, 1861*, drawn by Thomas Nast, *New York Illustrated News*, June 1861. 15 × 21 in. AS 146.

THE GREAT BAKERY FOR THE UNITED STATES ARMY AT THE CAPITOL, WASHINGTON, D. C.—SKE

The public buildings in Washington, during the threatened invasion by the Confederates, were barricaded and fortified. So great was the appre the Capitol were defended by howitzers. The iron plates cast for the dome of the Capitol were set up as breastworks between the columns, where protected by heaving planking; and the basement of the building was used as a kitchen. When the regiments began to pour in, the public buildi basement of the Capitol, which we illustrate, became first a storehouse, and then a bakery.

Colored woodcut, *The Great Bakery for the United States Army at the Capitol, Washington, D.C.,* in *Harper's Weekly,* 1861. 10 × 15 in. AS 105.

BY OUR SPECIAL ARTIST.

...on of a raid upon the city, that the passageways of the Treasury and
...ere supported by heavy timbers. The statuary and the pictures were
...re given as quarters to the troops which came to defend them. The

The Great Bakery for the United States Army at the Capitol, Washington, D.C.

When Fort Sumter, in Charleston, South Carolina, fell to Confederate troops on April 15, 1861, President Lincoln called for 75,000 volunteer troops to suppress the rebellion. Many Union states immediately sent troops to Washington, but they had difficulty passing through the secessionist mobs in Baltimore, who stoned them as they went through the city to change train stations to continue south to Washington. The first troops arrived in Washington from Pennsylvania on April 18 and immediately occupied the Capitol to protect it from possible Confederate attack. Other troops from Massachusetts, New York, and Rhode Island avoided Baltimore by arriving by ship in Annapolis and then taking the train to Washington. By the end of April over 10,000 Union troops had arrived in Washington, camping in government buildings including the Capitol, Treasury, Patent Office, Post Office, and City Hall.

Every part of the Capitol was occupied by soldiers—as many as 4,000 were camped there. The Eighth Massachusetts Regiment bivouacked in the rotunda even as the construction of the dome overhead continued. Corridors were piled high with supplies, mostly barrels of flour, beef, pork, and crackers. The Sixth Massachusetts Infantry constructed dozens of ovens for the city's main army bakery, erected in the basement and under the western terrace of the Capitol. When it was under full operation, over 16,000 loaves of bread were produced daily. Soldiers passed the bread through windows to the courtyard and onto wagons waiting to distribute this staple to the soldiers occupying the dozens of camps around the city. Unfortunately the books and paintings in the Library of Congress, two floors directly above the bakery, were damaged by the rising smoke from the ovens. It was not until October 1861, when President Lincoln called a special session of Congress, that the bakery was closed.

Prince Napoleon Visiting President Lincoln, 1861

This colored woodcut from *Frank Leslie's Illustrated Newspaper* depicts the visit of Prince Napoleon to the White House on August 3, 1861. He is shown, right center, wearing a red sash and talking to President Lincoln under the south portico. In the background, the Marine Band is playing at their weekly Saturday afternoon concert in the bandstand on the south lawn. Lincoln had the wooden bandstand built with a blue and white canvas roof in the spring of 1861. Prince Napoleon, the nephew of Napoleon I and cousin to Napoleon III, the current emperor of France, was serving as a colonel in the French army. He came to the United States with his wife and aide-de-camp to observe the Civil War on both sides. Prince Napoleon was thus able to gain information on tactics used, including military maneuvers, transportation systems, and new weapons. Officers sent by France, England, and Germany usually visited both the Union and the Confederate armies. Both sides were especially polite to the visiting officers because the North did not want any European country to recognize the Confederate government diplomatically, and the South sought the recognition.

All three American illustrated newspapers—*Gleason's Pictorial Drawing-Room Companion, Frank Leslie's Illustrated Newspaper, and Harper's Weekly*—sent their artists to Washington and to Union armies in the field to draw scenes in pencil and send them back to New York or Boston by train. Other artists in house would take the drawings and produce woodblock prints for publication. Several artists would carve the oak blocks, which would then be screwed together for printing.

The following text was printed with the woodcut:

Prince Napoleon arrived at the capital on Friday, the 2d last [August 2]. He remained at the French Minister's—then located in the leased William Corcoran House across Lafayette Park at Connecticut Avenue and H Streets N.W.—on that night, and the next day he paid a visit to the President at the White House. He was most cordially received, Mr. Lincoln offering him the hospitalities of the Presidential mansion and alluding [sic] to the critical period of his visit. The Prince was equally cordial in manner, but was far more reticent in his expressing. The dinner which the President tendered the Prince was a social and pleasant one, politics as a general thing being avoided.

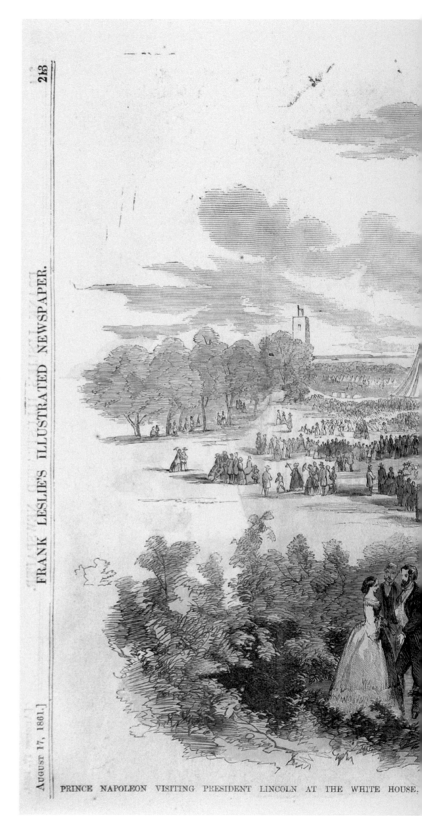

FRANK LESLIE'S ILLUSTRATED NEWSPAPER.

213

August 17, 1861.]

PRINCE NAPOLEON VISITING PRESIDENT LINCOLN AT THE WHITE HOUSE.

Guests at the dinner reported that the mood had been somber. Less than two weeks earlier, the Union army under Brig. Gen. Irvin McDowell had been soundly defeated by Confederate troops at the First Battle of Bull Run in northern Virginia. Mrs. Lincoln's cousin, Elizabeth Todd Grimsley, was visiting at the White House from Kentucky and was present at the dinner. She wrote: "In close proximity to such gaiety came harrowing scenes of wretchedness, full of pathos, and indeed, we all felt as if it were no time for eating, drinking, and making merry, but policy demanded a show and pretence of cheer and hopefulness we were far from feeling."

Secretary of State William H. Seward gave the prince a tour of the city and the Capitol building. The following day, August 4, Union officers showed him several Union camps protecting Washington, where he met Gen. McDowell,

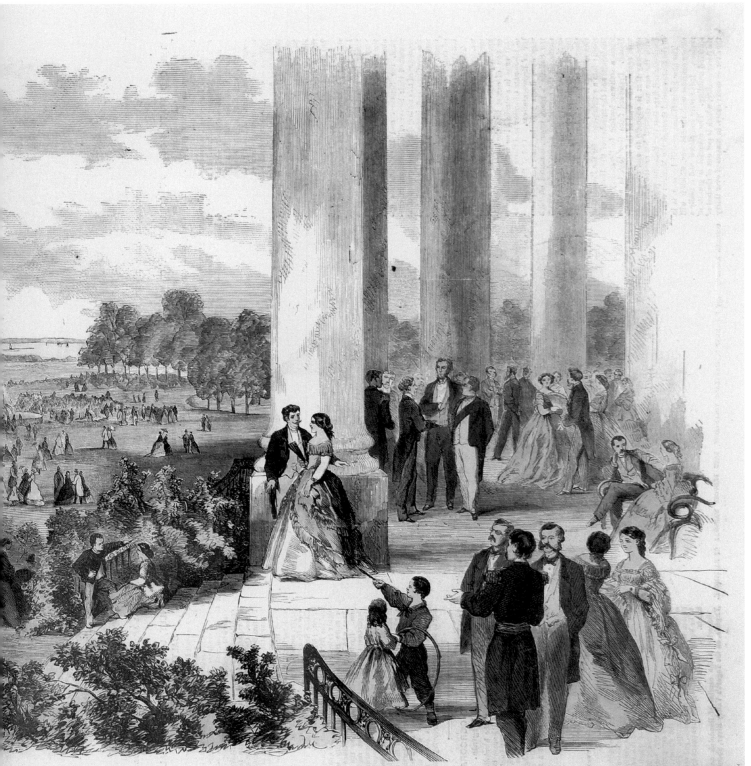

TON. D. C.—SCENE ON THE BALCONY DURING THE PERFORMANCE BY THE BAND.—FROM A SKETCH BY OUR SPECIAL ARTIST ACCOMPANYING GEN. McCLELLAN'S COMMAND.

Colored woodcut, *Prince Napoleon Visiting President Lincoln*, in *Frank Leslie's Illustrated Newspaper*, August 17, 1861. 10 × 15 in. AS 447.

who was commanding Union forces in northern Virginia. On August 8, Prince Napoleon and his party were escorted in two carriages to see Mount Vernon, which was considered neutral ground. Under a flag of truce he then met with the Confederates—Col. J. E. B. Stuart in Fairfax and then Gen. Beauregard, the commander of the Army of Northern Virginia, in Manassas. They entertained him and took him on a tour of the recent battlefield of the First Bat-

tle of Bull Run, where corpses and dead horses remained exposed.

Prince Napoleon's stay in America lasted two months. From Washington, he returned to New York City and then went to Boston, Cleveland, Detroit, and Canada. He and his party sailed for France from New York City on September 26. Prince Napoleon left the United States favoring the northern cause.

Enlist Now and Get Your $100 Bounty!

This dramatic broadside was printed in New York City at the beginning of the Civil War to recruit soldiers for the newly formed 11th New York Cavalry Regiment—nicknamed "Scott's 900." At the time, a cavalry regiment comprised 10 companies of 90 men each, thus the "900" in the Scott's moniker. In 1861 President Lincoln appointed First Lt. James B. Swain with the mission of raising a cavalry regiment. Swain named the regiment after his good friend Thomas A. Scott, who was serving as the assistant secretary of war under Secretary of War Edwin Stanton. Company D was recruited from towns in northern New York near the Saint Lawrence River—mostly from Canton but also from Potsdam and Ogdensburg. The men from the other companies came from New York City. Many were immigrants from Britain, Ireland, and Italy and were experienced with military life because they had served in the Crimean War or other wars in Europe.

When the Scott's 900 regiment arrived in Washington, they were assigned to the Provost Guard—that is, military police. They guarded headquarters and Confederate prisoners, searched for deserters, and policed civilians in areas under military control. After spending the winter of 1861–62 on Staten Island, the regiment was assigned to Washington and set up camp on Meridian Hill in May 1862. That year, Secretary of War Stanton compelled Lincoln to accept a military escort composed of a cavalry officer and about 25 additional men. The president protested this small Provost Guard cavalry detachment as a guard for his carriage, since he and Mrs. Lincoln could not hear themselves talk above the guards' noise. Nevertheless, from 1862 to 1864 soldiers from Company A formed the bodyguard for President Lincoln. They accompanied him on all of his travels, including his daily trips either by horseback or carriage from his summer residence, known as Anderson Cottage at the Soldiers' Home, to the White House. The Lincoln family stayed at the cottage, with its wide verandas and elevated hilltop site, for the summers of 1862, 1863, and 1864 to escape the heat, humidity, and noise of downtown Washington. The house has recently been restored by the National Trust for Historic Preservation and has been open to the public since 2008.

Soldiers from the other companies served as guards for the many high-ranking Union officers stationed in Washington. They also were entrusted with delivering important messages and served as scouts and spies within the Confederate lines. The regiment was reassigned in 1864 to Louisiana, where it suffered heavy casualties. Forty-four died on December 22, 1864, when the steamer *North America* sank off the Florida coast. Only 25 died in battle; the remaining 287 deaths resulted from malaria and other diseases. The survivors published a history of the regiment in 1897 and held reunions into the early 20th century.

Broadside, *Enlist Now and Get Your $100 Bounty!*, printed by Baker and Godwin, New York, 1861. 38 × 23 in. AS 656.

Civil War U.S. Camp Flag

This small United States flag, with 34 stars, was known during the Civil War as a "camp flag" or as "camp colors." Used by both the Confederate and Union armies, camp flags were attached to poles and placed in front of the tents of the commanding officers in the field—in companies, regiments, or battalions. This flag is printed on wool and cotton bunting, which was made to withstand outdoor weather conditions. During the Civil War, the U.S. flag and various regimental flags, usually printed on silk with silk fringes on the sides, were carried into battle. The cavalry used a different flag—a swallow-tailed guidon. The design of Union flags was standardized in 1862 by Gen. George McClellan's General Order Number 4, which required all flags to have stars and stripes. The order did not specify how the stars were to be arranged, however.

United States army forts in the mid-Atlantic states— Maryland, Delaware, New Jersey, and Pennsylvania— tended to design the stars on their flags in a circular formation. Other forts in New York, Ohio, and elsewhere tended to place the stars on their flags in horizontal rows.

This flag has a large central star, then a circle of stars, and then a square arrangement of stars as an outer border. We know this flag was made in either 1861 or 1862, after Kansas was admitted as the 34th state. West Virginia became the 35th state to enter the Union after it separated from Virginia in 1863. Each new star was added to the flag on July 4 after a new state's admission. Most of the U.S. flags made during the Civil War included the stars of the "departed" Confederate states. The flags in which the Confederate stars were left out were called "exclusionary" flags.

Two important flag regulations have shaped the official design of the American flag. The first was the Flag Act of 1818, which required all U.S. flags to show only 13 stripes— this ended the occasional practice of adding a new stripe for each new state. It also mandated that the addition of new stars take place only on July 4. The second was President Wilson's Executive Order Number 1 in 1912, which required all flags to have horizontal rows of stars. The present U.S. flag dates from 1959, incorporating the states of Alaska and Hawaii.

Printed wool and cotton bunting camp flag,
U.S. army, 1861. 24 × 15 in. AS 634.

Topographical Map of the Original District of Columbia and Environs Showing the Fortifications around the City of Washington

The "Arnold Map" of early 1862, one of the most detailed topographical maps then in print, shows the terrain in the District of Columbia as well as the street grid of Washington City, Georgetown, and Alexandria. It also illustrates all turnpikes, roads, canals, railroads, and even mills in the District of Columbia and in Alexandria, Alexandria County (present-day Arlington County), and Fairfax County, Virginia, as well as part of Montgomery County and Prince George's County in Maryland. At least 40 army hospitals are labeled, often in close proximity to one another. On Meridian Hill, just north of Florida Avenue and 15th Street N.W. were Columbian College Hospital, Carver Hospital, Cliffbourne Hospital, Stone Hospital, and Mount Pleasant Hospital.

This colored map was especially important because it labeled the 53 army forts and camps protecting the city, naming them and identifying them with red dots. Over four dozen smaller but still important batteries, which were usually built on hills with earth embankments, were also identified. Secretary of War Edwin Stanton was alarmed when he learned about the map because it could alert the Confederate army to points to attack. Two days after it had been put on sale in Washington stores, War Department agents confiscated all the copies they were able to find, while other department officials went to New York to destroy publisher G. Woolworth Colton's lithographic stone. The War Department obtained the names and addresses of some of those who had purchased it (in stores or from Colton) and entered private houses to seize the censored map. Colton was ultimately compensated $8,000 for his losses.

Also notable on the map is the legend on the bottom left, which lists the populations of Washington City, Georgetown, and Alexandria—divided by race—for every decade between 1800 and 1860. The total number of slaves declined every decade from 1830 to 1860. The 1860 population included: "Whites, 60,788; Free Colored, 11,107; and Slaves, 3,181."

Map, *Topographical Map of the Original District of Columbia and Environs Showing the Fortifications around the City of Washington*, drawn by E. G. Arnold, published by G. Woolworth Colton, New York, 1862. 30 × 34 in. AS 9.

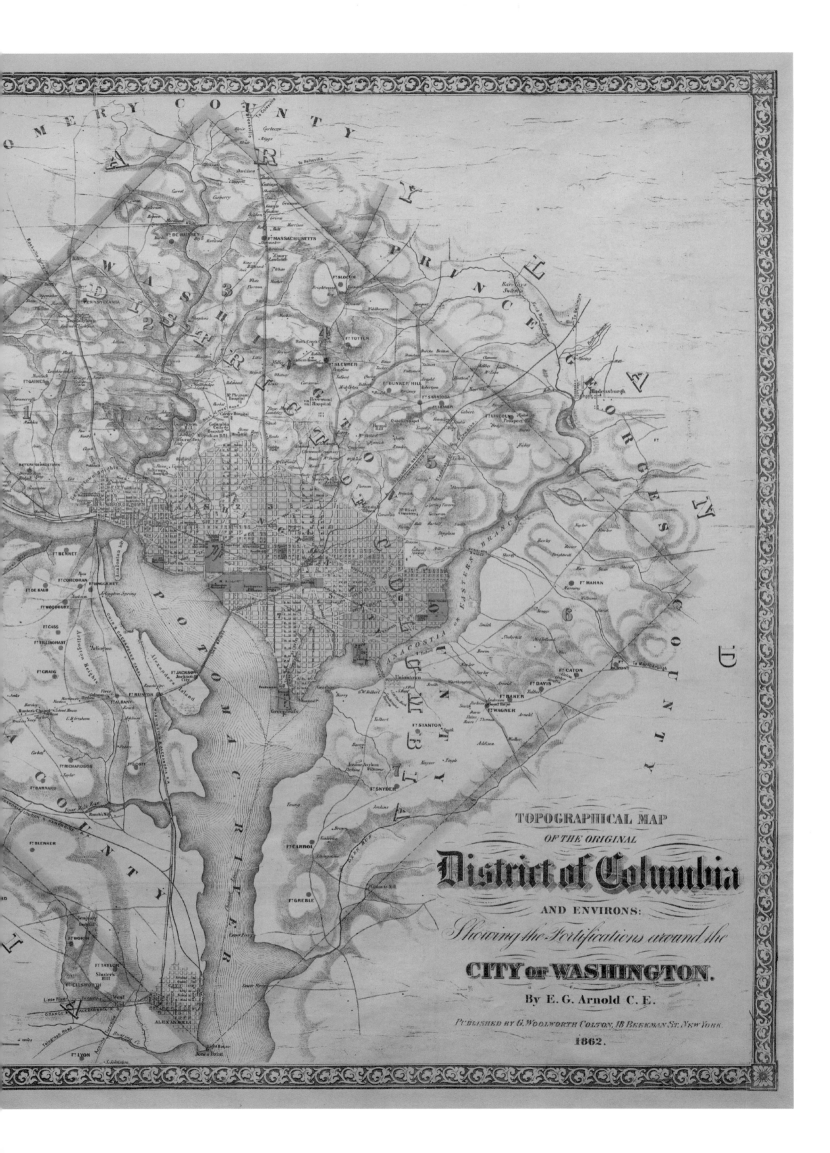

TOPOGRAPHICAL MAP

OF THE ORIGINAL

District of Columbia

AND ENVIRONS:

Showing the Fortifications around the

CITY OF WASHINGTON.

By E. G. Arnold C. E.

PUBLISHED BY G. WOOLWORTH COLTON, 18 BEEKMAN ST. NEW YORK.

1862.

Photograph, No. 300—*Engines Stored in Washington, D.C., to Prevent their Falling into Rebel Hands, in Case of a Raid on Alexandria*, Capt. Andrew Russell Jr., 1862. 10 × 12 in. AS 255.

Engines Stored in Washington, D.C.

The Civil War was the first war in which Americans made heavy use of trains. This 1862 photograph shows several steam locomotives stored on tracks near the Smithsonian Castle in southwest Washington, D.C. The U.S. Capitol building appears to the left in the distance. As explained by the photographer, Capt. Andrew Russell Jr., the locomotives were brought from Alexandria to Washington "to prevent their falling into Rebel hands, in case of a Raid on Alexandria."

The locomotives were driven over the tracks of the Washington and Alexandria Railroad across the Long Bridge (now 14th Street Bridge) to the Freight Depot of the Baltimore and Ohio Railroad at Maryland Avenue and 10th Street S.W. The Washington and Alexandria Railroad paid the Baltimore and Ohio Railroad a share of its earnings from using their tracks within the city of Washington. The tracks proceeded north, crossed the National Mall at the foot of Capitol Hill at 1st Street, and then proceeded to the Baltimore and Ohio Railroad passenger station at North Capitol Street and New Jersey Avenue N.W. From there, it ran to Baltimore and points north and west.

Alexandria was an important railroad hub both before and during the Civil War. The Smith and Powell Ironworks located near Duke Street manufactured both locomotives and passenger cars and maintained a "round house" for the repair of both. After the Civil War began, in February 1862,

Congress created the U.S. Military Railroads. This bureau was initially given control of only 25 miles of track between Washington and Annapolis, but it expanded rapidly. The superintendent of the U.S. Military Railroads was responsible for the efficient movement of troops, munitions, equipment, and food to support the Union armies, both in the Northern states and in occupied portions of the Confederacy.

Col. Daniel C. McCallum was given command of the U.S. Military Railroads. He was eminently qualified because of his railroad experience. In the decade before the Civil War, McCallum had been superintendent of the New York and Erie Railroad and founder of the McCallum Bridge Company, which built primarily railroad bridges.

Northern railroads facilitated the flow of rail traffic much better than those in the South. In the North, the railroads between cities shared the same gauges, or track widths, and the North had approximately twice as much track in place as the South. Since the railroads in the South were poorly connected and had different gauges, McCallum had to rebuild the Southern tracks when they were captured so they would conform to the Northern widths. By the war's end, McCallum had been promoted to brigadier general because of his successful operations. In May 1865, at the end of the war, he commanded 2,105 miles of railroad track with 419 locomotives and 6,330 railroad cars.

The Destruction of Union Supply Trains at Manassas Junction, Virginia

This small but very detailed watercolor was drawn and then painted by Private Robert Knox Sneeden, an eyewitness to the Second Battle of Bull Run. He was a Canadian immigrant who had traveled to New York City to study architecture. At the outbreak of the Civil War Sneeden supported the Union and volunteered with the 40th New York Infantry in 1861. His talents were soon recognized, and he was made an army surveyor and transferred to the army field headquarters at the Second Battle of Bull Run.

After he was captured in November 1863, Sneeden spent the next year in five Confederate prisons, most of the time in Andersonville Prison in southwest Georgia. The conditions there were the worst by far. Here the commandant, Capt. Henry Wirz, offered no medical aid to the sick and forced the overcrowded prisoners to drink and bathe in a single dirty stream that traversed the camp. Although Sneeden built a shanty of tree limbs covered by a dirty blanket, he remained cold most of the time. Many prisoners died of disease, starvation, or exposure. Weak and sick prisoners were beaten and robbed by other prisoners known as Raiders. Finally a group of strong prisoners, known as Regulators, organized themselves as a police force to try to prevent the attacks. After the war, Wirz was tried in a military court and hanged for his cruelty. Sneeden left Andersonville in December 1864 as part of prisoner exchanges.

Throughout the war Sneeden kept a diary and made more than 800 pencil and ink drawings of scenes he had witnessed. These he mailed back home periodically. While Sneeden was confined in Confederate prisons in 1864, he made shorthand diary entries and sketches and kept them hidden from the guards. He managed to save his diary and sketches at Andersonville by sewing them into his hat, coat,

and shoes. After the war, in the late 1870s, Sneeden went over his drawings, added details, and colored them. He wrote a five-volume memoir of his experience in the war, based on his diaries.

The Second Battle of Bull Run was a major Confederate victory—fought over a three-day period, July 28–30, 1862, in Prince William County, Virginia, between Maj. Gen. John A. Pope of the Union army and Confederate Gen. Robert E. Lee of the Confederate army. It was fought on much of the same ground as the First Battle of Bull Run, in July 1861, but it was larger both in scale and number of casualties.

Two days before the main battle, on July 26, Confederate Maj. Gen. Thomas "Stonewall" Jackson made a surprise move with his troops and captured Maj. Gen. Pope's supply depot at Manassas Junction. It was an important railroad hub where the Orange and Alexandria Railroad and two other smaller railroads met. Jackson overpowered the Union guard and captured 10 locomotive engines with 200 railroad cars loaded with supplies for Maj. Gen. Pope's army. These included clothing, ammunition, tents, and vast supplies of food such as beef, pork, bacon, bread, coffee, beans, sugar, rice, whiskey, and canned meats. The Confederate soldiers consumed part of the food and then carried away as much as they could, slipping past the Union lines undetected. Before leaving Manassas Junction, the Confederate soldiers burned the railroad locomotives and cars, then heated and twisted the railroad ties into knots so that they could never be used again.

When the battle was over, President Lincoln relieved Maj. Gen. Pope of command and banished him to a backwater military post in Saint Paul, Minnesota.

Watercolor, *The Destruction of Union Supply Trains at Manassas Junction, Virginia*, Robert Knox Sneeden, 1862. 5.5 × 8 in. AS 479.

Ruins at Manassas Junction

This original 1865 photographic print, produced by Alexander Gardner from the glass negative made by Barnard and Gibson in 1862, shows the Manassas Junction after the Second Battle of Bull Run. It complements the preceding watercolor drawn and painted by Private Sneeden, an eyewitness to the destruction of the engines and cars by Confederate troops under the command of Stonewall Jackson. Sneeden wrote in his diary, now in the collections of the Virginia Historical Society (*Diary*, 511):

The whole ground was covered with half burnt barrels, boxes, dirty clothing, which the rebels had exchanged for new clothes . . . The wreck of the trains laid on the track: nothing but the wheels and other iron work having escaped the burning. 10 locomotives laid on their sides with running gear destroyed or carried away . . . I counted 163 car trucks [sic]. The whole Rail Road track smoked for 1,000 yards, from the yet smoldering fire. Large quantities of horse and mule shoes were yet near red hot and the sleepers on the track were half burnt . . . the rails were all twisted out of shape . . . The telegraph lines were broken and hung in twisted coils from every pole far as could be seen north and south.

Photograph, *Ruins at Manassas Junction*, Barnard and Gibson, 1862, printed by Alexander Gardner, Washington, D.C., 1865. 8 × 9 in. AS 489.

Johnson's Pennsylvania, Virginia, Delaware, and Maryland

This 1862 map, which primarily shows the state of Virginia, is one of the last maps printed before the western counties of Virginia seceded from the Confederacy and were recognized by the U.S. Congress as the State of West Virginia on June 20, 1863. Even though the map was printed during the Civil War, the map maker, Alvin Jewett Johnson, does not recognize the existence of the Confederate state of Virginia, of which Richmond was the capital.

The northwest counties of Virginia before the Civil War were different from the rest of Virginia because their economy was not built heavily around slavery but around industry. The city of Wheeling, located in Ohio County, Virginia, on the Ohio River, was only 56 miles from Pittsburgh, Pennsylvania. Wheeling was noted for its iron and glass production. Since 1852 it had been connected by the Baltimore and Ohio Railroad with northern and western cities—Baltimore, Pittsburgh, Louisville, and Saint Louis—rather than with the South. An important part of the population consisted of immigrants who worked in the factories there and had little allegiance to the rest of Virginia. Harper's Ferry was noted for its arms production, while many of the other western counties produced coal, which was transported by rail to Alexandria for sale.

While the vast majority of Virginians voted for secession in May 1861, the opposite was true in western Virginia, where 90 percent voted to stay in the Union. Soon afterward, in April 1862, the western counties sent delegates to a convention in Wheeling and voted to form their own state government, to be known as West Virginia. Their petition to Congress for admission into the Union as a new state was approved by Congress and President Lincoln, effective June 20, 1863. During the Civil War the city of Harper's Ferry changed hands several times because of its strategic location at the intersection of the Baltimore and Ohio Railroad and the Potomac Railroad. The Union army controlled most of the railroads in West Virginia during the war and slowly pushed the Confederate troops out.

This map is especially interesting because of the ornate Victorian border and the group of three illustrations of prominent sites in Virginia. They are grouped along the left and right margins. On the top left is the view of the University of Virginia at Charlottesville, showing the domed Rotunda, with the Lawn before it bordered with professors' houses and student rooms. It was designed by Thomas Jefferson with the assistance of Benjamin H. Latrobe. In the foreground is a train belonging to the Orange and Alexandria Railroad. That line connected to the Virginia Central Railroad at Manassas Junction. They provided the only direct rail

service between Washington and Richmond when the war began. The First and Second Battles of Bull Run were fought to gain control over the rail connection at that point.

The illustration on the lower left shows the city of Richmond, which had been the capital of the state since the government relocated there from Williamsburg in 1780. Once Virginia had seceded from the Union in May 1861, the Confederate government moved from Montgomery, Alabama, to Richmond because of its industry, rail and river connections, working coalfields, and economic power. The Virginia

Map, colored lithograph, *Johnson's Pennsylvania, Virginia, Delaware, and Maryland*, published by J. H. Colton and A. J. Johnson, *Johnson's New Illustrated Family Atlas, with Descriptions, Geographical, Statistical, and Historical.* New York, Johnson and Ward, 1862. 17 × 26 in. AS 930.

capitol building, which would soon become the home of the Confederate legislature, dominated the scene. Richmond's famed Tredegar Iron Works produced over 1,000 Confederate cannons and many other arms during the war.

On the lower right is a view of Fort Monroe, a star-shaped fortress enclosing 63 acres of a 570-acre island on the Chesapeake Bay. It was held by the Union throughout the war and became a strategic location for staging attacks on Norfolk, Richmond, and the coast of North Carolina. At the beginning of the war it was occupied by Maj. Gen. Benjamin Butler, who effectively freed many Virginia slaves who otherwise would have been forced to work for the Confederacy. Butler considered them "contraband" of war and allowed them to stay in the fortress. Shortly before Richmond fell to the Union army on April 3, 1865, President Jefferson Davis and his cabinet fled by train to Danville, Virginia. He was arrested in Georgia on May 10 and imprisoned for two years at Fort Monroe. Davis was released from prison on bail in May 1867, but the charges against him were soon dropped and he never had to stand trial.

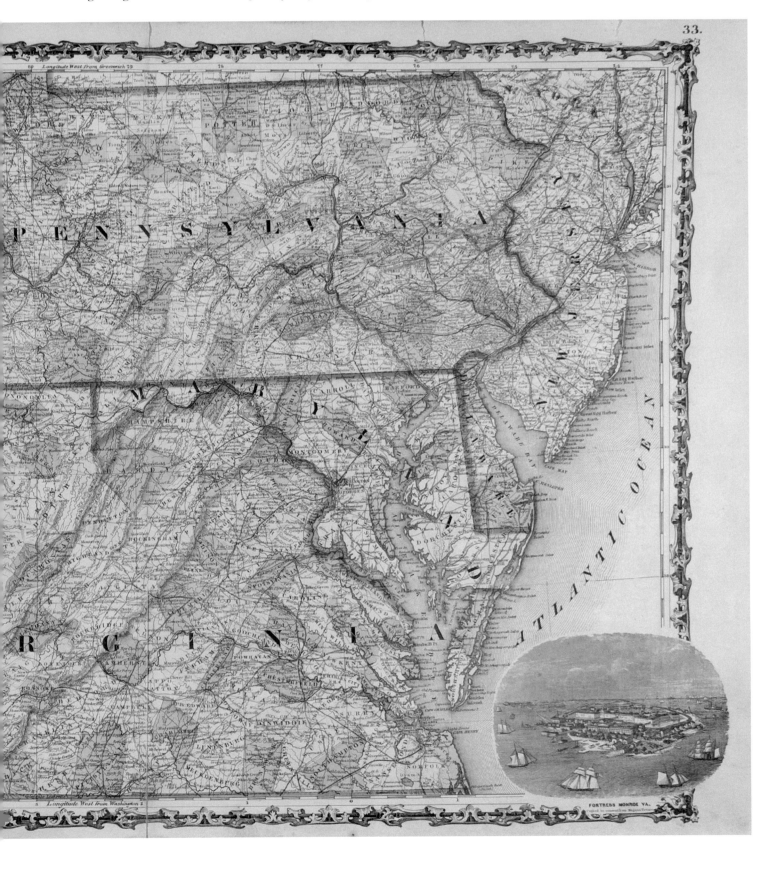

FORTRESS MONROE, VA.

Bird's Eye View of Alexandria, Va.

This view of Alexandria, Virginia, was made two years after the Civil War began. The occupied city became the leading supply center for the Union armies fighting in Virginia. During the war it distributed over 80 million loaves of bread, over 400 million pounds of oats and hay, and 530 million pounds of coal. Goods could be shipped by boat or by railroad. Alexandria was the home base for three railroads. The Orange and Alexandria Railroad connected to Manassas and points west, while the Alexandria, Loudoun, and Hampshire Railroad reached Leesburg. A third line, the Alexandria and Washington Railroad, connected to the Baltimore and Ohio Railroad station in Washington and points north. In addition it was a major hospital center, with 26 hospitals operating in large houses, churches, and the Episcopal Seminary. One of the largest hospitals was located in the Mansion House hotel, the tall, white building shown to the right of lower King Street.

During the 1850s, the city of Alexandria grew dramatically. Scheduled steamship service between Alexandria and Baltimore began in 1852, while weekly round-trip voyages were started by steamships between Alexandria and New York City in 1859. Large amounts of coal were shipped to the city via the Alexandria Canal, which connected to the Chesapeake and Ohio Canal at Georgetown. Thousands of tons of wheat were brought to the city yearly from the Shenandoah Valley via Alexandria's railroads. The wheat was delivered to large mills along the Alexandria waterfront, which produced flour for export. The city also exported significant quantities of fertilizer, fish, and slaves. The firm of Franklin and Armfield on Duke Street was the largest slave auction house in Virginia. In addition, manufacturing was important. Alexandria's factories produced cotton fabric and furniture, and a large foundry on upper Duke Street turned out both railroad locomotives and passenger and freight cars. At the start of the Civil War the city had 12,500 residents, of whom 1,000 were slaves and 1,000 were free blacks.

Notable landmarks include the government bakery, which was housed in a long, low white building shown on the upper right. On the horizon can be seen the two major forts that protected Alexandria—Fort Lyons on the left and Fort Ellsworth on Shuter's Hill at the center. The residents of Alexandria who remained in town lived under martial law the entire four years of the Civil War. Although they were mostly pro-Union in 1860, they overwhelmingly voted for secession when Lincoln called on all the states to furnish troops to suppress the rebellion after Confederate troops captured Fort Sumter in Charleston Harbor.

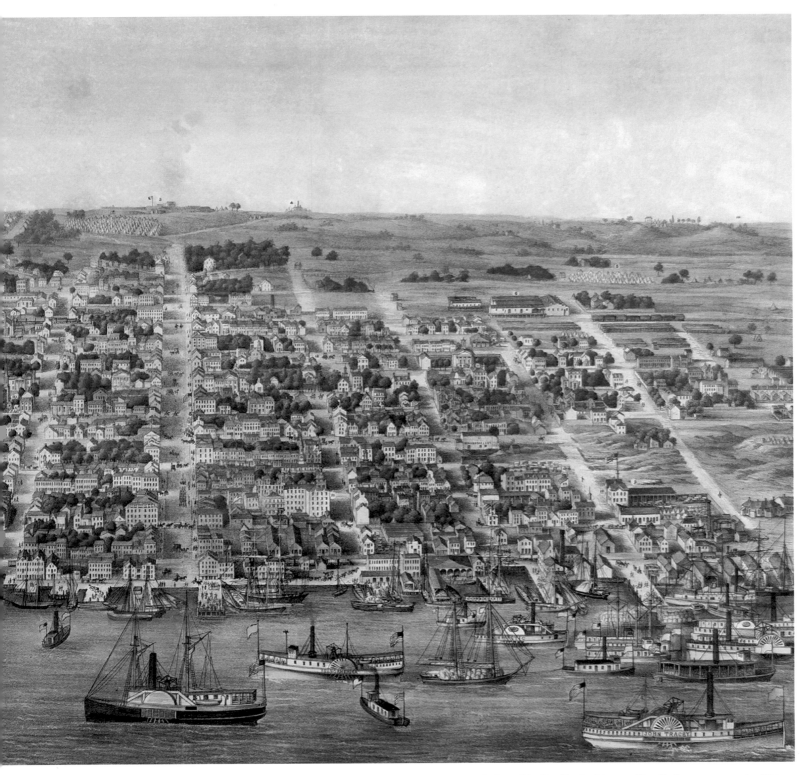

Colored lithograph, *Bird's Eye View of Alexandria, Va.*, Charles Magnus, New York, 1863. 16 × 24 in. AS 304.

Reservoir Georgetown.

Rock Creek Bridge.

Stuice well.

Bridge on Cab

Griffith park Bridge

Great falls Gate house.

VIEWS OF THE GREAT AQUEDUCT, WASHINGTON, DISTRICT OF COLUMBIA.—[SEE PAGE 809.]

Colored woodcut, *Views of the Great Aqueduct, Washington, District of Columbia*, in *Harper's Weekly*, May 14, 1864. 11 × 15.5 in. AS 578.

Gate House.

Waste Weir.

Entrance to aqueduct.

Views of the Great Aqueduct, Washington, District of Columbia

One of the major engineering feats that took place in Washington in the 19th century was the construction of the Washington Aqueduct system, which was begun in 1853 and completed in 1864. It was authorized by Congress after a serious fire at the U.S. Capitol on December 24, 1851, which destroyed much of the Library of Congress and threatened the entire building because of the lack of water available to the volunteer fire companies.

Capt. Montgomery C. Meigs of the U.S. Army Corps of Engineers was selected to design and build the aqueduct. Meigs was a West Point graduate and was the superintendent of construction of the new wings of the Capitol, which were designed by architect Thomas U. Walter. During the Civil War Meigs served as quartermaster general of the U.S. army and laid out the plan of Arlington National Cemetery.

The design of the Washington Aqueduct employs the same principles used in the aqueducts of ancient Rome. The governing principle for these aqueducts is gravity; the route of the aqueduct must ensure the constant flow of water at a steady downward slope. Since men have to enter the conduit physically to service it, only half of it can be full of water at any time. Along the aqueduct route, the conduit periodically drains into the settling tank to filter out impurities.

Meigs placed the start of the Washington Aqueduct 12 miles west of the city on the Potomac River at Great Falls. It then ran parallel to the river into the city. It consisted of seven basic parts, as shown on the print above—a masonry dam at Great Falls, a control gatehouse at the source, the 12-mile-long conduit, 11 tunnels, six bridges, pump stations, and two reservoirs. The conduit was built primarily of local Seneca sandstone, quarried near Poolesville, Maryland. It has a diameter of nine and a half feet. The water is propelled through the conduit both by gravity and the aid of pumping stations. The conduit has a steady slope of nine inches every 5,000 feet. The larger of the two reservoirs—for draining debris—is the Dalecarlia Reservoir at the District line. The smaller one was the Georgetown Reservoir at Wisconsin Avenue and R Street N.W., the present site of the Georgetown Library.

Following construction techniques of the Romans, Meigs built a maintenance road parallel to the conduit. It was originally called Conduit Road until renamed MacArthur Boulevard in 1942. Two of the innovative techniques used by Meigs included the designs of Rock Creek Bridge and the Cabin John Bridge. The Rock Creek Bridge, which carries Pennsylvania Avenue traffic from Foggy Bottom to Georgetown, is supported by massive, arched iron pipes, which also carry water into the city. The bridge over Cabin John Run was considered an engineering marvel. When completed in 1864, the 220-foot-long sandstone arch was the longest single-arch span in the world. Among the nine views of structures belonging to the Washington Aqueduct in this print are the Georgetown Reservoir, top left; the Rock Creek Bridge, top center; and the Cabin John Bridge, center of the middle row.

[113]

Colored lithograph, *Douglas & Stanton Hospitals*, Charles Magnus, New York, 1864. 12 × 17 in. AS 466.

Douglas & Stanton Hospitals, Washington, D.C.

The Douglas and Stanton Hospitals, located at I and 2nd Streets N.W., were opened to receive wounded Union troops in early 1862. The Douglas Hospital occupied the three large rowhouses shown in the left center of the print, while the Stanton Hospital was located in newly built one-story wooden wards.

A row of three large houses, known as "Douglas Row," was built in 1856–57 as an investment by Sen. Stephen A. Douglas (1813–61) of Illinois. Douglas was a major force in supporting the Compromise of 1850, which had been meant to settle the slavery issue. However, he reopened the slavery question when, as chairman of the Committee on Territories, he instigated the Kansas-Nebraska Act. This reversed the former policy of not allowing slavery in the territories of Kansas and Nebraska by allowing the settlers to decide for themselves whether to keep slaves. Opposition to this view, known as "popularity sovereignty," led to the formation of the Republican Party. Douglas ran as the Northern Democratic candidate against Lincoln in 1860. The slavery issue split the Democratic Party into three factions with three different candidates that year, and this divisiveness allowed Lincoln to win the election. Although he lost the presidency, Douglas strongly supported Lincoln and opposed secession. He died in Chicago of typhoid fever only two months after the Civil War began.

After the houses were completed in 1857, Douglas and his wife, Adele Cutts, grandniece of James Madison, gave a large reception for local and national notables. The two other houses were purchased by other politicians—Sen. Henry M. Rice of Minnesota and Vice President John C. Breckinridge of Kentucky. Soon after the outbreak of the Civil War, Adele Douglas, by then a widow, and Senator Rice moved out of Douglas Row and offered their houses to the government for use as a military hospital. The government accepted and soon seized the third house for hospital use, since it was owned by Breckinridge, who had become a Confederate major general. Across the street was a vacant square block, also owned by the Douglas family. It was quickly converted to one-story wards and named Stanton Hospital after Secretary of War Edwin Stanton.

Soldiers Rest, Washington, D.C.

During the Civil War, Washington, D.C., became the nucleus of the Union war effort. In addition to the 68 camps and forts guarding the city from Confederate attack, dozens of hospitals were built in or near the city or located in confiscated houses and churches. Other large facilities were quickly established early in 1861 and 1862—cattle pens were located on the Washington Monument grounds, while large horse corrals and Quartermaster Division warehouses were set up in Foggy Bottom.

One of the largest military facilities in Washington was the Soldiers Rest, which was built in 1862 on the north side of Capitol Hill, along North Capitol Street and Delaware Avenue N.W., adjacent to the Baltimore and Ohio Railroad Station. It was managed by the quartermaster general to provide lodging and food for Union troops moving through the area. Entire regiments would arrive by train from the north en route to battles fought by the Army of the Potomac or the Army of the Shenandoah in Virginia. Soldiers Rest also provided a place for soldiers convalescing before returning to their units or Union soldiers recently freed from Confederate captivity by way of exchange. In addition, civilian employees of the U.S. government stayed there—carpenters, teamsters, painters, and laborers—mostly involved in the construction of Union fortifications in Washington and northern Virginia. The Soldiers Rest provided hot meals and a bed to men for a few hours to a week. The same activities existed at the Soldiers Rest in Alexandria, Virginia, which was constructed in 1864 on Duke Street near the Alexandria train station.

The Soldiers Rest in Washington closed in March 1866. During its existence, it saw 974,000 men pass through its dormitories and mess halls.

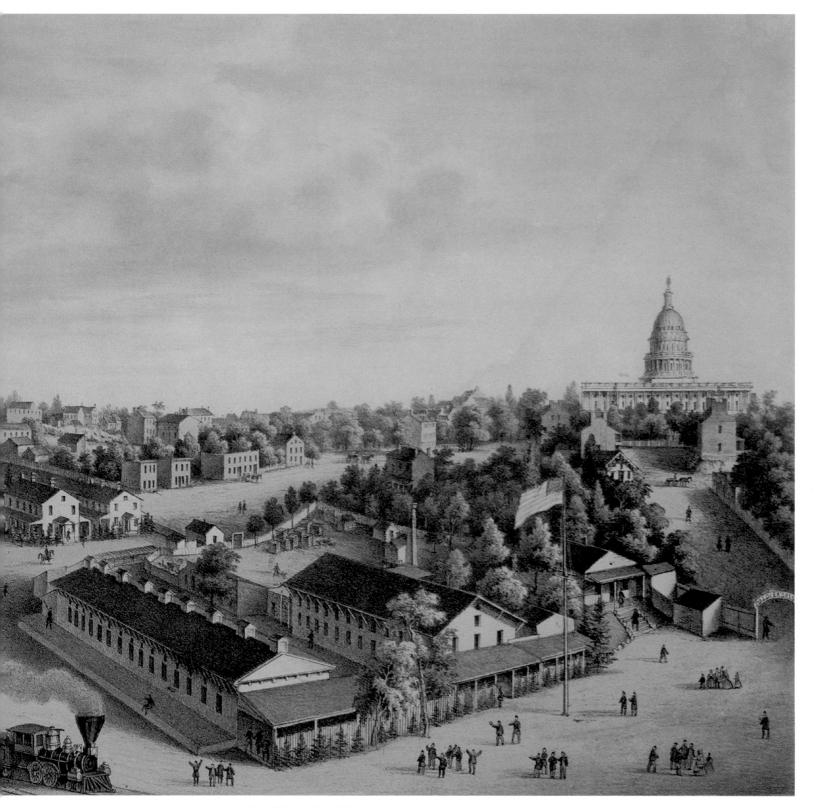

Colored lithograph, *Soldiers Rest*, *Washington*, *D.C.*, Charles Magnus, New York and Washington, D.C., 1864. 13 × 18 in. AS 50.

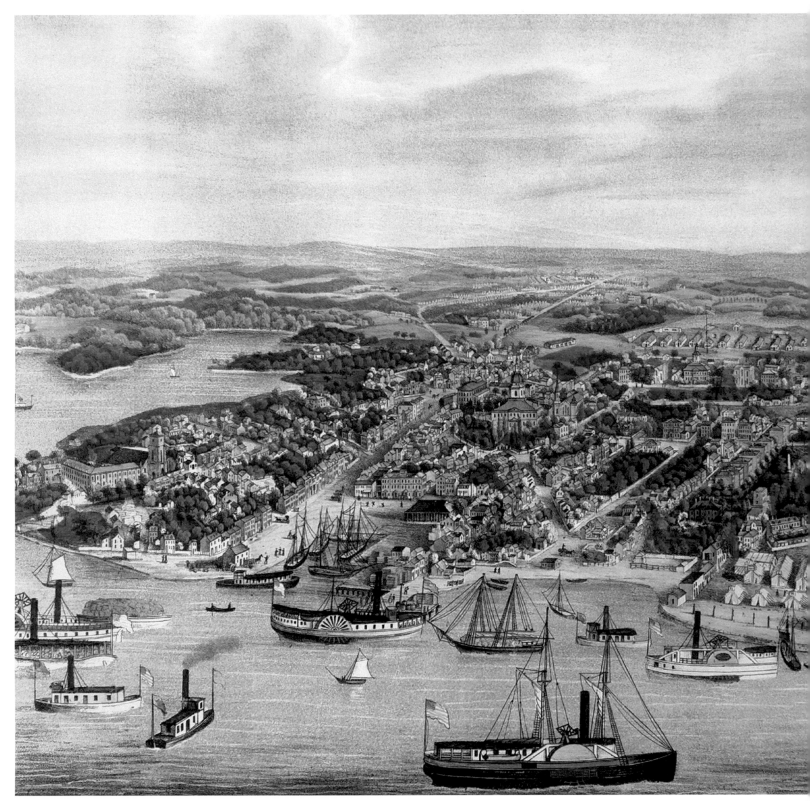

Colored lithograph, *Bird's Eye View of the City of Annapolis, Md.*, Charles Magnus, New York, 1864. 13 × 18 in. AS 8.

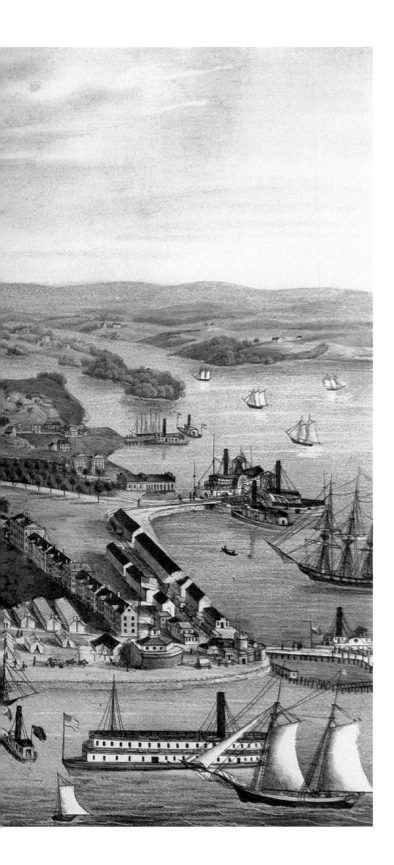

Bird's Eye View of the City of Annapolis, Md.

In addition to its importance as the capital of Maryland, Annapolis was significant during the Civil War for its strategic location. In the first two months of the war, Union regiments from Massachusetts and New York passed through Baltimore on the way to Washington to protect it from Confederate forces. After they were attacked by pro-Southern mobs on Baltimore's streets, a safer route to change trains had to be found. The solution was to ship the Union troops by water from New York to Annapolis, unload them there, and have them continue the trip to the nation's capital by rail.

During the war Annapolis, like Washington, became a major hospital center. This bird's eye view of Annapolis has a legend below the title of the print, locating the three hospitals serving Annapolis and their names. Since the Naval Academy had just been moved to Newport, Rhode Island, for safety from Confederate attack, the first of the three large hospitals was located on its former grounds. It was named "U.S. General Hospital, Division No. 1" (shown on the right of the print). A second hospital was established on the grounds of Saint John's College (shown upper center on the print). The third hospital was located at Camp Parole, a few miles to the west of town. Camp Parole was established primarily to hold paroled Union prisoners for future exchange with Confederate prisoners. At one point Camp Parole held as many as 20,000 paroled Union prisoners.

Bird's eye views became very popular in the United States during the second half of the 19th century. During this time, artists and print makers produced bird's eye views of an amazing 5,000 American cities and towns. This realism resulted from an artist, who walked the streets of the town making individual sketches of each building. Then, on a large sheet of paper, he drew in the streets and added the buildings to their exact locations, imagining what they would look like from a certain point in the sky.

The artist's final drawing was placed on public display in the town, and orders were taken for copies. Corrections were made and the drawing sent to a lithographer, who printed it. The artist then traveled to another town to begin another bird's eye view.

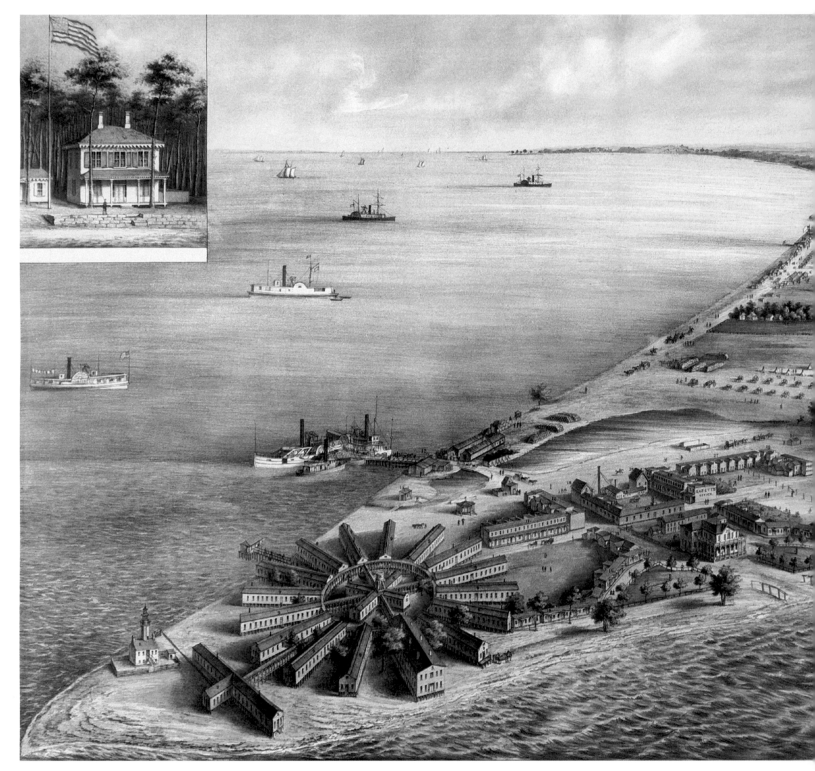

Colored lithograph, *Point Lookout, Md.: View of Hammond Genl. Hospital & U.S. Genl. Depot for Prisoners of War*, Edward Sachse, published by George Everett, Point Lookout, Maryland, 1864. 22 × 32 in. AS 248.

Point Lookout, Md.: View of Hammond Genl. Hospital & U.S. Genl. Depot for Prisoners of War

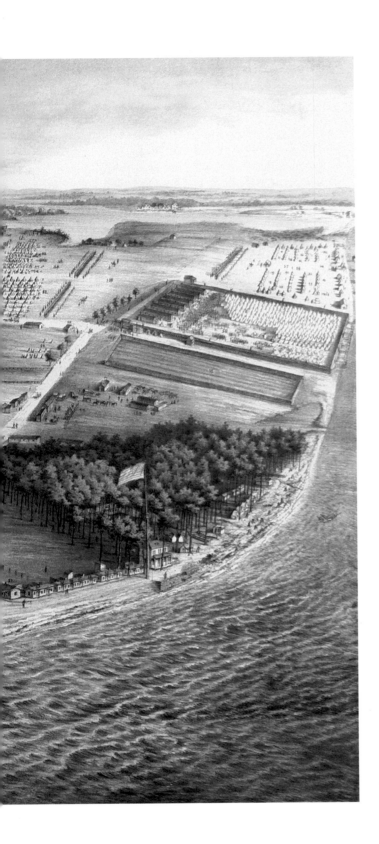

Point Lookout is a peninsula formed by the confluence of the Potomac River and the Chesapeake Bay in southern Saint Mary's County, Maryland. The first use of this site by the federal government was the construction of a lighthouse in 1830, which remained in use until it was deactivated in 1966. In the 1850s developer William Cost Johnson of Frederick County, Maryland, purchased 400 acres of land at this location for a bathing resort. He commissioned Baltimore architects Edmund G. Lind and William T. Murdoch to design a hotel and several boarding houses, which began operation by 1859. The U.S. army seized the "Point Lookout Bathing Place" in 1862 and constructed Hammond General Hospital at this location.

This detailed lithograph shows the one-story wards of the hospital, arranged like the spokes of a wheel and connected by pavilions. A legend below the title identifies 63 buildings on the large site, including the lighthouse, wharf, ice house, contraband quarters, "dead house" or morgue, old hotel and boarding houses, photo gallery, bakery, kitchen, laundry, and dining room.

This Union military facility eventually covered 1,000 acres. In addition to the hospital it included Fort Lincoln, a large wharf for receiving supplies, and a prison, named Camp Hoffman, for Confederate soldiers. The prison covered 40 acres and consisted of a large stockade with 14-foot wooden walls for enlisted men and a smaller, walled enclosure for Confederate officers. A walkway surrounded the tops of the walls, where guards marched day and night and harassed the prisoners.

Today Point Lookout is mainly remembered for its prison, where the Confederate inmates were harshly treated by the sadistic provost marshal, Maj. Allen G. Brady of New York. The prisoners were housed in defective tents that had been rejected by the Union army and given starvation rations and one blanket per two men as well as inadequate firewood for heating. Designed to house 10,000 prisoners, the prison witnessed extreme overcrowding, with 20,000 there at times. It is estimated that one-fifth of the 50,000 Confederate prisoners held there between 1863 and 1865 died from malnutrition and exposure to the freezing weather. Confederate generals often designed battle plans with the intention of freeing Confederates held at Point Lookout. Gen. Robert E. Lee and Lt. Gen. Jubal A. Early hoped to achieve this at the Battles of Antietam and Fort Stevens, respectively.

Today there is no trace of the once enormous military reservation. Point Lookout was considered the largest and worst Union prisoner-of-war camp. During the 1950s the State of Maryland purchased all of the land formerly occupied by the Civil War hospital, fort, and prison from farmers and the lighthouse from the federal government and created the Point Lookout State Park. None of the Civil War structures remain standing.

Artillerymen at Fort Stevens

Fort Stevens is one of the few Civil War forts in the Washington area, along with Fort Ward in Alexandria, Virginia, that have been restored to their Civil War appearance. It is located in Washington, D.C., just west of Georgia Avenue at the intersection of 13th and Quakenbos Streets N.W. Although small compared with some of the other forts built to protect Washington during the Civil War, it became famous because it was the only one to be attacked directly by the Confederate army, during its only invasion of Washington, D.C.

Fort Stevens was built immediately after the Confederate victory at the First Battle of Bull Run in July 1861. At that time it was named "Fort Massachusetts" after the home state of the troops that built it. It was located outside the city limits in Washington County, five miles northwest of the U.S. Capitol and built on land belonging to Elizabeth Proctor Thomas, a free black woman. The fort was doubled in size in September 1862 after the Confederate victory at the Second Battle of Bull Run and renamed to honor Brig. Gen. Isaac I. Stevens, who was killed at Chantilly, Virginia. It was situated on high ground, 321 feet above sea level, overlooking an open terrain extending several miles to the north. Fort Stevens was built to protect a major road entering the District of Columbia from Maryland—the Seventh Street Turnpike (now Georgia Avenue).

By 1864, Fort Stevens was enclosed by high earthen walls. It contained about two dozen cannons, howitzers, and other heavy guns and included a bombproof shelter for over 400 officers and men. An abatis, or fence of sharpened wooden spikes, protected it in the front.

In early July 1864, Lt. Gen. Jubal A. Early led his Confederate forces from the Shenandoah Valley of Virginia into Maryland with the intent of capturing Washington, D.C. He was delayed by one day at the Battle of the Monocacy outside Frederick, Maryland. This delay allowed Gen. Ulysses S. Grant to send part of his army in Petersburg, Virginia, to buttress the defense of Washington, thus saving the capital from Confederate capture. Although Lt. Gen. Early arrived near Fort Stevens on July 10, he delayed the attack to allow his troops to recover from fatigue and the summer heat. The battle was fought over a 33-hour period on July 11 and 12. On the late afternoon of July 12, President Lincoln and part of his cabinet arrived at Fort Stevens to observe the fighting. Shortly after Lincoln had climbed to the parapets to watch the action, Confederate sharpshooters began peppering the earthen walls of the fort with bullets. Within minutes a Pennsylvania officer standing six feet from Lincoln was hit and killed. At that point Maj. Gen. Horatio G. Wright, the commanding officer, ordered Lincoln and the other spectators off the parapet to safer ground. Lincoln and Madison were the only sitting presidents ever to be subjected to enemy fire. That night Early withdrew his Confederate troops across the Potomac River and camped at Leesburg, Virginia.

When the battle ended, 40 of the Union dead were buried nearby on what is now called the Battleground Military Cemetery. In 1936 the last surviving Union veteran of the battle died and was buried there also. Less than an acre in size, the cemetery is now maintained by the National Park Service, along with the fort itself. Its site was marked with a bronze plaque placed as early as 1911 by Union veterans of the battle. The earthen walls and the parapet were reconstructed by the Civilian Conservation Corps in 1938 as a New Deal project.

Photograph, *Artillerymen at Fort Stevens*, unknown photographer, 1864. 10.5 × 14 in. AS 550.

Lithograph, *Civilian Pass No. 5154, Headquarters Department of Washington, Washington, D.C.,* by Phelp and Solomons, Washington, D.C., January 17, 1865. 3.5 × 6.25 in. AS 813.

[124] *Civilian Pass No. 5154, Headquarters Department of Washington, Washington, D.C., Jany. 17th 1865*

During the Civil War, both military and civilian passes were issued by the War Department for soldiers and civilians to enter and leave the city of Washington. This surviving Civil War pass is extremely rare, as almost all were discarded after use.

While the National Archives does not have any civilian passes, it does hold the U.S. army's Department of Washington register books of passes issued to Union soldiers for 1864–65. The passes issued are recorded with the name of the soldier, date, pass number, the soldier's regiment, and the reason for leaving the District of Columbia. Although many passes were good for several months, some passes expired after only one day. Frequent reasons for departure included furloughs, rejoining regiments, and reporting for duty in Alexandria, Virginia, which was occupied by the Union army throughout the Civil War.

Thousands of letters were written by civilians to the War Department, asking for passes to visit Washington, D.C., or areas in the Confederacy that were occupied by Union troops. Civilians wanted to visit sick or wounded soldiers, return a soldier's body, or deliver supplies or medicine to humanitarian organizations such as the privately organized Sanitary Commission (which functioned much as the Red Cross does today). Passes were issued to civilians only after a loyalty oath was signed on the rear of the pass.

This civilian pass was issued on January 17, 1865, to two boys, H. W. Walbridge and George Scidmore, allowing them to cross the Aqueduct Bridge in Georgetown, D.C., into Alexandria County (now Arlington County), Virginia. It expired a month later, on February 17. On the reverse is this printed oath of loyalty to the U.S. government and the Constitution:

In availing myself of the benefits of this Pass, I do solemnly affirm that I will support, protect and defend the Constitution and Government of the United States against all enemies, whether domestic or foreign; that I will bear full faith, allegiance and loyalty to the Union; that I will not give aid, comfort or information to its enemies, and further, that I do this with a full determination, pledge and purpose, without any mental reservation or evasion whatsoever; so help me God.

The pass was approved and signed by J. A. Glippy for Maj. Gen. Christopher C. Augur, commander of the Department of War. It allowed the boys "to skate and play" on the other side of the river.

Colored lithograph, *Camp Fry, Washington, D.C.*, Charles Magnus, New York, 1865. 12.5 × 17 in. AS 38.

Camp Fry, Washington, D.C.

This 1865 lithograph shows Washington Circle with Clark Mills's 1860 equestrian statue of George Washington in the foreground, with a bird's eye view looking down 23rd Street to the Potomac River. In the left center is a streetcar pulled by two horses on the way from Georgetown to the Navy Yard via Pennsylvania Avenue.

The rows of wooden barracks on both sides of 23rd Street between the circle and H Street were built in 1863 and originally named Martindale Barracks. Next to them on the west was the Martindale Barracks Hospital and nearby, at 24th Street and New Hampshire Avenue, was the Circle Hospital. During the Civil War, these barracks housed the Veteran Reserve Corps (VRC)—soldiers disabled in battle who were unable to return to the field. They remained in the army, however, and served mostly in northern cities to guard government buildings and work as nurses, cooks, or clerks. They also performed some unusual tasks; for example, they were rushed to Fort Stevens in August 1864 to help block the Confederate attack led by Lt. Gen. Jubal A. Early, and they were later detailed to guard Lincoln's accused assassins as they awaited their trial while hostilities ran high against them.

Foggy Bottom was divided economically and socially into two sections in the 19th century. The area east of 23rd Street, to the left, was a middle- and upper-middle-class residential area, while the area to the west consisted of light industry and lower-class housing. In the western area were gas storage tanks belonging to the Washington Gas Light Company, as well as glass factories, lime kilns and foundries.

Almost every block of Foggy Bottom was occupied during the Civil War with some military installation. Camp Fry was established in June 1864, when the names of Martindale Barracks and Martindale Barracks Hospital became Camp Fry Barracks and Camp Fry Hospital. The post was renamed for Maj. Gen. James B. Fry (1827–94), who was appointed provost marshal general in March 1863. He was the only person to hold that post before it was abolished just after the Civil War. Fry, a West Point graduate and an artillery expert, arrived in Washington in early 1861 to protect the government. Camp Fry was named for him because of all of the kindnesses he performed for the VRC. For example, when the VRC was first established in 1863 it was known as the Invalid Corps. The members of the Invalid Corps were humiliated by that name as well as having to wear light blue uniforms to distinguish them from regular troops. By 1864, with the help of Gen. Fry, the more dignified sounding name of "Veteran Reserve Corps" and the standard dark blue uniform of regular troops were adopted by the VRC. In addition, Fry used his influence to have the leaking tents housing the Invalid Corps on 23rd Street replaced with wooden barracks.

Portrait of
President Abraham Lincoln

This portrait of Abraham Lincoln was taken by Alexander Gardner in his Washington studio on November 8, 1863, when Lincoln was preparing his remarks for the dedication of the military cemetery at Gettysburg, Pennsylvania, which he delivered a week and a half later. It is therefore sometimes called the "Gettysburg Portrait." Lincoln's two secretaries, John Nicolay and John Hay, accompanied Lincoln to the Gardner Gallery and were both photographed with Lincoln in another shot. Of the 127 known photographs of Lincoln, the first was an 1846 daguerreotype taken when Lincoln was elected to Congress. The first to show him with a beard was made after he was elected president—he had grown a full beard by January 13, 1861, when he was photographed by C. S. German in Springfield, Illinois. The last photo was a postmortem view taken by Jeremiah Gurney on April 24, 1865, when Lincoln's casket lay open in the New York City Hall.

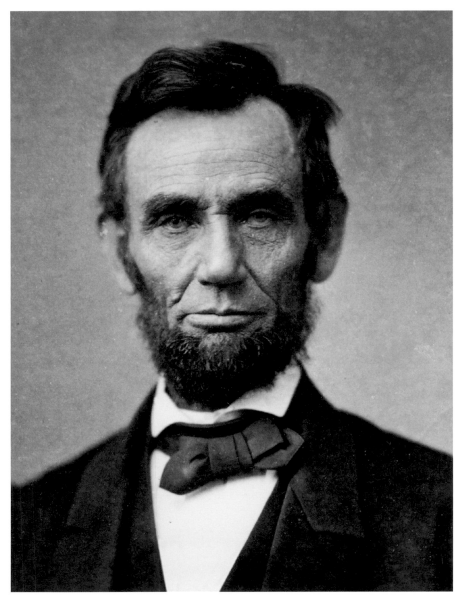

Photograph, *Portrait of President Abraham Lincoln*, Alexander Gardner, 1863. 4.5. × 3.5 in. AS 472.

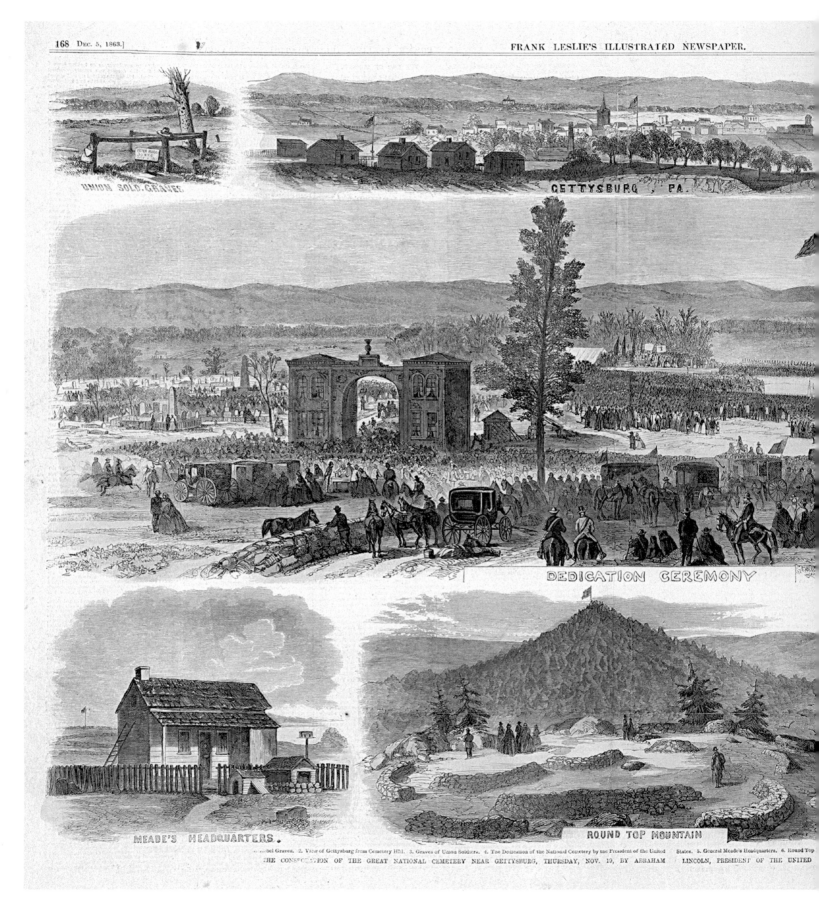

UNION SOLD. GRAVES

GETTYSBURG, PA.

DEDICATION CEREMONY

MEADE'S HEADQUARTERS.

ROUND TOP MOUNTAIN

el Graves. 2. View of Gettysburg from Cemetery Hill. 3. Graves of Union Soldiers. 4. The Dedication of the National Cemetery by the President of the United States. 5. General Meade's Headquarters. 6. Round Top
THE CONSECRATION OF THE GREAT NATIONAL CEMETERY NEAR GETTYSBURG, THURSDAY, NOV. 19, BY ABRAHAM LINCOLN, PRESIDENT OF THE UNITED

Woodcut, *Dedication Ceremony—The Consecration of the Great National Cemetery Near Gettysburg, Nov. 19, by Abraham Lincoln, President of the US*, in *Frank Leslie's Illustrated Newspaper*, December 5, 1863. 15.25 × 22.25 in. AS 652.

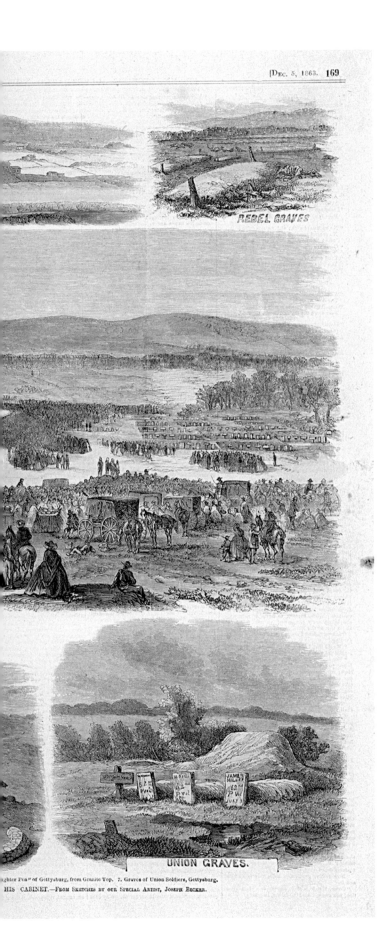

REBEL GRAVES

UNION GRAVES.

ughter Pen" of Gettysburg, from Granite Top. 7. Graves of Union Soldiers, Gettysburg.
HIS CABINET.—From Sketches by our Special Artist, Joseph Becker.

Dedication Ceremony— The Consecration of the Great National Cemetery near Gettysburg, Nov. 19, by Abraham Lincoln, President of the U.S.

This double-page print from *Frank Leslie's Illustrated Newspaper* shows the dedication of the military cemetery in the center and six other smaller scenes in Gettysburg, including Maj. Gen. George G. Meade's headquarters during the battle and a view of Round Top mountain. At noon on November 18, 1863, President Lincoln left Washington in a four-car train on a six-hour journey to Gettysburg, Pennsylvania, to give his "remarks" at the dedication of the military cemetery the next day. Lincoln and Edward Everett, his fellow speaker, spent the night in the house belonging to David Wills, a Gettysburg civic leader who was in charge of organizing the burials.

The thousands of soldiers who died during the three-day Battle of Gettysburg were quickly buried in shallow graves where they fell on the battlefield. Wills was in charge of transferring the Union remains to wooden coffins and re-burying them in the new military cemetery built on the edge of town adjacent to the older Evergreen Cemetery. Only one-third of the dead soldiers had been moved by the dedication date. Coffins were still stacked at the train platform—shipped from Washington by the Department of War—when Lincoln's train arrived. Edward Everett, a well-known public speaker and former president of Harvard College and Secretary of State, spoke for two hours. After blaming the South for starting the war, Everett lyrically described the military progress leading up to the battle and then the events that took place during the battle.

After a hymn, Lincoln spoke for a mere three minutes. Today, his speech is considered one of the most significant in American history. He clearly stated for the first time that the war was being fought for two reasons: to preserve the Union and to make all men free and equal, as guaranteed in the Declaration of Independence.

[129]

Death of President Lincoln at Washington, D.C., April 15, 1865, Nation's Martyr

After John Wilkes Booth shot Lincoln in his box at Ford's Theater, three physicians who were also attending the play carried the president across 10th Street to a rear bedroom in Petersen's boarding house. The print shows most of Lincoln's cabinet at the deathbed, as well as Mary Todd Lincoln, Robert Lincoln, Clara Harris, and his physicians. Chief Justice Salmon Chase, shown on the far left, was not actually present at the deathbed—when he heard the news it was close to midnight, and he decided to remain in his house rather than get in the way in the small bedroom at Petersen's or risk being assaulted himself. Tad, the Lincolns' younger son, was also never there. He was attending another play that night, *Aladdin*, at Grover's Theater. After the announcement was made that Lincoln had been shot, Tad was taken back to the White House. The Petersen House has been maintained as a historic house museum by the National Park Service since the 1930s.

Colored lithograph, *Death of President Lincoln at Washington, D.C., April 15, 1865, Nation's Martyr*, Currier & Ives, New York, 1865. 13.5 × 17 in. AS 296.

SURRAT. BOOTH. HAROLD.

War Department, Washington, April 20, 1865,

☛ $100,000 REWARD!

THE MURDERER

Of our late beloved President, Abraham Lincoln,

IS STILL AT LARGE.

$50,000 REWARD

Will be paid by this Department for his apprehension, in addition to any reward offered by Municipal Authorities or State Executives.

$25,000 REWARD

Will be paid for the apprehension of JOHN H. SURRATT, one of Booth's Accomplices.

$25,000 REWARD

Will be paid for the apprehension of David C. Harold, another of Booth's accomplices.

LIBERAL REWARDS will be paid for any information that shall conduce to the arrest of either of the above-named criminals, or their accomplices.

All persons harboring or secreting the said persons, or either of them, or aiding or assisting their concealment or escape, will be treated as accomplices in the murder of the President and the attempted assassination of the Secretary of State, and shall be subject to trial before a Military Commission and the punishment of DEATH.

Let the stain of innocent blood be removed from the land by the arrest and punishment of the murderers.

All good citizens are exhorted to aid public justice on this occasion. Every man should consider his own conscience charged with this solemn duty, and rest neither night nor day until it be accomplished.

EDWIN M. STANTON, Secretary of War.

DESCRIPTIONS.—BOOTH is Five Feet 7 or 8 inches high, slender build, high forehead, black hair, black eyes, and wears a heavy black moustache.

JOHN H. SURRAT is about 5 feet, 9 inches. Hair rather thin and dark; eyes rather light; no beard. Would weigh 145 or 150 pounds. Complexion rather pale and clear, with color in his cheeks. Wore light clothes of fine quality. Shoulders square; cheek bones rather prominent; chin narrow; ears projecting at the top; forehead rather low and square, but broad. Parts his hair on the right side; neck rather long. His lips are firmly set. A slim man.

DAVID C. HAROLD is five feet six inches high, hair dark, eyes dark, eyebrows rather heavy, full face, nose short, hand short and fleshy, feet small, instep high, round bodied, naturally quick and active, slightly closes his eyes when looking at a person.

NOTICE.—In addition to the above, State and other authorities have offered rewards amounting to almost one hundred thousand dollars, making an aggregate of about TWO HUNDRED THOUSAND DOLLARS.

$100,000 REWARD!
The Murderer of Our Late Beloved President, Abraham Lincoln

Secretary of War Edwin Stanton, pictured in the adjacent deathbed print, had this broadside printed six days after Lincoln's murder in an effort to capture the principal figures involved. It was immediately known that John Wilkes Booth had shot Lincoln. Stanton ordered the army in Washington to look for Booth and had all rail and boat travel in and out of the city stopped to prevent Booth's escape. He also posted a guard to protect Vice President Andrew Johnson.

John Wilkes Booth and his accomplice, David Herold, made their escape by horseback into Maryland. Twelve days later, on April 26, 1865, they were both trapped in a barn near Port Royal, Virginia, by the 16th New York Cavalry. Without any authority, one of the enlisted soldiers, Boston Corbett, shot and killed Booth. Herold was taken prisoner.

Of the eight people thought to be conspirators, seven were captured and put on trial. Four were sentenced to death and were hanged at what is now Fort McNair on July 7, 1865. These included Mary Surratt, who held the meetings of the conspirators in her Washington boarding house; Lewis Payne, who attempted to kill Secretary of State William Seward in his Lafayette Park house; David Herold, who helped Booth escape; and George Atzerodt, who planned to assassinate Vice President Johnson. Three others received prison sentences. Only one, the son of Mary Surratt, John Surratt Jr., managed to escape and fled to Europe. He was eventually located and arrested in Egypt in December 1866. Two years later he was released from prison and acquitted of all charges. The last names of David Herold and John Surratt are misspelled on the original broadside as *Harold* and *Surrat*.

Broadside, *$100,000 REWARD! The Murderer of Our Late Beloved President, Abraham Lincoln*, War Department, Washington, April 20, 1865. 23 × 12 in. AS 48.

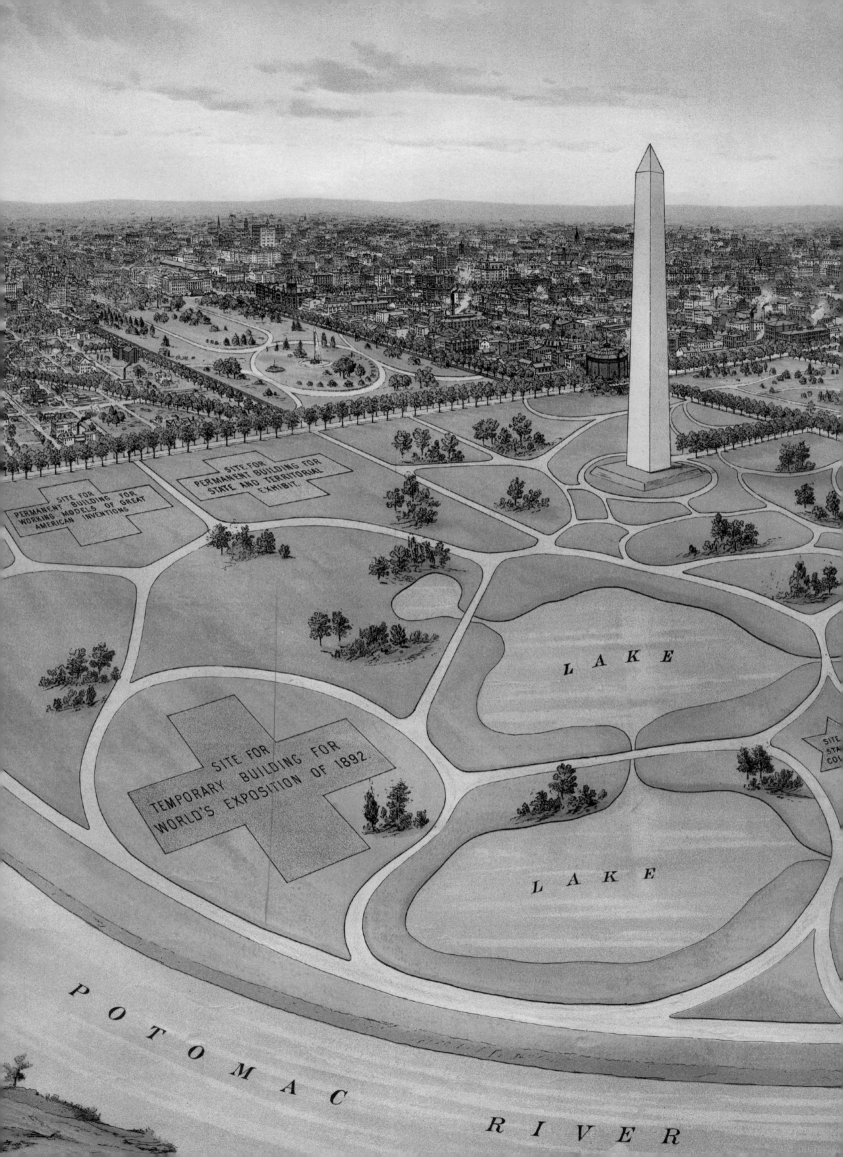

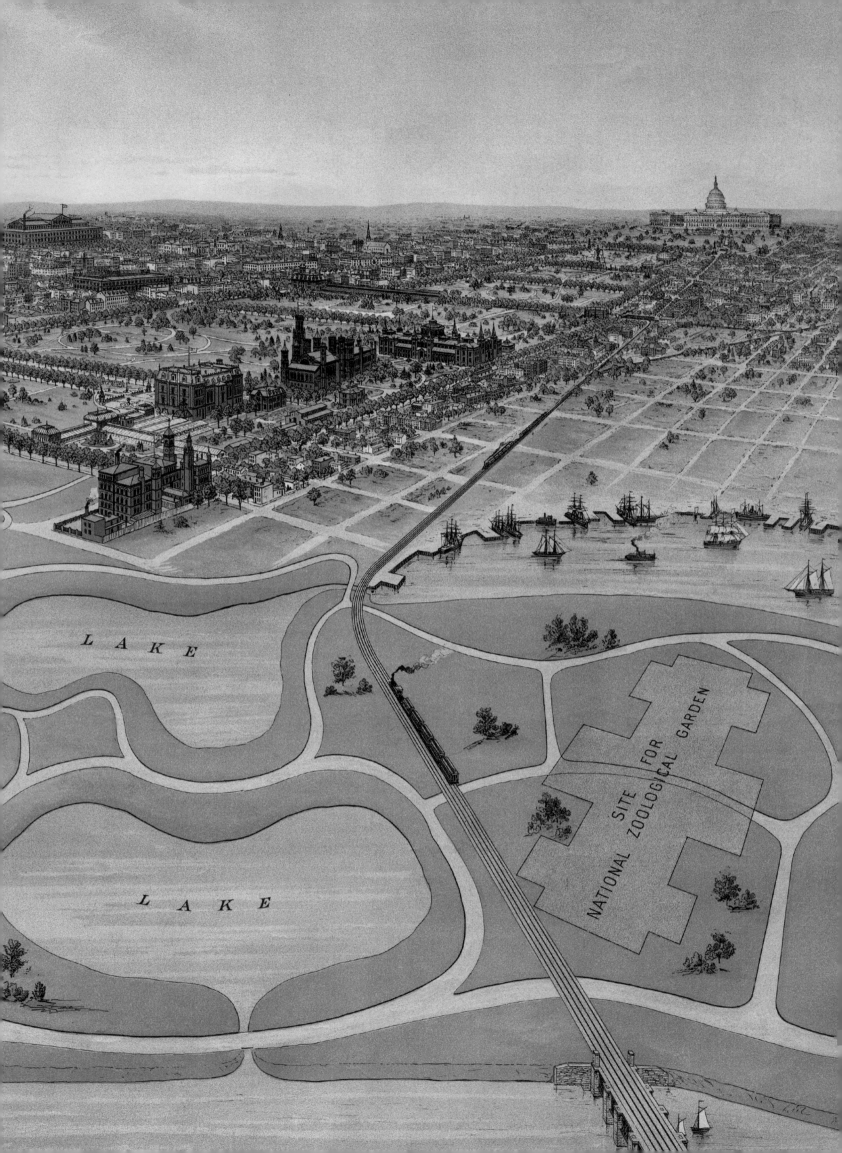

LAKE

LAKE

NATIONAL SITE FOR ZOOLOGICAL GARDEN

PART THREE

The Emergence of a Modern City

1866–1960

Modern Washington's origins are a significant part of the Albert H. Small Collection, even though the bulk of its resources focus on the founding of Washington, D.C., the Early Republic (including the War of 1812), and the city during the Civil War. Following the Civil War, the United States underwent a period of growing national spirit, with the Capitol, the White House, and the Washington Monument symbolizing this strengthening sentiment. Images of the elaborate parade for the inauguration of President James A. Garfield capture a sense of post–Civil War Washington's grandeur as the capital of an expanding nation.

Although Garfield's administration was cut short by his assassination, he set in motion the professionalization of the civil service, which led to the growth of a larger permanent white middle class. An aspect of a changing city for its residents and visitors was the creation of Rock Creek Park. Great monuments and elaborate public ceremonies made the city an appealing tourist attraction. Proposals in 1888 for a World's Fair in Washington demonstrated the ambitions and energy of local boosters, who were nevertheless not able to pull off such an extravaganza. Even so, tourism grew as visitors flocked to the city's grand public buildings. A major private destination was George Washington's home, Mount Vernon, which spurred on the growing sense of the first president as the father of his country. Finally, increasingly well known and positively viewed symbols found their way into advertising, by associating, for example, the sale of insurance with the Washington Monument and that of automobiles with the Capitol.

William Becker
Professor of History
The George Washington University

National Farm School

This colored lithograph portrays an idealized version of the National Farm School. It was established in 1866 by Henri de Mareil, the editor of a French-language newspaper published in New York City. The purpose of the school was to teach black orphan boys agriculture. The print features a white teacher showing the black students how to harvest wheat in the foreground, while other students plow a field in the background. The buildings shown include, left to right, the barn, school house, and large dormitory.

The National Farm School was located on a 100-acre tract of land at Giesboro Point, a peninsula on the Anacostia River near the present Bolling Air Force Base. The adjacent white farmers resented the black farm school in their neighborhood. They harassed the African American boys when they bathed in the river and threw stones at their schoolhouse. The local freedmen were also against the school and distrusted the Freedmen's Bureau in helping to recruit new students. The school, personally managed by de Mareil and his wife, had only 50 students during the one year it was in operation. When the Freedmen's Bureau withdrew their subsidy, the school closed in June 1867 and de Mareil lost $12,000 of his personal funds in the ill-fated experiment.

Colored lithograph, *National Farm School*, Ferd. Mayer & Co., New York, 1866. 14.5 × 19.5 in. AS 28.

Washington, D.C.

This bird's eye view of the White House and its surrounding buildings, drawn just after the Civil War, shows the low scale of Washington, D.C., before major expansion of new buildings began. In the early 19th century four executive office buildings were built around the White House in the area designated as President's Park. By 1820 all four had been completed and occupied by the State Department on the northeast corner, the Treasury Department on the southeast corner, the War Department on the northwest corner, and the Navy Department on the southwest corner. After the Treasury Building burned in 1833, President Andrew Jackson commissioned Robert Mills to design a monumental Neoclassical building to replace it, and the new structure eventually took up the entire east side of the White House. Its enlargement—during which the old State Department Building had to be razed—was not finished until 1866. Overcrowding in the other executive office buildings resulted in the emergence of the mammoth new State, War, and Navy Building on the entire west side of the White House, between 1871 and 1888, in the Second Empire style of architecture. These departments gradually moved out, and it is now known as the Eisenhower Executive Office Building and is used for White House offices.

Another notable building in the foreground of the print—along 17th Street—is the Winder Building in the center. This L-shaped brick and iron building was the first large office building in the city. It was built in 1848 by an investor, William H. Winder, to rent for surplus office space for the War and Navy Departments during the Mexican War. It is now owned by the federal government and is the oldest office building in Washington. To the right, just across F Street on the corner, is the low Victorian house that was used as Gen. Ulysses S. Grant's headquarters just after the Civil War. To the far left at Pennsylvania Avenue and 17th Street is the Corcoran Gallery of Art, built between 1858 and 1861 by William W. Corcoran. It was taken by the government during the Civil War for the headquarters of the quartermaster general's office. After it was returned to Corcoran in 1869, he repaired it and opened it to the public as the Corcoran Gallery of Art. Today it houses the Renwick Gallery, part of the Smithsonian Institution.

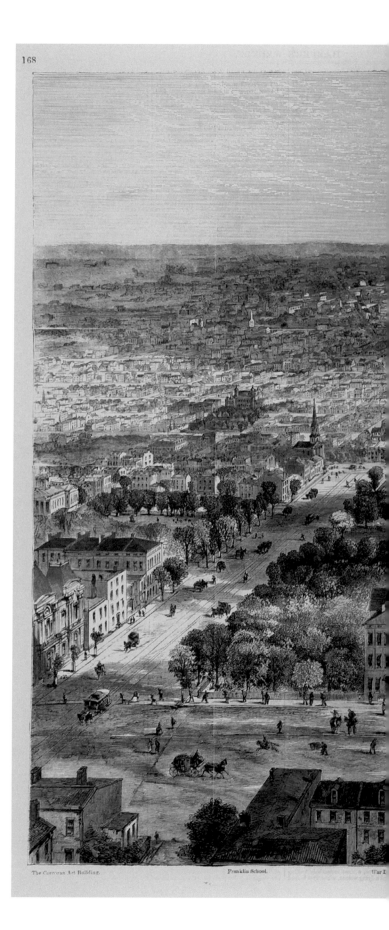

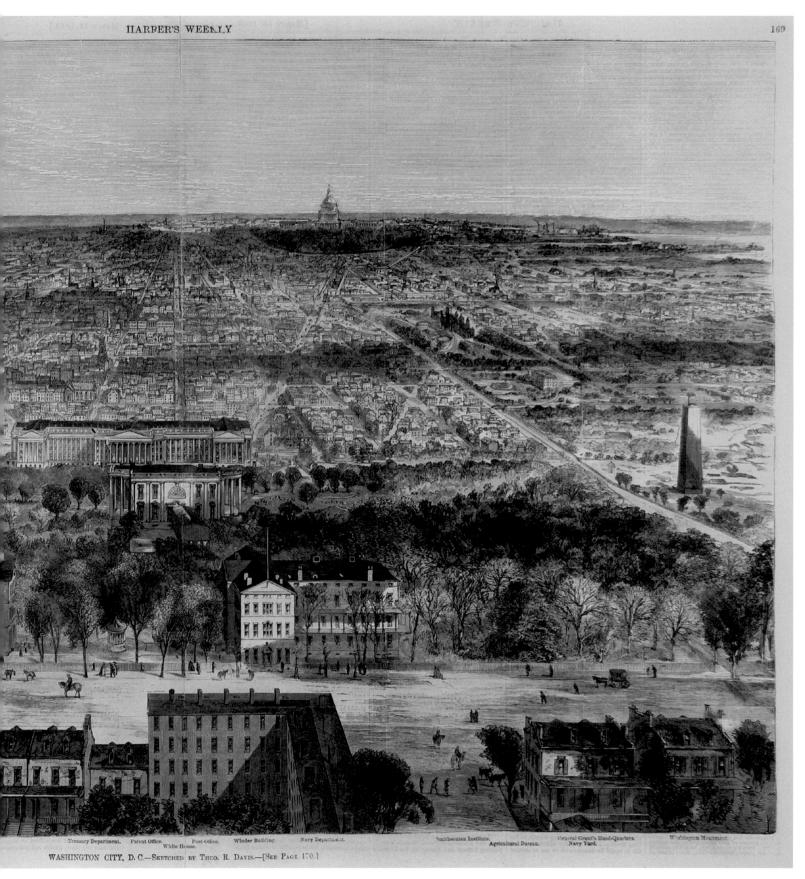

Treasury Department. Patent Office. Post-Office. Winder Building. Navy Department. Smithsonian Institute. General Grant's Head-Quarters. Washington Monument.
White House. Agricultural Bureau. Navy Yard.

WASHINGTON CITY, D. C.—Sketched by Theo. R. Davis.—[See Page 170.]

Colored woodcut, *Washington, D.C.*, Theodore R. Davis, *Harper's Weekly*, March 13, 1869. 15 × 21 in. AS 185.

THE CONGRESSIONAL LIBRARY, CAPITOL, WASHINGTON.—[PHOTOGRAPHED BY BELL BROTHERS, WASHINGTON, D. C.]

Woodcut, *The Congressional Library, Capitol, Washington*, after a photograph by Bell Brothers,
Washington, D.C., probably published in *Harper's Weekly*, 1871. 7.5 × 11.75 in. AS 357.

The Congressional Library, Capitol, Washington

The Library of Congress, designed by Architect of the Capitol Charles Bulfinch, opened in 1824 on the west side of the Capitol, located in a room behind the portico. Two fires occurred here. The first broke out at night in December 1825 but was fortunately discovered early and put out by neighbors with the use of the Capitol's own fire engine.

A second and disastrous fire began in the same room about 8 P.M. on December 24, 1851—caused by the faulty insertion of a stove pipe into a flue in the wall. When the alarm was sounded, seven volunteer fire companies responded. By working all night and well into the following day, they were able to stop the fire from spreading into the wooden dome, from which it would have consumed the entire building. A detachment of marines arrived and helped with the bucket brigade, but when the fire was finally extinguished around midnight the room was a burned-out shell. Gone were 36,000 books—about 65 percent of the library's holdings. These books included two-thirds of Thomas Jefferson's library, which had been purchased in 1815 to replace the books lost when the British burned the Capitol the year before. Also burned were dozens of rare portraits, marble busts, and manuscripts.

The secretary of the interior asked Architect of the Capitol Thomas U. Walter to prepare plans for a reconstruction of the room. Three weeks later Walter submitted his revolutionary plans: rebuilding the entire room, including the ceiling, in iron. The final work on the room was completed in 1853 with the installation of thousands of gold leaf embellishments, making the room spectacular. This space was vacated when a separate building was completed for the Library of Congress across the street in 1897. The room disappeared in 1906, when it was converted into multiple committee rooms.

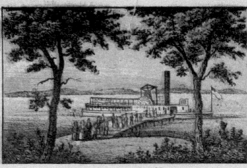

LANDING - PLACE.

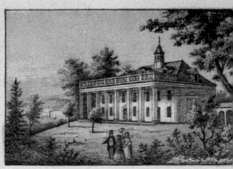

MOUNT VERNON - EAST FRONT.

SUMMER - HOUSE.

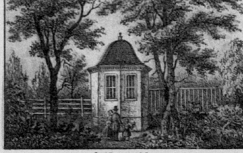

SEED - HOUSE.

BIRTH-PLACE OF WASHINGTON.

MRS WASHINGTON. WASHINGTON.

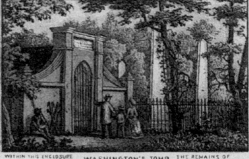

WITHIN THIS ENCLOSURE REST WASHINGTON'S TOMB. THE REMAINS OF GL GEO WASHINGTON

ROOM IN WHICH WASHINGTON DIED.

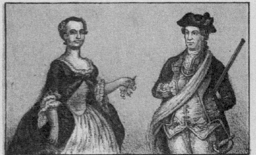

LEMON-TREE & CENTURY-PLANT. SAGO PALM.

CHIMNEY PIECE. MIRROR & PORCELAIN VASES

SIDE-BOARD TEA-TABLE SILVER TEA SETS THE LANTERN & THE KEY OF THE BASTILE & PUNCH-BOWL.

MONTICELLO.

ROOM IN WHICH JEFFERSON DIED.

HERE LIES BURIED THOMAS JEFFERSON AUTHOR OF THE DECLARATION OF AMERICAN INDEPENDENCE.

JEFFERSON'S GRAVE. STATUE OF JEFFERSON

Broadside, *Souvenir of Mount Vernon including Monticello and Arlington*, by Edward Sachse, Baltimore, 1876. 14 × 16 in. AS 574.

MOUNT VERNON—WEST FRONT.

WASHINGTON. LAWRENCE WASHINGTON.

DEATH-BED. LID OF THE COFFIN. WASHINGTON'S COFFIN.

WASHINGTON'S OLD ICE HOUSE. WASHINGTON'S CAMP CHEST.

WASHINGTON'S TENT & SWORD. IRON CHEST.

ARLINGTON HOUSE.

Souvenir of Mount Vernon including Monticello and Arlington

After the Mount Vernon Ladies' Association (MVLA) purchased Mount Vernon from John Augustine Washington III in 1858 and took over operations in 1860, the association relied on an admission fee from visitors to restore and maintain the mansion and grounds. In the opening months of the Civil War, many Union soldiers came to visit and paid 25 cents to enter. After the Second Battle of Bull Run in July 1862, the MVLA's income plummeted when the Union army stopped the operation of the daily steamboat between Washington, D.C., and Mount Vernon. With the return of peace in May 1865, the steamboat resumed its old schedule and hundreds of visitors arrived for tours. In the second half of 1865, the MVLA made double the income they had received during the last three years of the war. Even so, Mount Vernon now had to vie for tourists who were lured to more recent nearby Civil War shrines such as the Gettysburg Battlefield, Arlington National Cemetery, and Ford's Theater.

When this broadside was purchased from a dealer in 2012, it was thought to be an early publication of the MVLA to lure tourists to visit the landmark. A curator at Mount Vernon says, however, that it was definitely not published by Mount Vernon. Since it is dated 1876 and features two other historic Virginia houses besides Mount Vernon—Monticello and Arlington—it seems plausible that it may have been produced by the state of Virginia to give to tourists while visiting the Virginia Pavilion at the Philadelphia Centennial. Record numbers of people were attracted to Mount Vernon that year. For the month of October, over 13,000 visitors came to Mount Vernon, many having stopped first to see the Philadelphia Centennial before traveling south. Besides admission fees, a second major income for the estate, beginning in 1872, was the practice of serving picnic lunches to the hundreds of visitors. Both the isolation of Mount Vernon and the long waits between the steamboat rides gave Mount Vernon a monopoly over food sales. With these additional funds, the MVLA built the side porch on the mansion. More income was brought in by vice regents of the MVLA, who sponsored "Martha Washington Tea Parties" in many other states.

The first guidebook, E. B. Johnson's *Visitor's Guide to Mount Vernon*, was published in Washington, D.C., in 1876 for the MVLA to coincide with the Centennial. It was sold on the steamship as well as on the grounds of Mount Vernon for 25 cents and included information on sights to see on the way down the Potomac, from Alexandria to Fort Washington. Most of the space in the 40-page pamphlet was devoted to describing the rooms in the mansion and various original objects, such as the Key to the Bastille, which was given to George Washington by Lafayette. Visitors were also warned against taking souvenirs from the estate. The door frame of Washington's bedroom had been so defaced by visitors who cut pieces of wood from it for souvenirs that a guard was posted there to prevent vandalism when that room was open.

[145]

Home of Washington, Mount Vernon, Virginia

Photographers have been coming to Mount Vernon to record the images of visitors since the mid-1850s. This 1889 portrait of a family group from Orange, Virginia, on the east lawn of Mount Vernon was taken by Luke C. Dillon (1836–1904). Dillon was born in New York to Irish parents and served in the Civil War as a photographer to the Army of the Potomac. As "Photographer to Mount Vernon" from 1874 through 1897, his duties were to photograph not only rooms at Mount Vernon and the members of the MVLA at their annual meetings but also hundreds of tourists each year. During this time he lived in Washington, D.C., where he maintained a photographic gallery at 935 Pennsylvania Avenue N.W.

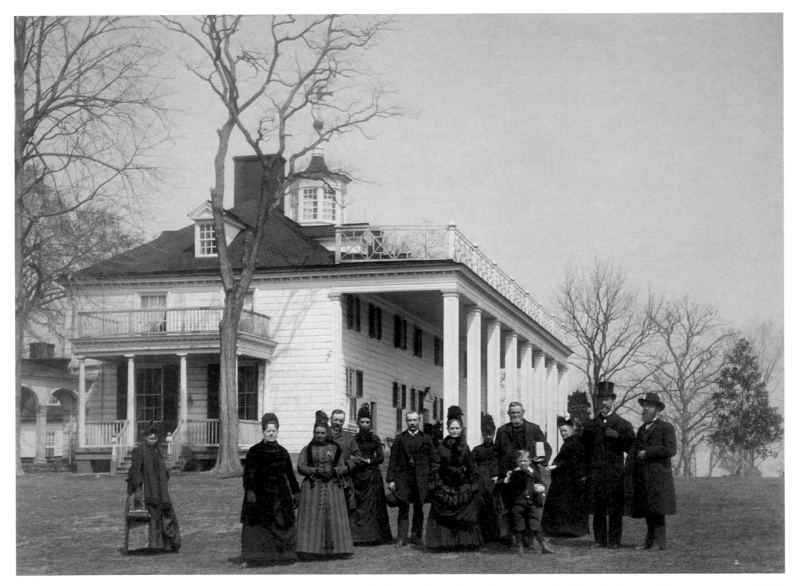

Photograph, *Home of Washington, Mount Vernon, Virginia,* Luke C. Dillon, Washington, D.C., 1889. 9 × 11 in. AS 883.

HARPER'S WEEKLY.

JOURNAL OF CIVILIZATION

Vol. XXIII.—No. 1197.] NEW YORK, SATURDAY, DECEMBER 6, 1879. [SINGLE COPIES TEN CENTS. $4.00 PER YEAR IN ADVANCE.

Entered according to Act of Congress, in the Year 1879, by Harper & Brothers, in the Office of the Librarian of Congress, at Washington.

UNVEILING THE STATUE OF GENERAL THOMAS, AT WASHINGTON.—Drawn by W. P. Snyder.—[See Page 969.]

Unveiling the Statue of General Thomas, at Washington

The dedications of equestrian statues in Washington, D.C., to American military heroes in the 19th and early 20th centuries were major public events. Before the Civil War, two were erected—the statue of Maj. Gen. Andrew Jackson in Lafayette Park in 1853 and the statue of Lt. Gen. George Washington at Washington Circle in 1860. After the war, 10 equestrian statues were rapidly erected to Union generals: Winfield Scott, 1874; James B. McPherson, 1876; George H. Thomas, 1879, shown here; Winfield S. Hancock, 1896; John A. Logan, 1901; William T. Sherman, 1903; George B. McClellan, 1907; Philip H. Sheridan, 1908; Philip Kearny, 1914; and Ulysses S. Grant in 1923.

One of the most elaborate ceremonies surrounded the unveiling of the equestrian statue of Maj. Gen. George H. Thomas (1816–1870) on November 19, 1879, at Thomas Circle at the intersection of Massachusetts Avenue and 14th Street N.W. The $40,000 bronze equestrian statue was paid for by the loyal veterans of Thomas's Civil War Army of the Cumberland, while the federal government donated the public space and the elaborate granite pedestal. Thomas is best remembered for defeating Confederate forces in Tennessee. When the Civil War began in April 1861, Thomas did not join his native state in seceding but remained loyal to the Union. From then until his death, most of his children considered him a traitor to Virginia and to his own family.

The dedication ceremony began with a parade of 2,000 U.S. soldiers, sailors, and marines who marched from the Capitol west to the White House and then north to Thomas Circle. At the site various military bands gave concerts and a 100-man chorus sang several songs, including "The Star Spangled Banner." President Rutherford B. Hayes was one of the speakers who praised Maj. Gen. George H. Thomas for commanding the Army of the Cumberland in Tennessee during the Civil War. The statue was unveiled by Maj. Gen. Don Carlos Buell, who pulled on a single rope that dropped the four large U.S. flags concealing the statue. The two-hour program ended after a hymn was sung, and the estimated 50,000 spectators then departed.

Colored woodcut, *Unveiling the Statue of General Thomas, at Washington*, in *Harper's Weekly*, December 6, 1879. 14 × 10 in. AS 569.

EXTERIOR VIEW OF THE BUILDING.

A READING OF THE BAROMETER.

ARRANGING THE

THE U. S. METEOROLOGICAL SERVICE.

IF ever building gave sign of the special uses to which it is devoted, that edifice is the house, or two houses rolled into one, in the City of Washington in which the secrets of the elements are reluc-

tantly forced from them by the subtle hand of science; their action formulated; and much of their destructive efforts, by the precautions taken to anticipate them, paralyzed, foiled and baffled. A glance at the roof of the Meteorological Department strikes awe and bewilderment into the passer by. The sky is crossed and recrossed, as a schoolgirl's first love-letter, by electric wires—wires "giving

away" the north, south, east and west winds, as they crouch in far-distant corners of the world are leaping upon the warpath. The roof actually bristles with meteorological insignia—cups and balls, and flags and mirrors, and weather-cocks, and poles with curiously-devised instruments, measuring the four points of the compass, and a very grove of electric wires. The roofs of the neighbor-

ing dwellings are compelled to pay tribute, till they resemble an elevated Holland, so rich are they in miniature windmills of every sort, shape, size and description, each set of cups facing till it makes one giddy to gaze at them. How courageously and unerringly these little cups do their duty, standing to their posts until blown away, as was the case last August during the cyclone, when eleven hundred

miles of wind was registered in one day! The Signal Service, as now organized, consists of 18 commissioned officers, 150 sergeants, 30 corporals and 200 privates. This force has the management of 300 stations, extending from the Dominion of Canada to the Rio Grande, and from the Atlantic to the Pacific Ocean. Of these stations, 143 take meteorological observations; 34 are known as sunset stations, 11 al-

THE INSTRUMENT-ROOM ON THE TOP FLOOR.

WASHINGTON, D. C.—THE METEOROLOGICAL WORK OF THE UNITED STATES SIGNAL SERVICE—FROM SKETCHES BY H. A. OGDEN.

WASHINGTON, D. C.—THE M

Colored woodcut, *Washington, D.C.—The Meteorological Work of the United States Signal Service*, in *Frank Leslie's Illustrated Newspaper*, May 1, 1880. 16 × 22 in. AS 450.

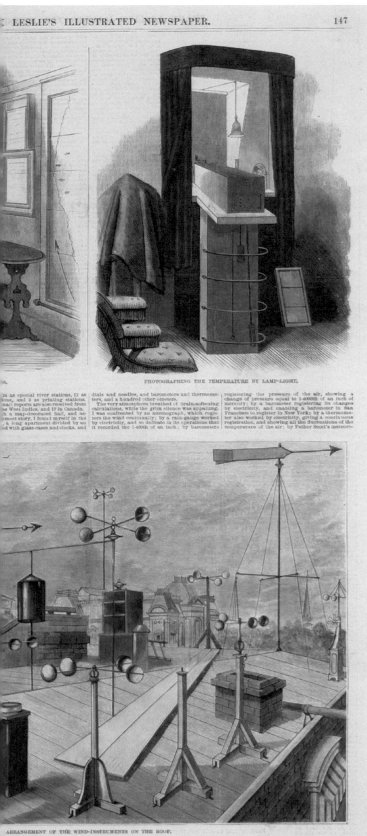

PHOTOGRAPHING THE TEMPERATURE BY LAMP-LIGHT.

24 as special river stations, 12 as ions, and 3 as printing stations. nal reports are also received from he West Indies, and 19 in Canada. h a map-decorated hall, and assemest story, I found myself in the a long apartment divided by an ed with glass-cases and clocks, and

dials and needles, and barometers and thermometers, and a hundred other ometers. The very atmosphere breathed of brain-softening calculations, while the grim silence was appalling. I was confronted by an anemograph, which registers the wind continually; by a rain-gauge worked by electricity, and so delicate in its operations that it recorded the 1-400th of an inch; by barometers

registering the pressure of the air, showing a change of pressure equal to 1-400th of an inch of mercury; by a barometer registering its changes by electricity, and enabling a barometer in San Francisco to register in New York; by a thermometer also worked by electricity, giving a continuous registration, and showing all the fluctuations of the temperature of the air; by Father Secci's meteor-

ARRANGEMENT OF THE WIND-INSTRUMENTS ON THE ROOF.

ICAL WORK OF THE UNITED STATES SIGNAL SERVICE.—FROM SKETCHES BY H. A. OGDEN.

Washington, D.C.— The Meteorological Work of the United States Signal Service

These colored woodcuts from *Frank Leslie's Illustrated Newspaper* in 1880 show the operations of the U.S. Meteorological Service of the army's Signal Corps in Washington. The Signal Corps was first established in 1859 by Albert J. Myer (1828–80), an army surgeon from Newburgh, New York, who invented a system of signaling across long distances by using a single signal flag. This "wig-wag" signaling, or aerial telegraphy, was subsequently used by both sides during the Civil War. Myer later used electrical telegraphy in field communication.

Congress established a national weather forecasting bureau in 1870 and assigned the duties to the U.S. Signal Corps. In the beginning the weather bureau required U.S. army forts across the country to telegraph their weather conditions three times a day to the U.S. Meteorological Service headquarters in Washington, D.C.

Myer used signal flags, light beacons, and the telegraph to announce approaching storms on the coast and on the Great Lakes, techniques that substantially improved commercial shipping and safety. His weather reports also greatly aided farmers in planning times to plant or harvest crops. Myer used Fort Whipple, adjacent to Arlington Cemetery, as the center for training signalmen and weather forecasters. Shortly after his death, it was renamed Fort Myer in his honor in 1881. The weathermen took courses there in military tactics, signaling, telegraphy, telegraphic line construction, electricity, meteorology, and practical work in weather observation. Every day, the headquarters in Washington telegraphed weather conditions and predictions to thousands of post offices, railroad stations, and newspapers across the country.

In 1880 the U.S. Meteorological Service of the Army Signal Corps was housed in this new four-story landmark located near the War Department Building, at 17th and G Streets N.W. in Foggy Bottom. Its location was easily recognizable from the myriad instruments on the roof to measure the wind, as well as the dozens of telegraph lines entering the building. These illustrations show clerks reading a barometer and placing pins on a large wall map of the United States indicating weather conditions. Visitors were allowed to inspect the vast array of weather apparatus in the instrument hall on the fourth floor.

In 1891 the weather bureau was removed from military control and placed under the Agriculture Department. Today it is known as the National Weather Service and operates under the supervision of the Commerce Department. It is headquartered in the National Oceanic and Atmospheric Administration Building in Silver Spring, Maryland.

Washington, D.C.—The Presidential Party Passing through the Grand Arch

This 1881 woodcut shows President James A. Garfield in a carriage on 15th Street passing under the Grand Inaugural Arch while returning to the White House from his inauguration at the Capitol. For the Garfield inauguration, Congress established a decorating committee and appropriated funds for its expenses. The funds were spent on two items. The first was toward the decoration of the interior of the Smithsonian's just-completed second museum building on the mall, the Arts and Industries Building, for the inaugural ball. Here, flags and bunting were everywhere, along with an allegorical statue of America, dressed in a flowing robe and holding a lighted torch and a shield.

The second and most noticeable decoration consisted of 39 arches on Pennsylvania Avenue under which the inaugural parade would pass. The Grand Triumphal Arch, far larger than the others, was built spanning 15th Street at F Street between the Treasury Department Building and the Corcoran Office Building. This ornate central arch was built of wood and designed to resemble a European castle. The central arch rose to a height of 49 feet, while towers on each side were 82 feet tall. It was covered with flags and bunting, along with Garfield's name. The other 38 arches, representing the number of states at the time, were small and simple, built of metal poles. Each was covered with flags with the name of a state and its motto, coat of arms, and date of admission to the union. All contributed to a festive atmosphere, even though the temperature was below freezing.

Woodcut, *Washington, D.C.—The Presidential Party Passing through the Grand Arch*, in *Frank Leslie's Illustrated Newspaper*, March 19, 1881. 16 × 11 in. AS 901.

WASHINGTON, D. C.—THE PRESIDENTIAL PARTY PASSING BENEATH THE GRAND ARCH, EN ROUTE TO THE WHITE HOUSE, AFTER THE INAUGURATION.—From Sketches by our Special Artists.—See Page 38.

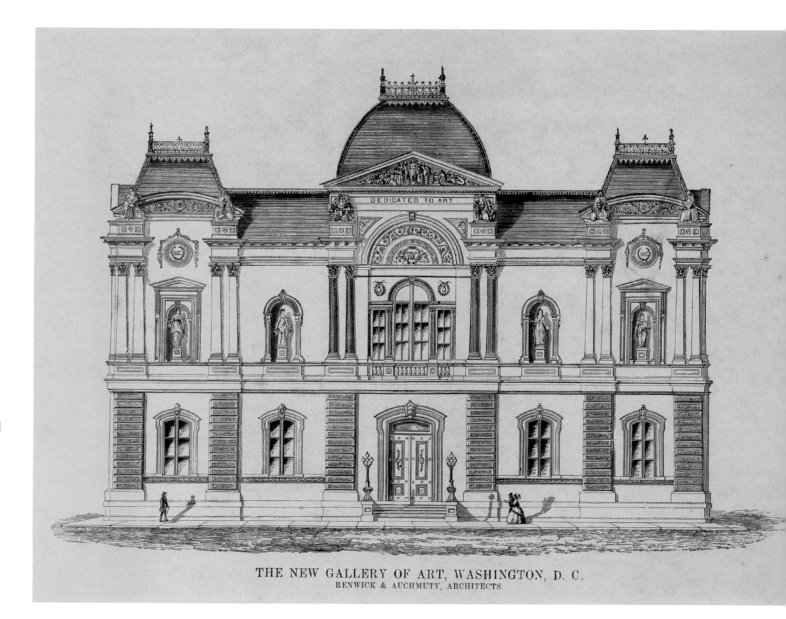

THE NEW GALLERY OF ART, WASHINGTON, D. C.
RENWICK & AUCHMUTY, ARCHITECTS.

The New Gallery of Art, Washington, D.C., Renwick & Auchmutz, Architects

This shows the original Corcoran Gallery of Art building at the northeast corner of Pennsylvania Avenue and 17th Street N.W. It opened to the public in 1874. The building is significant because it was one of the first Second Empire buildings built in the United States between 1859 and 1861. It was taken for use by the U.S. army during the Civil War and then returned to the builder, Washington banker and philanthropist William Wilson Corcoran (1798–1888). The design includes four pavilions—three facing Pennsylvania

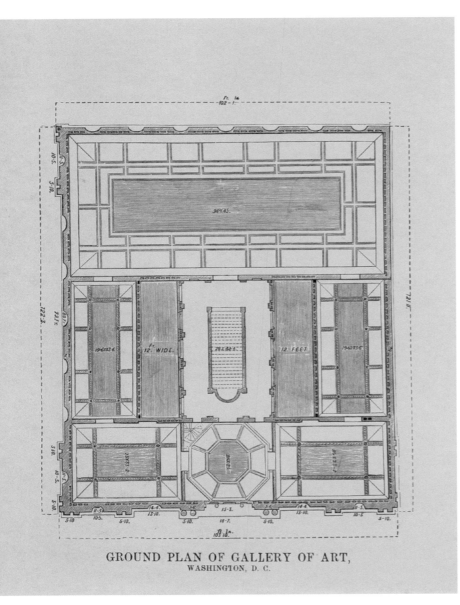

GROUND PLAN OF GALLERY OF ART,
WASHINGTON, D. C.

Lithograph, *The New Gallery of Art, Washington, D.C., Renwick & Auchmutz, Architects,* Waters-Tilton, New York, 1885. 8 × 17 in. AS 941.

Avenue and a fourth in the rear facing 17th Street. Each is crowned with a mansard roof with iron cresting. Featured prominently on its façade and side elevation are 11 niches located on the second floor. They held statues sculpted by Moses Ezekiel and represented famous artists and sculptors. The only American included is Thomas Crawford, who sculpted the Statue of Freedom on the U.S. Capitol dome. The Corcoran School of Art was added in a rear annex to the building in 1889.

Because of overcrowded conditions, a new building to house the museum and the school was designed by Ernest Flagg in the Beaux Arts style. Construction was completed in 1897 at the corner of 17th Street and New York Avenue. The U.S. government bought the old building and used it as offices for the Court of Claims before it was transferred to the Smithsonian in 1965. The landmark was renovated and re-opened as the Renwick Gallery in 1972. It is administered by the Smithsonian American Art Museum.

The National Washington Monument, Erected at the City of Washington, D.C., by the Government and the People of the United States, as a Tribute to the Glorious Memory of General George Washington

After the Civil War it was common for private companies to publish prints and photographs of Washington area landmarks for their advertising purposes. A view of the Capitol, White House, Washington Monument, or Mount Vernon linked the product being advertised to wholesome American patriotism. This print of the Washington Monument is a perfect example. Currier & Ives produced the colored lithograph for the United States Mutual Accident Association in 1885, the year the obelisk was completed and dedicated. This print shows Robert Mills's original design with a Greek colonnade circling its base—an expensive part of the monument that was left off after the Civil War. The name of the insurance company is prominently emblazed around the base of the monument.

The Continental Congress voted in 1783 to erect an equestrian statue to honor George Washington. When the government did not act, a group of private citizens in 1833 founded the Washington National Monument Society to raise funds to build an important monument to the founder of the country. Chief Justice John Marshall was the society's first president, followed by President James Madison upon Marshall's death. The society opened a competition in 1836 for the design of the monument, proposed to cost $1 million. Architect Robert Mills won the contest with his design of a tall marble obelisk surrounded by a Greek colonnade that would shelter statues of Revolutionary War heroes, with a pair of sculptures showing Washington in a chariot on top of the colonnade.

Congress authorized construction of the monument on the mall, and work began with private funds in 1848, with the monument originally aligning with the White House. Because the ground was marshy, the monument was moved closer to the Capitol to take advantage of a natural hill, where it now stands. Lack of financing caused the construction to stop in 1854. To celebrate the Centennial, Congress voted in 1876 to finish the monument. The Army Corps of Engineers resumed and completed the construction between 1878 and 1884. The monument, minus the colonnade, was dedicated on February 21, 1885, and officially opened to the public in 1888.

The United States Mutual Accident Association, the commissioner of the Currier & Ives print, was a short-lived travel insurance company. Founded in 1877, it closed in bankruptcy in 1895. Headquartered in New York City, the company offered a $10,000 insurance policy with a $50 weekly indemnity for $26 a year to those in preferred occupations. The company produced several other lithographs for advertising purposes, including a view of its office building on Broadway. In another, it educated its policy holders on the correct names for sailing vessels, which are identified by the number and arrangement of sails—sloops, brigs, schooners, brigantines, barkantines, cat rigs, barks, and ships. The profits of the company began to fall rapidly in the early 1890s. In May 1895, the company was placed in receivership, with liabilities $300,000 in excess of assets and having shrunk from over 80,000 policyholders in 1890 to only 30,000 by 1895.

[156]

Colored lithograph, *The National Washington Monument, Erected at the City of Washington, D.C., by the Government and the People of the United States, as a Tribute to the Glorious Memory of General George Washington*, published as an advertisement for the United States Mutual Accident Association by Currier & Ives, New York, 1885. 30 × 22 in. AS 896.

Colored lithograph, *The Washington Monument*, Louis P. Griffith, Baltimore, published by J. H. Bufford's Sons, Boston, 1885. 19 × 14 in. AS 482.

The Washington Monument

The second print was published by J. H. Bufford's Sons in Boston, also in 1885. It shows the monument as completed without the colonnade. This print includes an extensive legend with information of the monument: height 555 feet; cost $1,187,000; thickness of the walls—15 feet at the base and seven inches at the top; 900 steps to the top of the shaft; and the foundation built with 15,000 barrels of Portland cement. Landmarks are also identified in the background: Bureau of Engraving and Printing; Arlington, Lee's Residence; Observatory; Georgetown College; State, War, and Navy Building; White House; and Treasury Department.

In 1885 the Washington Monument was the tallest building in the world, towering over Germany's Cologne Cathedral. Soon, however, the Eiffel Tower in Paris surpassed it when it was finished in 1889, reaching a height of 1,063 feet. The Washington Monument remains today the tallest masonry structure in the world.

Plan for the Improvement of the West Side of Monument Park under the Direction of Colonel Theo. A. Bingham, U.S. Army

The third item relating to the Washington Monument is this 1902 map of its grounds, showing the plan proposed by the Corps of Engineers to improve the landscaping. Trees were to be planted on both sides of 14th Street on the east, on 17th Street on the west, on B Street (now Constitution Avenue) on the north, as well as on the circular drives around the monument. Control of the National Mall was transferred to the Corps of Engineers in 1867. They established a large nursery on eight acres to the south of the Washington Monument (top of map) in 1873. The nursery, which produced trees and plants to beautify the mall, was closed in 1942 when World War II caused a shortage of labor to operate it. The area then became a maintenance yard for the National Park Service and finally was redeveloped as a park in 1962.

The three existing ponds adjacent to the west of the monument were used by the U.S. Fish Commission to breed fish to replenish American lakes and rivers between 1877 and 1906. At the urging of Spencer F. Baird, Assistant Secretary of the Smithsonian Institution, Congress passed a bill establishing the Fish Commission in 1871. Baird and his associates then managed the Fish Commission from the old Washington Armory Building at 7th Street and Independence Avenue S.W. (now the site of the National Air and Space Museum), until it became an independent agency in 1888.

The National Mall was restored to L'Enfant's original 1791 design by President Franklin D. Roosevelt. He used New Deal funds to grade and landscape the mall to its present appearance in the 1930s.

Colored lithograph, *Plan for the Improvement of the West Side of Monument Park under the Direction of Colonel Theo. A. Bingham, U.S. Army*, Andrew B. Graham, Washington, D.C., drawn by Frederick D. Owen and F. F. Gillen, published by the U.S. Army Corps of Engineers, 1902. 39 × 27 in. AS 298.

CORPS OF ENGINEERS
U·S·Army·
Office of Public Buildings and Grounds.
WASHINGTON·D·C·

PLAN
FOR THE
IMPROVEMENT
OF THE WEST SIDE OF
MONUMENT PARK

Under the direction of
Colonel Theo. A. Bingham
·U·S·Army·

Scale in Feet.

1902-3

POTOMAC PARK

WASHINGTON CHANNEL

TIDAL

RESERVOIR

267 283

B STREET

268 282

C STREET

284

263

NURSERY

OFFICE OF PUBLIC BUILDINGS AND GROUNDS

BUREAU OF
ENGRAVING AND
PRINTING

ELECTRIC
DISPLAY
FOUNTAIN

TIDAL

RESERVOIR

BOAT LANDING

POWER HOUSE

M O N U M E N T

P A R K

THE
WASHINGTON
MONUMENT

FISH POND

NOW OCCUPIED BY U.S FISH COMMISSION

POND

FISH POND

RIVER

FOR FUTURE ROADWAY

SEVENTEENTH STREET

ENTRANCE

GROUNDS

WASH. DEPT.

FOURTH STREET

B STREET N.W.

THE PRESIDENT'S PARK

1. DRESS PARADE ON THE ELLIPSE OF THE "WHITE LOT." 2. REPRESENTATION OF THE NAVAL BATTLE BETWEEN THE "MONITOR" AND THE "MERRIMAC." 3. VIEW OF CAMP FROM THE BALCONY OF THE BUREAU OF ENGRAVING AND PRINTING

WASHINGTON, D. C.—THE NATIONAL MILITARY DRILL ON THE PARK SOUTH OF THE WHITE HOUSE

FROM SKETCHES BY C. UPHAM.—SEE PAGE 255.

Colored woodcut, *Washington, D.C.—The National Military Drill on the Park South of the White House Grounds*, in *Frank Leslie's Illustrated Newspaper*, June 4, 1887. 15 × 21 in. AS 385.

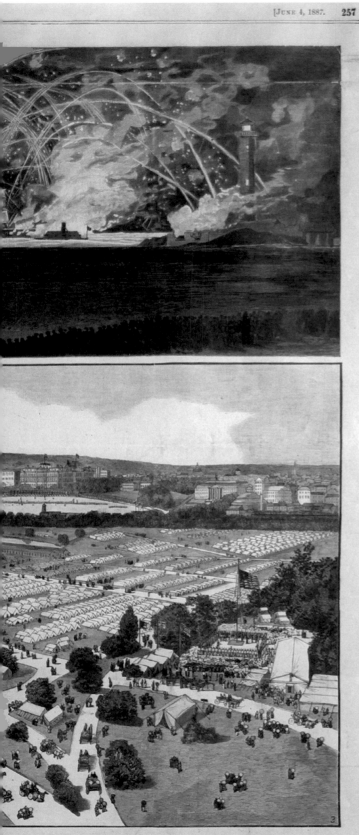

Washington, D.C.—The National Military Drill on the Park South of the White House Grounds

The National Military Drill Competition was held in Washington, D.C., in the last week of May, 1887. This event, a gathering of dozens of infantry, artillery, and cavalry regiments from across the country, encouraged patriotism and national unity. It was especially helpful in healing the emotional wounds of the recent Civil War. The 3,000 men who participated were housed on the mall near the Washington Monument as well as in local hotels. In the print, from the fourth-floor balcony of the adjacent building, clerks from the Bureau of Engraving and Printing observe the arrangement of the soldiers' tents and the movement of the troops.

The competitive drills of the infantry were held on the Ellipse, then called the "White Lot," where a grandstand was erected for spectators. Seats on benches cost 25 cents while seats on the grandstand were 50 cents. The other competitions, of artillery and cavalry, were not appropriate for the Ellipse because of the size and weight of the wheels of the cannons and the large number of horses involved. These competitive drills were held to the north of the city on baseball fields.

The opening ceremony took place on May 23. "The Star Spangled Banner" was played, a prayer was read, and Maj. Gen. Christopher C. Augur paraded the Washington Light Infantry before a large crowd. During the week special competitions were held for the Zouave and cadet regiments. President and Mrs. Grover Cleveland attended the infantry competitions on May 25. Many of the uniforms were spectacular—one Minnesota company wore sober uniforms but with fancy, brass-tipped helmets, and the Wooster City Guards from Ohio had helmets decorated with flowing, white horse tails.

One of the highlights was the evening re-enactment of the March 1862 Battle of Hampton Roads between the two Civil War ironclads—the USS *Monitor* and the CSS *Virginia*. Fireworks, rather than live ammunition, were used to depict this Union victory. This event is portrayed in the upper right of the print.

[163]

Birdseye View of the National Capital Including the Site of the Proposed World's Exposition of 1892 and Permanent Exposition of the Three Americas

This unusual bird's eye view of the National Mall shows the proposed development of its west end, as well as the new West Potomac Park to the right. This area, just west of the Washington Monument, was created in the 1880s and 1890s when the Potomac River was dredged. The four large ponds pictured were to be created with water from the Potomac River. This 1888 image was printed to promote Washington, D.C., as the site for the World's Columbian Exposition of 1892, to honor the 400th anniversary of the discovery of America by Christopher Columbus. Three permanent fair buildings were proposed west of the Washington Monument, while a fourth, larger one would be built as a temporary exhibition hall. Other proposed attractions included a statue of Columbus and a large building on the site for the National Zoo. The zoo was actually established the following year, in 1889, and located next to land that would become Rock Creek Park a year later.

Four other American cities vied for the location of this World's Fair—Philadelphia, New York, Saint Louis, and Chicago. It was awarded to Chicago because that was the only city that could raise the $5 million cost of building the vast array of temporary plaster Beaux Arts buildings. The Chicago World's Fair, as it came to be known, opened one year late, in 1893, and was extremely popular with both the American public and the thousands of European visitors who attended. It advertised to the world the many new inventions and manufactured goods produced in the United States, which helped make it a world power. It also introduced the Neoclassical architectural style to America, resulting in the design and construction of thousands of white marble public buildings across the country during the next 30 years.

Colored lithograph, *Birdseye View of the National Capital Including the Site of the Proposed World's Exposition of 1892 and Permanent Exposition of the Three Americas*, by A. Hoen, published by E. Kurtz Johnson, 1888. 27 × 36 in. AS 286.

Within the image:

RIVER

LAKE

LAKE

LAKE

LAKE

SITE FOR STATUE OF COLUMBUS

SITE FOR NATIONAL ZOOLOGICAL GARDEN

A New Dissected Map of the World
with a Picture Puzzle of the Capitol at Washington

One of the more unusual items in the Small Collection is this 1888 jigsaw picture puzzle of the U.S. Capitol. It includes fashionable visitors in open carriages on the east plaza of the Capitol. A world map with a smaller map of the United States inserted in the lower left corner was included with the jigsaw puzzle. It comes with its original cardboard box with a globe printed on the cover. Jigsaw puzzles showing maps became popular in England in the 1760s to teach geography to the children of upper-class families. Even the children of George III played with them to learn the geography of the vast British Empire.

The man who made puzzles popular in England was John Spilsbury, who is listed in the 1763 London directory as "Engraver and Map Dissector in Wood, in order to facilitate the Teaching of Geography." He made two dozen different map puzzles, then called "dissections," including maps of the world, five continents, and a number of European countries. Spilsbury and his staff engraved and printed the maps, glued them to thin mahogany boards, and cut them with a delicate handheld fret saw. The 18th-century dissected maps were very expensive, selling for 21 shillings when the average workman received only two shillings a day in wages.

By the late 18th century, other puzzle makers in England had expanded the map puzzles into picture puzzles, with the idea of teaching history rather than geography. One group of picture puzzles included all of the major monarchs of England. The scope of puzzles expanded in the 19th century to celebrate special events, including the coronation of Queen Victoria and the 1851 opening of the Crystal Palace Exhibition. Puzzles illustrating nursery rhymes and fairy tales became popular with small children.

The earliest known American puzzle maker was Andrew T. Goodrich of New York, who made puzzle maps of the United States and other nations to teach children geography. In the 1860s, Charles Magnus of New York produced puzzles illustrating Civil War land and sea battles. After the war, the main producers of dissected maps were Milton Bradley of Springfield, Massachusetts, and McLoughlin Bros. of New York, who produced this puzzle. At that time, the McLaughlin family employed 75 artists in their Brooklyn factory to design puzzles and other educational toys. Favorite pictorial topics were steamships, locomotives, and the Brooklyn Bridge.

By 1890 the term "jigsaw puzzle" replaced the earlier terms "map dissection" and "picture puzzle." A jigsaw is another name for a fret saw, the hand-operated saw used to cut puzzles. In the late 19th century the puzzle industry became modern—the puzzles were cut by machines rather than by hand and the prints were glued to cardboard rather than mahogany boards. By 1910, more challenging jigsaw puzzles began to be made specifically for adults for the first time. The new puzzles had many more and smaller pieces. During the 1930s the jigsaw puzzle reached the height of its popularity in the United States, when millions of copies were produced annually as affordable Depression-era entertainment.

Above and opposite (both). Chromolithographs, *A New Dissected Map of the World with a Picture Puzzle of the Capitol at Washington,* McLoughlin Bros., New York, 1888. 18 × 24 in. each. AS 632-C, AS 632-A, and AS 632-B.

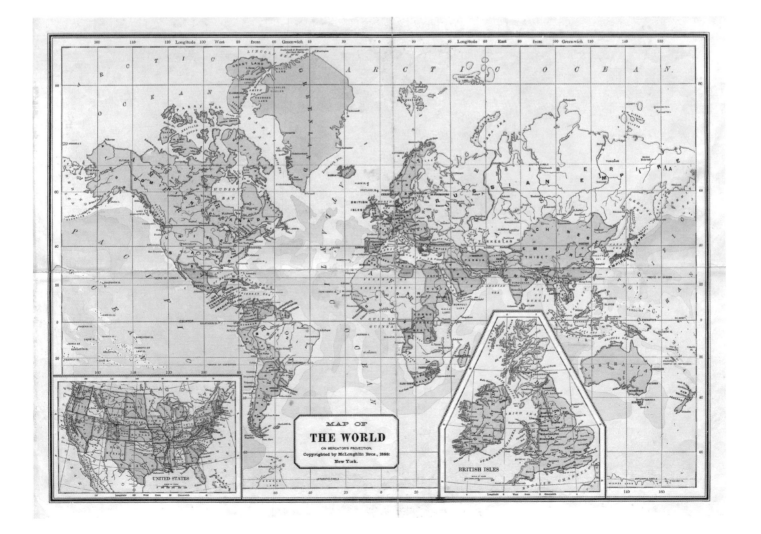

Flood at Pennsylvania Avenue and 6th Street N.W.

This photograph of the northeast corner of Pennsylvania Avenue and 6th Street N.W. shows one of the worst floods in the history of Washington—June 1 and 2, 1889. The month of May that year was unusually wet, with a total of 11.78 inches of rainfall. The worst time was the last two days of May, during which 4.4 inches came down. Because the earth was already saturated, most of this water ran off into the Potomac River.

As a result of the severe rainstorm of May 30–31, much of the eastern edge of Washington flooded with between one and four feet of water. The Potomac River was 18 feet above its normal level when it crested at Washington on June 1. The waters completely covered the east end of the National Mall. The three fish ponds at the foot of the Washington Monument, used by the U.S. Fish Commission to breed carp to replenish American streams and rivers, were inundated, allowing the fish to escape. Thousands of the fish were stranded on the mall when the waters receded. A two-foot carp was found trapped in the ladies' room of the Pennsylvania Railroad Station on 6th Street. The backtracking waters left a "thick, slimy deposit of soft mud" on the Washington and Georgetown wharves and produced a "sickening smell" because of the rotting fish.

The Chesapeake and Ohio Canal suffered so much from the flood waters that it never recovered. During the 1880s the canal was a key part of Georgetown's economy. Coal, lumber, lime, and fertilizer were carried on it between Cumberland, Maryland, and Georgetown. Flour and paper were manufactured in factories along the way, which used the canal to ship their products to and from Georgetown. When the floodwaters overflowed the canal, more than 100 canal boats, on which entire families lived, were either smashed or carried away. In addition to the damage to the canal boats, the tow paths and bridges used by the mules and mule drivers to pull the canal boats were destroyed. Georgetown warehouses and many flour mills were badly damaged. Over 400 workmen lost their jobs. Even though the canal reopened two years later, it was never profitable again.

This same storm also hit Johnstown, Pennsylvania, on May 31. When the South Fork Dam failed there, 2,000 lives were lost. Ironically, Washingtonians raised more relief money for the Johnston victims than for their own Georgetown neighbors.

Photograph, *Flood at Pennsylvania Avenue and 6th Street N.W.*, unknown photographer, 1889. 6.5 × 8 in. AS 418.

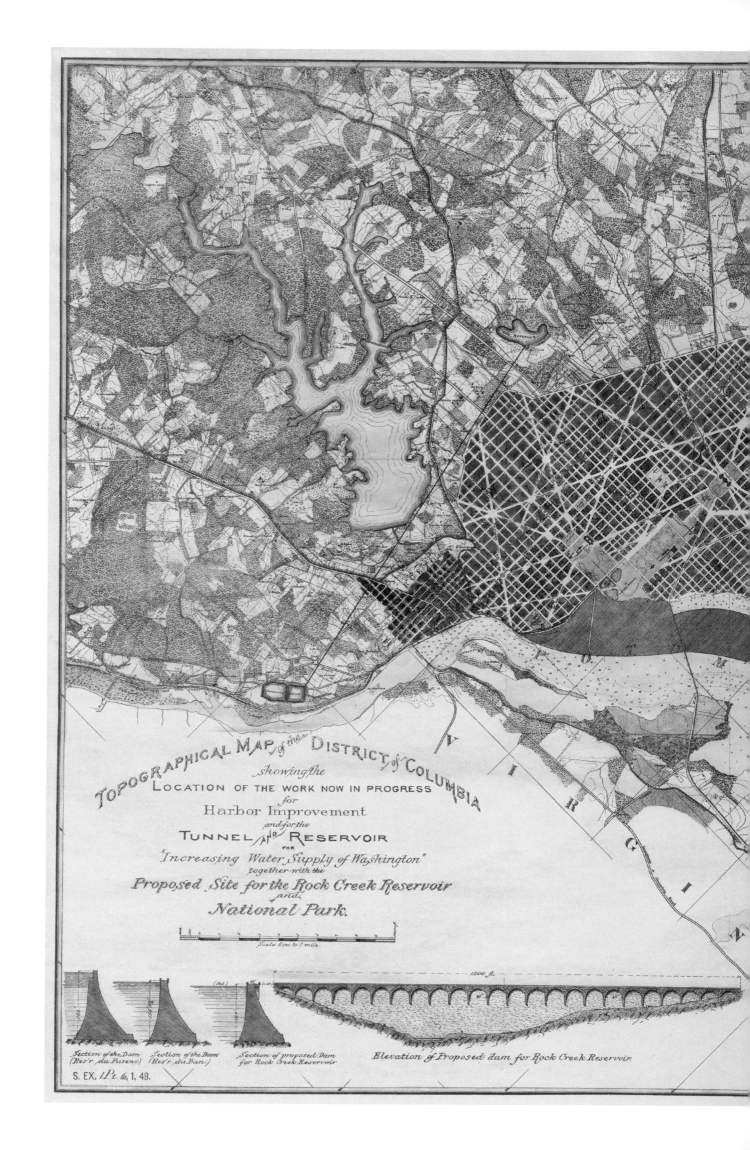

TOPOGRAPHICAL MAP of the DISTRICT of COLUMBIA

showing the

LOCATION OF THE WORK NOW IN PROGRESS

for

Harbor Improvement

and for the

TUNNEL AND RESERVOIR

FOR

"Increasing Water Supply of Washington"

together with the

Proposed Site for the Rock Creek Reservoir

and

National Park.

Scale 8 ins. to 1 mile.

Section of the Dam (Res'r du Furens) Section of the Dam (Res'r du Ban) Section of proposed Dam for Rock Creek Reservoir

Elevation of Proposed dam for Rock Creek Reservoir.

S. EX. 1 Pt. 6, 1, 48.

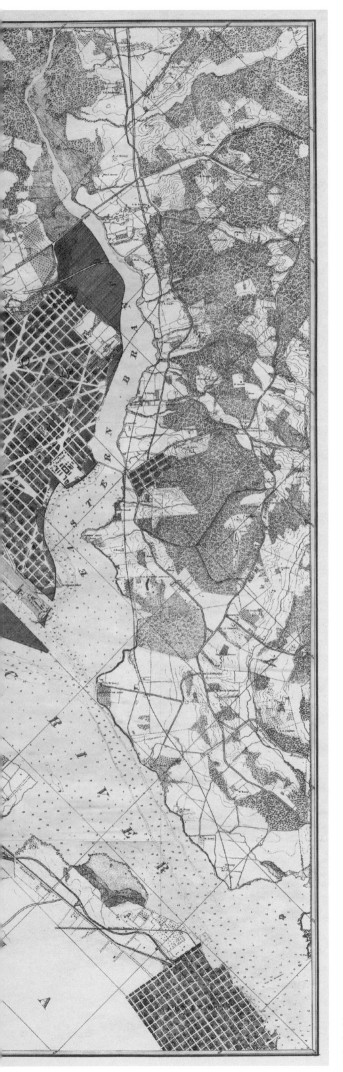

Topographical Map of the District of Columbia, Showing the Location of the Work Now in Progress for Harbor Improvements for the Tunnel and Reservoir

The movement to create large public parks in American cities began in the 1850s with the creation of Central Park in New York City. By the 1880s Brooklyn had Prospect Park, Philadelphia had Fairmont Park, and Baltimore enjoyed Druid Hill Park. The nation's capital was sadly lacking a large rural park even though two earlier attempts had been made to create a park around Rock Creek in 1866 and 1884. The first effort was to create Rock Creek Park and relocate a new presidential mansion there to escape its then unhealthy location next to the Washington City Canal—essentially an open sewer. The second attempt was to dam Rock Creek to create a large lake that would supply the city with water and build a public park around the reservoir. In both efforts, Congress failed to vote the funds to buy the land. This 1884 map shows the area to be covered by the reservoir—mostly in present-day Cleveland Park.

Lithograph, *Topographical Map of the District of Columbia, Showing the Location of the Work Now in Progress for Harbor Improvements for the Tunnel and Reservoir*, Washington, D.C.: U.S. Army Corps of Engineers, 1884. 20 × 20 in. AS 433.

Letter to Charles C. Glover Regarding the Founding of Rock Creek Park

By the 1880s, Charles C. Glover (1846–1936) was a major civic leader in Washington and would later become president of the Riggs Bank. He had supported the efforts to dredge the Potomac River to improve shipping and create Potomac Park, complete the construction of the Washington Monument, establish the National Zoo on Rock Creek land, and begin building the Washington National Cathedral. An avid horseback rider, Glover used the area along

Rock Creek for regular horseback rides with his friends. He determined in 1888 to lobby Congress to save this handsome wilderness and create Rock Creek Park. Glover took members of Congress on tours of the land and talked to them in their offices. Even though his efforts to get a bill passed to create the park in 1889 failed, Glover succeeded in September 1890. Congress authorized $1.2 million to purchase 2,000 acres along the creek, extending from the National Zoo to the Maryland boundary. In this letter of October 1, 1890, Rep. John Hemphill of South Carolina, chairman of the House District Committee, praises Glover for his efforts to preserve the Rock Creek land for future generations to enjoy. He writes that without Glover's sustained efforts, Rock Creek Park would never have been created.

Opposite and above. Autographed letter signed, Rep. John Hemphill (D-SC) to Charles C. Glover, 1890. 10 × 12 in. AS 698.

Glimpses of Glen Echo, the National Chautauqua, on the Lower Potomac River, near Washington, D.C.

In 1889 real estate developers Edwin and Edward Baltzley purchased 516 acres of land on the heights of Montgomery County, Maryland, to build a new suburban development that they called Glen-Echo-on-the-Potomac. They were attracted to its picturesque setting along the Cabin John Run and its proximity to Washington, D.C. The Baltzleys were twins, the sons of a successful industrialist from Ohio. They made a fortune when they invented and manufactured an improved eggbeater through their Keystone Manufacturing Co. in Philadelphia. The brothers hoped to attract wealthy Washingtonians to live in Glen Echo during the summer months, so they established the 53rd Chautauqua Assembly there.

The Chautauqua Movement, of which Glen Echo was a part, was founded in 1874 on the shores of Lake Chautauqua near Jamestown, New York. It was started as a camp to train Protestant Sunday school teachers. It soon evolved into a summer camp for wealthy adults, featuring outstanding lecturers on a multitude of cultural topics as well as band concerts, painting classes, and physical education courses. Having a Chautauqua settlement in the midst of Glen Echo would bring culture to the area and attract a desirable group of permanent residents.

The brothers opened several stone quarries on their property, from which they hoped to supply home builders at Glen Echo. Edward Baltzley built his own residence as a large stone castle to set the example for other residents. To bring more prestige to the town, he offered a free lot and the use of his laborers at no cost for building a house at Glen Echo for Clara Barton of the American Red Cross, if she would move there. Barton accepted and shipped the lumber from one of the temporary hotels she had built for the victims of the 1889 flood in Johnstown, Pennsylvania. She built the interior of her house in the design of a Mississippi riverboat, including an open, two-story enclosed court with balconies, as well as 78 closets to store her Red Cross bandages, blankets, lanterns, and other supplies. She moved there from Washington in 1892, and found the new streetcar line built by the Baltzleys very convenient.

The purchase of lots by former President Grover Cleveland and by President Benjamin Harrison and his cabinet members in 1890 helped to increase the prestige of Glen Echo. Four hundred visitors stayed in August for the six-week summer season, lodging in the 48-room Powtomac Tent Hotel, complete with a dining room, or renting their own tents. Even though the 1891 Chautauqua session was a great success, it was also the last. In August of 1891, Dr. Henry Spencer, a prominent resident of Glen Echo and head of the Chautauqua Business School, died suddenly of pneumonia. When rumor spread quickly that he had died of malaria, the summer visitors and real estate buyers stayed away. The Chautauqua site declined and by 1899 had become an amusement park known as Glen Echo Park, complete with a merry-go-round, bowling alley, band pavilion, and picnic grounds. It became a popular destination in the early 20th century but closed in 1968, to be reopened as an arts education center in the 1970s. The most interesting artifact from the old Chautauqua era is the Clara Barton House, which is maintained as a historic house museum by the National Park Service.

Woodcut, *Glimpses of Glen Echo, the National Chautauqua, on the Lower Potomac River, near Washington,* in *Frank Leslie's Illustrated Newspaper,* New York, July 27, 1891. 15 × 10 in. AS 137.

Residence of Edwin Baltzley.

The secretary's tent.

Conduit road.

Red Cross building.

View from the lot of Mrs. President Harrison.

The Cabin John.

Hall of Philosophy.

The Amphitheatre.

Residence of R. A. Charles.

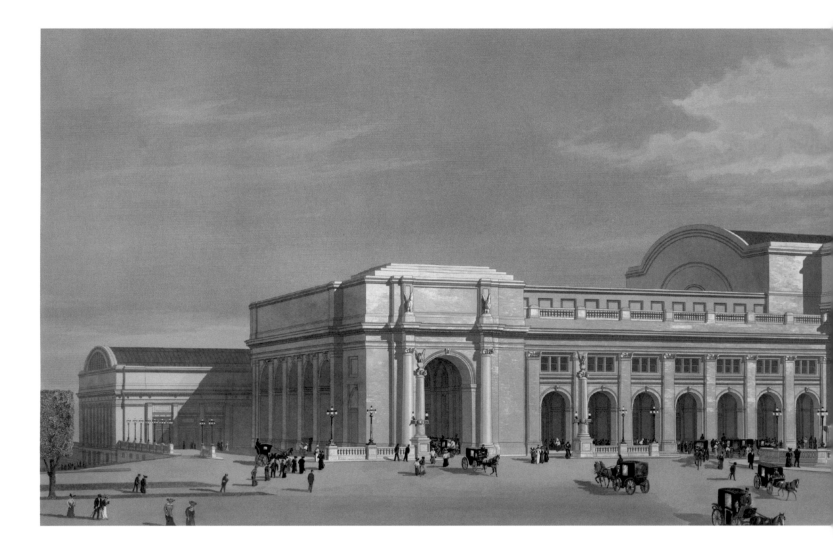

The Pennsylvania Railroad's
Union Station, Washington, D.C.

Washington's Union Station was the largest train station in the United States when it opened in 1907. It was a result of the recommendations of the McMillan Commission of 1901, in which Sen. James McMillan established a committee of prominent architects, landscape artists, and sculptors to study ways to improve the city planning of the nation's capital. They recommended that L'Enfant's original design of an open greensward for the National Mall be restored and that all public buildings be constructed in the Beaux Arts style. They also recommended building a monumental new train station.

At the time, rail travel in Washington was served by two train stations located a half mile apart. The Baltimore and

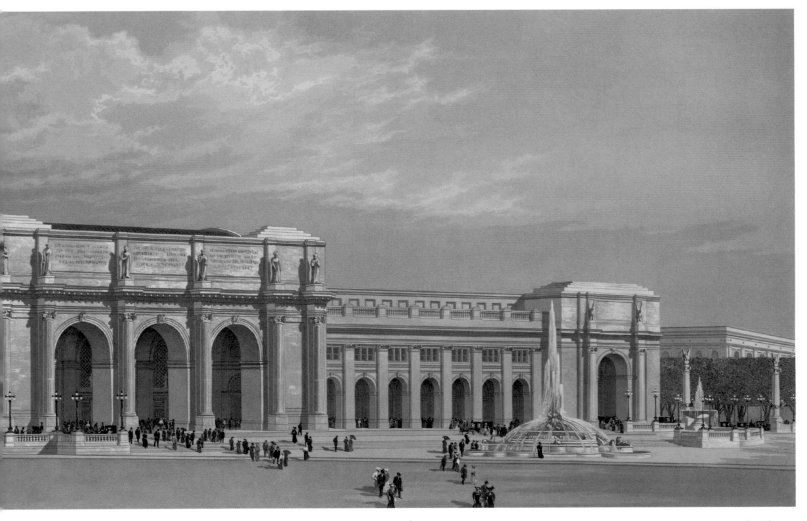

Colored lithograph, *The Pennsylvania Railroad's Union Station, Washington, D.C.*, John A. Lowell Bank Note Co., Boston, 1906. 18 × 48 in. AS 252.

Ohio Station had been built just north of the Capitol on New Jersey Avenue and served passengers traveling north. Southbound passengers used the Baltimore and Potomac Station on the mall at 6th Street and Constitution Avenue. The new station was designed by Daniel H. Burnham in the Beaux Arts style and built between 1903 and 1904, just north of the Capitol on Delaware Avenue. Two tunnels were built under First Street between the Capitol and the Library of Congress to provide consolidated north–south rail connections.

Burnham's design of Union Station was influenced by classical buildings in Rome, including the three massive central arches, which were based on the Arch of Constantine. Thirty-two tracks led into the rear of the station, which covered 200 acres. The front plaza was embellished with a large fountain and statue of Christopher Columbus designed by American sculptor Lorado Taft.

By the 1960s train travel had declined, and Union Station had fallen into disrepair. Congress authorized funds to restore the landmark—this was completed in 1988. Today Union Station is vibrant with renewed rail travel, a metro stop, a bus depot, and a popular shopping mall located in the central part of the station.

Norway's Joyous Coronation Day. How the Hospital-Corps Soldier Is Trained.

No. 2655 JULY 26, 1906 PRICE 10 CENTS

LESLIE'S WEEKLY

[178]

AN AUTOMOBILE LINE-UP AT WASHINGTON.

MOTOR-CARS IN FRONT OF THE IMPOSING CAPITOL STARTING OFF ON A CONTEST OR TOUR—A FREQUENT
INCIDENT AT WASHINGTON.—*Photograph by Clinedinst.*

An Automobile Line-Up at Washington

Frank Leslie, an English engraver born in London, came to New York in 1848 and founded *Frank Leslie's Illustrated Newspaper* in 1855. The newspaper gained prominence by publishing stories and woodcuts of the American Civil War. It became a serious competitor of the popular *Harper's Weekly*, also of New York.

The article accompanying this cover photo stated that New York and New Jersey had more new automobile drivers than any other states. The fees for registering cars in those two states went to improve their highways. The four Winton cars parked in front of the Capitol were similar to other Winton cars that were then involved in the Glidden Cup Race. It started in Buffalo, New York, on July 12, 1906, and was scheduled to finish at Bretton Woods, New Hampshire. The race had few participants because of rainy weather—just a few Winton cars, one Knox, and two Oldsmobiles. The American Automobile Association, founded in 1902, made the rules for most of the races.

The manufacture of gasoline-powered automobiles began in the United States in 1893 when two brothers, Charles and Frank Duryea, invented the first successful American automobile. Shortly thereafter in 1896 they began to manufacture and sell their cars from their small factory in Springfield, Massachusetts. Barnum and Bailey and other circuses used the Duryea auto in almost every circus parade in America between 1896 and 1898. In most cases it was the first time the American public had seen an automobile. Frank Duryea left the company in 1900, but his brother continued to manufacture Duryea cars at a new factory he established in Reading, Pennsylvania, until 1914. The automobiles sold for $1,600.

The Winton Motor Carriage Co., founded in Cleveland, Ohio, by Alexander Winton in 1897, was another early car manufacturer. Priced at $2,000, Winton cars were expensive. Alexander Winton entered his cars in many of the early car races to help publicize them. One of his first races was in 1897 from Cleveland to Elyria, Ohio. Winton usually had his mechanics drive in races because the cars frequently broke down. If Winton himself drove, he always took a mechanic with him. By 1915 Winton's sales began to decline rapidly because many other companies, such as Ford, could outprice him, and he finally closed in 1924.

Photograph, *An Automobile Line-Up at Washington,* in *Leslie's Weekly,* July 26, 1906. 16 × 10 in. AS 405.

Old Washington, D.C., Steamboats of the Potomac River

This recent print by Paul McGehee depicts two steamboats, *Potomac*, built in 1880, and *District of Columbia*, built in 1925, near the latter's pier at 7th and Maine S.W. on a summer evening in 1936. *Potomac*, which belonged to the Potomac River Line, is embarking on its three hour moonlight cruise, a nightly occurrence during the warm months. It also provided Sunday morning transportation for bathers bound for Columbia Beach. The passengers were entertained by music and dancing. The luxury steamer *District of Columbia*, owned by the Norfolk and Washington Steamboat Company, right, is preparing to make its evening departure for Norfolk, arriving 12 hours later.

The Norfolk and Washington Steamboat Company provided service between the two cities with stops in Alexandria and Old Point Comfort for over 60 years. It was

Old Washington, D.C., Steamboats of the Potomac River. Painted and published by Paul McGehee, Alexandria, Virginia, 1998. Size: 20 × 33 inches. AS 462. Reproduced with permission of artist. © Paul McGehee, *www.paulmcgeheeart.com.*

incorporated in 1890 and began service in 1891. Their busiest season was in 1907 when two of their steamers set out daily for Norfolk, departing at 8 A.M. and 6:30 P.M. Their boats on that route, *Jamestown* and *Newport News*, each carried about 400 passengers. Most were attending the Jamestown Exposition, a world's fair organized to celebrate the 300th anniversary of the founding of Virginia in 1607.

After the United States government requisitioned two of the Norfolk and Washington Steamboat Company's boats for use in World War II, only *District of Columbia* remained on the Washington to Norfolk route. In 1948 she collided with a tanker, causing the Baltimore Steam Packet Company to take over both the damaged ship and the corporation in 1949. The construction of modern highways throughout Virginia in the 1950s and the introduction of airline service to Norfolk spelled the end of steamboat service between Washington and Norfolk in 1957. Baltimore ceased steamboat operations to Norfolk five years later, and *District of Columbia* was sold to other interests and renamed *Provincetown*.

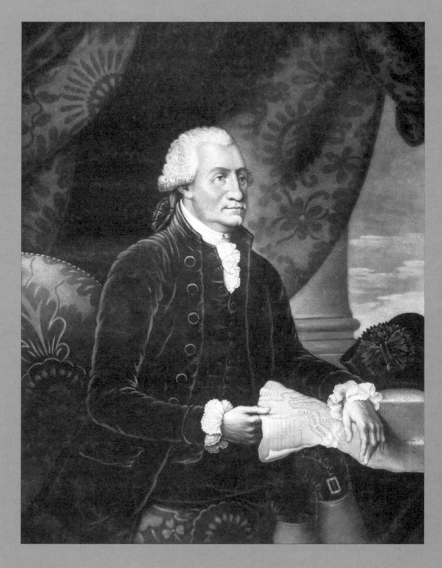

Engraved portrait of George Washington in 1793. See pages 50–51.

Epilogue

George Washington never governed from the Federal City he helped create, but he held strong visions of both the institutions and the landscape that would comprise it. In 1790, John Frederick Augustus Priggs surveyed the 100-square-mile range of land along the Potomac River that was to become the location of that city. Priggs created a hand-drawn map that gives us the first glimpse of where the three branches of government would settle 10 years later to attend to the business of governing our nascent republic. Priggs's map contains only the rivers and major roads running through the area—a *tabula rasa* of a city waiting to come to life. The potential for this new capital's development, and the possibilities for the United States as a nation under the new Constitution, were enormous. This was the central location where the ideals put forth in the Declaration of Independence, Constitution, and Bill of Rights would be challenged and tested. The Priggs map, along with the other rare letters, lithographs, books, and photographs in the Albert H. Small Washingtoniana Collection, provide a wonderful picture of how Washington, D.C., and the U.S. government grew and changed together. Without understanding one, it is difficult to fully understand and appreciate the other: both are central to our shared identity as Americans.

George Washington also had a dream of a national university in the capital, where scholars from all parts of the country could come to learn, question, and grow together. This dream has been realized in the George Washington University. I cannot imagine a better home for the Albert H. Small Collection than on this campus, located in the city whose story it tells. As a nation, we must strive to be conscientious stewards of the past so that we can pass on its lessons to future generations. I know that students, faculty, and researchers will benefit tremendously from studying at the Albert H. Small Center for National Capital Area Studies at the George Washington University. Indeed, Albert Small has enabled us to see and understand how our capital and our University have become part of our heritage.

Sandra Day O'Connor

Sandra Day O'Connor
Associate Justice, Retired
The Supreme Court
of the United States

[183]

Bibliography

PART ONE

The Early Decades
1790–1860

Second Published Map of Maryland, 1671 (pages 14–15)

Dobberteen, Anne. "Maryland's Second Map, 1671." Unpublished essay, Washington, DC, 2013.

Ogilby, John. *Atlas America: Being the Latest, and Most Accurate Description of the New World*. London: John Ogilby, 1671.

Papenfuse, Edward C. *The Maryland State Archives Atlas of Historical Maps of Maryland, 1608–1908*. Baltimore: Johns Hopkins University Press, 1982.

The Priggs "Alligator Map" (pages 16–17)

Bordewich, Fergus M. *Washington, the Making of the American Capital*. New York: HarperCollins, 2008.

Bowling, Kenneth R. *Creating the Federal City, 1774–1800: Potomac Fever*. Washington, DC: American Institute of Architects Press, 1988.

————. *The Creation of Washington, D.C.: The Idea and Location of the American Capital*. Fairfax, VA: George Mason University Press, 1991.

————. "The Other G.W.: George Walker and the Creation of the National Capital." *Washington History* 12, no. 1 (2000).

————. "The Priggs Alligator Map." Unpublished essay, George Washington University, January 2014.

Leak, Maggie. "Map of Future Site of Washington, D.C., 1790." Unpublished essay, Museum Studies Department, the George Washington University, April 2013.

The Evolution of the White House, 1792–1830 (pages 18–27)

Hart, Sidney, and Rachael L. Penman. *1812, A Nation Emerges*. Washington, DC: Smithsonian Institution Press for the National Portrait Gallery, 2012.

Herrick, Carole L. *August 24, 1814, Washington in Flames*. Falls Church, VA: Higher Education Publications, 2005.

Muller, Charles G. *The Darkest Day: 1814, The Washington–Baltimore Campaign*. Philadelphia: J. B. Lippincott, 1963.

Seale, William. *The President's House, a History*. 2 vols. 2nd ed. Washington, DC: White House Historical Association, 2008.

The Evolution of the Capitol, 1792–1865 (pages 28–45)

Allen, William C. *History of the United States Capitol, a Chronicle of Design, Construction, and Politics*. Washington, DC: Government Printing Office, 2001.

Goode, James M. "Architecture, Politics, and Conflict: Thomas Ustick Walter and the Enlargement of the United States Capitol, 1850–1865." Ph.D. dissertation, the George Washington University, 1994.

Gutheim, Frederick. *Worthy of the Nation: The History of Planning for the National Capital*. Washington, DC: Smithsonian Institution Press, 1977.

Scott, Pam. *Temple of Liberty: Building the Capitol for a New Nation*. New York: Oxford University Press, 1993.

Three Items Relating to George Washington's Capitol Hill Rental Houses (pages 46–49)

Bowling, Kenneth R. "George Washington's Vision for the United States." Unpublished essay, Washington, DC, January 2014.

Two Portraits of George Washington (pages 50–53)

Dobberteen, Anne. "He Wore Black Velvet: Savage's Portrait of Washington." Unpublished essay, Washington, DC, December 2013.

————. "Washington and His Family." Unpublished essay, Washington, DC, December 2013.

Martinez, Katherine, Page Talbott, and Elizabeth Johns. *Philadelphia's Cultural Landscape: The Sartain Family Legacy*. Philadelphia: Temple University Press, 2000.

Reaves, Wendy Wick. *George Washington, an American Icon: The Eighteenth-Century Graphic Portraits*. Washington, DC: Smithsonian Institution Traveling Exhibition Service, 1982.

Two Views of Mount Vernon (pages 54–57)

Dalzell, Robert F., Jr., and Lee Baldwin Dalzell. *George Washington's Mount Vernon, at Home in Revolutionary America*. New York: Oxford University Press, 1998.

Greenberg, Allan. *George Washington, Architect*. London: New Architects Group, 1999.

Manca, Joseph. *George Washington's Eye: Landscape, Architecture, and Design at Mount Vernon*. Baltimore: Johns Hopkins University Press, 2012.

Pogue, Dennis J. "Mount Vernon: Transformation of an Eighteenth-Century Plantation System." In *Historical Archaeology of the Chesapeake*, edited by Paul A. Shackel and Barbara J. Little. Washington, DC: Smithsonian Institution Press, 1994.

The Old Brick Capitol (pages 58–59)

Goode, James M. *Capital Losses, a Cultural History of Washington's Destroyed Buildings*. 2nd ed. Washington, DC: Smithsonian Books, 2003.

Peter Force's Office Ledger (pages 60–61)

Angeloni, Gabriella. "Notebook with Business Orders for the Printing Firm of Peter Force, 1826–1832." Unpublished essay, History Department, the George Washington University, 2013.

"Death of Peter Force." *Washington Daily National Intelligencer*, January 24, 1868.

Lee, Henry. *Memoirs of the War in the Southern Department of the United States*. Washington, DC: Peter Force Printing, 1827.

McGirr, Newman F. "The Activities of Peter Force." *Records of the Columbia Historical Society* (1940–41), 42–43.

Spofford, Ainsworth R. *The Life and Labors of Peter Force, Major of Washington*. Washington, DC: Columbia Historical Society, 1898.

Georgetown College / Columbia(n) College (pages 62–63)

"GWU: Up from Hard Times on Credit and Faith." *Washington Sunday Star*, February 7, 1971.

Kayser, Elmer L. *Bricks without Straw*. New York: Appleton-Century-Crofts, 1970.

————. *The George Washington University 1821–1966*. Washington, DC: The George Washington University, 1966.

————. *Luther Rice: Founder of Columbian College*. Washington, DC: The George Washington University, 1966.

————. *Washington's Bequest to a National University*. Washington, DC: The George Washington University, 1965.

Two Items Relating to Stagecoach Lines between Baltimore and Washington (pages 64–67)

Angeloni, Gabriella. "Phoenix Line, 'Safety Coaches.'" Unpublished essay, History Department, the George Washington University, 2013.

Cowan's Auction Catalog. Cleveland, OH, June 2013.

Dobberteen, Anne. "Look Out for Monopoly, the Story of Two Underdog Stagecoach Lines in the Mid-Atlantic." Unpublished essay, Washington, DC, 2013.

Goode, James M., and Laura Burd Schiavo. *Washington Images, Rare Maps and Prints from the Albert H. Small Collection*. Washington, DC: Historical Society of Washington, D.C., 2004.

Griffith, William E., Jr., *150 Years of History along the Richmond, Fredericksburg and Potomac Railroad*. Richmond, VA.: Whittet and Sheppeson, 1984.

Holmes, Oliver W. "Stagecoach Days in the District of Columbia." *Records of the Columbia Historical Society* 50 (1948–50).

————, and Peter T. Rohrbach, *Stagecoach East: Stagecoach Days in the East from the Colonial Period to the Civil War*. Washington, DC: Smithsonian Institution Press, 1983.

Topham, Washington. "First Railroad into Washington and Its Three Depots." *Records of the Columbia Historical Society* 27 (1925).

White, John H., Jr. *Wet Britches and Muddy Boots: A History of Travel in Victorian America*. Indianapolis: Indiana University Press, 2013.

United States' Telegraph. "Classifieds." December 17, 1830.

[184]

Two Items Regarding Slavery (pages 68–71)

Corrigan, Mary Beth. "Imaginary Cruelties: A History of the Slave Trade in Washington, D.C." *Washington History* 13, no. 2 (Fall/Winter 2001–02), 4–27.

Davis, John. "Eastman Johnson's Negro Life at the South and Urban Slavery in Washington, D.C." *Art Bulletin* 80, no. 1 (March 1998), 67–92.

Dillon, Merton L. *The Abolitionists: The Growth of a Dissenting Minority.* DeKalb: Northern Illinois University Press, 1974.

Dobberteen, Anne. "Reward: Eliza Coursy." Unpublished essay, Washington, DC, November 2013.

Green, Constance McLaughlin. *The Secret City: A History of Race Relations in the Nation's Capital.* Princeton: Princeton University Press, 1967.

Harrold, Stanley. *Subversives: Anti-Slavery Community in Washington, D.C., 1828–1861.* Baton Rouge: Louisiana State University Press, 2003.

Mitchell, Thomas G. *Antislavery Politics in Antebellum and Civil War America.* Westport, CT: Praeger, 2007.

Russell, Hillary. "Underground Railroad Activists in Washington, D.C." *Washington History* 13, no. 2 (Fall/Winter, 2001–02).

Winkle, Kenneth J. *Lincoln's Citadel: The Civil War in Washington, D.C.* New York: Norton, 2013.

Zemen, Jarrett. "Slave Market in America Broadside, 1836." Unpublished essay, History Department, the George Washington University, December 2013.

National Hotel Bill (pages 72–73)

DeFerrai, John. *Lost Washington, D.C.* Charleston, SC: History Press, 2011.

Dickens, Charles. *American Notes.* London: Collin's Clear Type Press, 1906.

Goode, James M. *Capital Losses: A Cultural History of Washington's Destroyed Buildings.* 2nd ed. Washington, DC: Smithsonian Books, 2003.

————, and Laura Burd Schiavo. *Washington Images: Rare Maps and Prints from the Albert H. Small Collection.* Washington, DC: Historical Society of Washington, D.C., 2004.

Lee, Richard M. *Mr. Lincoln's City: An Illustrated Guide to the Civil War Sites of Washington.* McLean, VA: EPM Publications, 1981.

Morley, Jefferson. *Snow-Storm in August: Washington City, Francis Scott Key and the Forgotten Race Riot of 1835.* New York: Doubleday, 2012.

Swanson, James. *Manhunt: The 12-Day Chase for Lincoln's Killer.* New York: HarperCollins, 2006.

Zeman, Jarrett. "Bill from the National Hotel, 1837." Unpublished essay, History Department, the George Washington University, 2013.

Two Items Relating to Saint Elizabeths Hospital (pages 74–77)

Zane, Robert. "St. Elizabeths Hospital." Unpublished essay, History Department, the George Washington University, 2013.

Two Smithsonian Images (pages 78–79)

Birnbaum, Charles A., and Robin Karson. *Pioneers of American Landscape Design.* New York: McGraw-Hill, 2000.

Longstreth, Richard, ed. *The Mall in Washington, 1791–1991.* Washington, D.C.: National Gallery of Art, 1991.

Olszewski, George J. *Lafayette Park.* Washington, D.C.: National Park Service, 1964.

Penczer, Peter R. *The Washington National Mall.* Arlington, Virginia: Oneonta Press, 2007.

Stamm, Richard E. *The Castle, an Illustrated History of the Smithsonian Building.* Washington, DC: Smithsonian Books, 2012.

Washington—View from the Balustrade of the Capitol (page 80)

Goode, James M. *Washington Sculpture, a Cultural History of Outdoor Sculpture in the Nation's Capital.* 2nd ed. Baltimore: Johns Hopkins University Press, 2008.

To the Officers and Members of the President's Mounted Guard (page 81)

Kaiser, Andrew. "The President's Mounted Guard." Unpublished essay, History Department, the George Washington University, 2013.

Katcher, Philip, and Ron Volstad. *American Civil War Armies: Volunteer Militia.* Vol. 5. London: Osprey Publishing, 1989.

Lockwood, Charles, and John Lockwood. *The Siege of Washington.* New York: Oxford University Press, 2011.

Steamships—Mount Vernon and Monticello (page 82)

"AY—Purchase of Merchant Vessels, Bill of Sales, etc." Record Group 45, Office of Naval Records and Library, box 127, folder M (2 of 2), National Archives.

"Our Steam Coasting Trade." *New York Times,* August 12, 1865.

"Petition of the New York and Virginia Steamship Company, with Accompanying Documents." New York: M. B. Brown and Camp, Law Printers, 1866. Library of Congress Online Archives.

Potter, E. B. *Sea Power.* Annapolis, MD: U.S. Naval Institute Press, 1981.

"Record of Vessels Bought from or Sold to the Federal Government, Seized in Wars or Forfeit for Breach of Laws, 1815–1923." Record Group 41, 1 vol., National Archives.

Zane, Robert. "SS *Mount Vernon* and SS *Monticello.*" Unpublished essay, History Department, the George Washington University, 2013.

Mills's Proposed Equestrian Statue of General Andrew Jackson, Dedicated to the American Army and the People of the United States (page 83)

Goode, James M. *The Outdoor Sculpture of Washington, D.C.* Washington, DC: Smithsonian Institution Press, 1974.

PART TWO

The Civil War Years

1861–1865

Sketch of the Seat of War in Alexandria & Fairfax Co. (pages 88–89)

Cooling, Benjamin Franklin, III. *Mr. Lincoln's Forts.* Toronto: Scarecrow Press, 2010.

Corbett Family Files. Folder 2 of 2, Virginia History Room, Arlington Central Library.

Dobberteen, Anne. "Northern Virginia in Limbo, Virgil P. Corbett's Early Sketch of the Seat of War." Unpublished essay, Washington, DC, 2013.

Rose, C. B., Jr. "Civil War Forts in Arlington." *Arlington Historical Magazine* 1, no. 40 (1960).

Ross, C. B. *Arlington County, Virginia: A History.* Baltimore: Arlington Historical Society, 1976.

Simpson, Brooks D., Stephen W. Sears, and Aaron Sheehan-Dean. *The First Year Told by Those Who Lived It.* New York: Literary Classics of the United States, 2011.

Stephenson, Richard, and Marianne McKee, eds. *Virginia in Maps.* Richmond: Library of Virginia, 2000.

Templeman, Eleanor Lee. *Arlington Heritage; Vignettes of a Virginia County.* Published privately by the author, 1959.

————. "From Dream to Nightmare." Arlington Heritage 25, *Northern Virginia Sun,* August 23, 1957.

"The War of the Rebellion," *A Compilation of the Official Records of the Union and Confederate Armies.* Series 1, vol. 2, report dated May 28, 1861, p. 38. Washington, DC: Government Printing Office, 1880.

Witt, Jane Chapman. *Elephants and Quaker Guns.* Saint Petersburg, FL: Vandamere Press, 1984.

Landing of Ellsworth's Zouaves at Alexandria, Va. on the Morning of May 24, 1861 (pages 90–91)

Kundahl, George G. *Alexandria Goes to War, beyond Robert E. Lee.* Knoxville: University of Tennessee Press, 2004.

Seale, William. *A Guide to Historic Alexandria.* 2nd ed. Alexandria, VA: Office of Historic Alexandria, 2000.

The Great Bakery for the United States Army at the Capitol, Washington, D.C. (pages 92–93)

Allen, William C. *History of the United States Capitol, a Chronicle of Design, Construction, and Politics.* Washington, DC: Government Printing Office, 2001.

Cooling, Benjamin Franklin, III. *Symbol, Sword and Shield, Defending Washington during the Civil War.* 2nd ed. Shippensburg, PA: White Mane Publishing, 1991.

Prince Napoleon Visiting President Lincoln, 1861 (pages 94–95)

Brown, Joshua. *Beyond the Lines: Pictorial Reporting, Everyday Life, and the Crises of Gilded Age America.* Berkeley: University of California Press, 2002.

"Prince Napoleon," *Frank Leslie's Illustrated Newspaper,* August 17, 1861.

Grimsley, Elizabeth T. "Six Months in the White House." *Journal of the Illinois State Historical Society* 19, no. 3 (1926–27), 43–73.

Leak, Maggie. "Prince Napoleon's White House Reception." Unpublished essay, Museum Studies Department, the George Washington University, April 2013.

Miers, Earl S., ed. *Lincoln Day by Day: A Chronology 1809–1865.* Washington, DC: Lincoln Sesquicentennial Commission, 1960.

Pisani, Camille Ferri. *Prince Napoleon in America, 1861: Letters from His Aide-de-Camp.* Bloomington: Indiana University Press, 1959.

Turner, Justin G., and Linda Levitt Turner. *Mary Todd Lincoln: Her Life and Letters.* New York: Random House, 1972.

Enlist Now and Get Your $100 Bounty! (pages 96–97)

Carpenter, Francis B. *Six Months at the White House.* New York: 1866.

Smith, Thomas West. *The Story of a Regiment: Scott's 900 Eleventh New York Cavalry.* New York: Veterans of the 11th New York Cavalry, 1897.

Civil War U.S. Camp Flag (pages 98–99)

Dobberteen, Anne. "Camp Flag." Unpublished essay, Washington, DC, December 2013.

Madas, Howard Michael, and Whitney Smith. *The American Flag: Two Centuries of Concord and Conflict.* Santa Cruz, CA: VZ Publications, 2006.

Topographical Map of the Original District of Columbia and Environs Showing the Fortifications around the City of Washington (pages 100–101)

Goode, James M., and Laura Burd Schiavo. *Washington Images: Rare Maps and Prints from the Albert H. Small Collection.* Washington, DC: Historical Society of Washington, D.C., 2004.

Quinn's Auction Company Catalog. Falls Church, VA: November 2013.

Engines Stored in Washington, D.C. (pages 102–3)

Campbell, E. G. "The United States Military Railroads, 1862–1865: War Time Operation and Maintenance." *Journal of the American Military History Foundation* 2, no. 2 (Summer 1938).

Clark, John E., Jr. *Railroads in the Civil War.* Baton Rouge: Louisiana State University Press, 2001.

"Map of the U.S. Military Railroads Operated between 1861 and 1866." Record Group 92, stack area BW2A, row 3, compartment 6- E-1529, National Archives.

Turner, George Edgar. *Victory Rode the Rails.* Westport, CT: Greenwood Press, 1953.

"Washington to Alexandria Railroad, May 1865." Record Group 77, Civil War map file, National Archives.

Zane, Robert. "Trains near the National Mall, Circa 1861." Unpublished essay, History Department, the George Washington University, 2013.

Two Items Relating to the Second Battle of Bull Run (pages 104–7)

Eicher, David J. *The Longest Night.* New York: Simon and Schuster, 2001.

Kaiser, Andrew. "Robert Knox Sneeden Witnesses the Destruction of Manassas Junction, August 1862." Unpublished essay, History Department, the George Washington University, 2013.

Sneeden, Robert Knox. *Diary, 1862.* Vol. 3, part 3, call number Mss 5:1 Sn237:1, Virginia Historical Society, Richmond, VA.

————. *Eye of the Storm.* Edited by Charles F. Bryan Jr. and Nelson D. Lankford. New York: Simon and Schuster, 2000.

Johnson's Pennsylvania, Virginia, Delaware, and Maryland (pages 108–9)

Colton, J. H, and A. J. Johnson. *Johnson's New Illustrated Family Atlas, with Descriptions, Geographical, Statistical, and Historical.* New York: Johnson and Ward: 1862.

Dobberteen, Anne. "Johnson's Pennsylvania, Virginia, Delaware, and Maryland Map." Unpublished essay, Washington, DC, November 2013.

Fones-Wolf, Ken. "Traitors of Wheeling: Secessionism in the Appalachian Unionist City." *Journal of Appalachian Studies* 13, no. 1/2 (Spring/Fall 2007), 75–95.

Lawler, Andrew. "Fort Monroe's Lasting Place in History." *Smithsonian Magazine,* July 2012.

Bird's Eye View of Alexandria, Va. (pages 110–11)

Kundahl, George G. *Alexandria Goes to War.* Knoxville: University of Tennessee Press, 2004.

Seale, William, *A Guide to Historic Alexandria.* 2nd ed. Alexandria, VA: Office of Historic Alexandria, 2000.

Views of the Great Aqueduct, Washington, District of Columbia (pages 112–13)

Goode, James M. *Capital Losses, a Cultural History of Washington's Destroyed Buildings.* 2nd ed. Washington, DC: Smithsonian Books, 2003.

Wallover, Christy. "Views of the Great Aqueduct, Washington, District of Columbia." Unpublished essay, Museum Studies Department, the George Washington University, December 2013, 1–5.

Douglas & Stanton Hospitals, Washington, D.C. (pages 114–15)

Cobb, Josephine. "Decorated Envelopes in the Civil War." *Records of the Columbia Historical Society,* 1963–65, 230–239.

"Douglas as a Union Man." *Harper's Weekly* 4, no. 9 (1864).

Goode, James M. *Capital Losses, a Cultural History of Washington's Destroyed Buildings.* 2nd ed. Washington, DC: Smithsonian Books, 2003.

McMurty, R. Gerald. "Lincoln Patriots." *Journal of the Illinois State Historical Society* 52, no. 1 (1959).

Walsh, Kristine. "Douglas and Stanton Hospitals, Washington, D.C." Unpublished essay, History Department, the George Washington University, DC, 2013.

Whitman, Walt. "Army Hospitals and Cases, Memoranda at the Time, 1863–66," *The Century: A Popular Quarterly* 36, no. 6 (1888).

Soldiers Rest, Washington, D.C. (pages 115–16)

Kaiser, Andrew. "The Establishment of the Soldiers Rest, Washington, D.C." Unpublished essay, History Department, the George Washington University, 2013.

Records Relating to the Arrival and Departure of Men at the Soldiers Rest. Record Group 393, Records of the U.S. Army Continental Commands 1817–1947, part 4, entry 2165, vol. 343, National Archives.

Bird's Eye View of the City of Annapolis, Md. (pages 118–19)

Brown, Joshua. *Beyond the Line: Pictorial Reporting, Everyday Life, and the Crises of Gilded Age America.* Berkeley: University of California Press, 2002.

Carey, Thomas. "The American Lithograph from Its Inception to 1865: With Biographical Considerations of Twenty Lithographers and a Check List of Their Works." Ph.D. dissertation, Ohio State University, 1954.

Leak, Maggie. "Bird's Eye View of Annapolis." Unpublished essay, Museum Studies Department, the George Washington University, 2013.

Norton, Bettina A. *Edwin Whitefield: Nineteenth-Century North American Scenery.* New York: Crown Publishers, 1977.

Reps, John W. *Bird's Eye Views: Historic Lithographs of North American Cities.* New York: Princeton Architectural Press, 1998.

————. *Cities on Stone: Nineteenth century Lithograph Images of the Urban West.* Austin: Amon Carter Museum of Western Art, 1976.

————. *Views and Viewmakers of Urban America: Lithographs of Towns and Cities in the United States and Canada.* Columbia: University of Missouri Press, 1984.

————. *Tidewater Towns: City Planning in Colonial Virginia and Maryland.* Williamsburg, VA: Colonial Williamsburg Foundation, 1972.

Point Lookout, Md.: View of Hammond Genl. Hospital & U.S. Genl. Depot for Prisoners of War (pages 120–21)

Allen, Bob. "Point Lookout's Prison Pen." *American Civil War* 16 (March 2003), 38–44, 72.

Woods, Connor. "Point Lookout." Unpublished essay, History Department, the George Washington University, 2013.

Artillerymen at Fort Stevens (pages 122–23)

Cooling, Benjamin Franklin, III. *Symbol, Sword, and Shield, Defending Washington during the Civil War.* Shippenburg, PA: White Mane Publishing, 1991.

————, and Walton H. Owen II. *Mr. Lincoln's Forts, a Guide to the Civil War Defense of Washington.* Lanham, MD: Scarecrow Press, 2010.

Civilian Pass No. 5154, Headquarters Department of Washington, Washington, D.C., Jany. 17th 1865 (page 124)

Zeman, Jarrett. "Civilian Pass, 1865." Unpublished essay, History Department, the George Washington University, 2013.

Camp Fry, Washington, D.C. (page 125)

"Records of the Adjutant General's Office." *Book Records of Union Volunteer Organization, 10th Veteran Reserve Corps Regimental Letter Book.* E112–115 Pl-17, vol. 4 of 10, National Archives.

Buckley, John Wells. "The War Hospitals." In *Washington during War Time: A Series of Papers Showing the Military, Political, and Social Phases during 1861–1865.* Edited by Marcus Benjamin. Washington, DC: National Tribune, 1902.

Consolidated correspondence file, 1794–1915. *Records of the Office of the Quartermaster General.* Record Group 92, box 640, entry 225, National Archives.

Dobberteen, Anne. "Camp Fry." Unpublished essay, Washington, DC, 2013.

Field Records of Hospitals, Post Hospital Camp Fry D.C., Register of the Stock and Wounded at Camp Fry and Martindale Hospital / Barracks. Record Group 94, vols. 580–585, National Archives.

Leech, Margaret. *Reveille in Washington, 1860–1865.* New York: New York Review, 1941.

Leepson, Marc. *Desperate Engagement.* New York: St. Martin's Press, 2007.

Letter, November 18, 1863. *Records of the Adjutant General's Office, Book Records of Union Volunteer Organizations, 9th VRC, Regimental Letter and Endorsement Book.* Record Group 94, E112–115 Pl-17, vol. 4 of 11, National Archives.

Sherwood, Suzanne Berry. *A Study in the Uses of an Urban Neighborhood.* Washington, DC: The George Washington University, 1975.

"Washington and Georgetown, D.C." *Indexes to Field Records of Hospitals, 1821–1912.* Record Group 94, National Archives.

Four Items Related to Abraham Lincoln (pages 126–33)

Chamlee, Roy Z., Jr. *Lincoln's Assassins: A Complete Account of Their Capture, Trial, and Punishment.* Jefferson, MO: McFarland, 1990.

Dobberteen, Anne. "The Gettysburg Address Print." Unpublished essay, Washington, DC, January 2014, 1–8.

————. "The Gettysburg Portrait and the Story of the Whiskers." Unpublished essay, Washington, DC, January 2014, 1–7.

————. "Now He Belongs to the Ages: Lincoln's Final Moments." Unpublished essay, Washington, DC, January 2014, 1–5.

Furguson, Ernest B. *Freedom Rising, Washington in the Civil War.* New York: Knopf, 2004.

Goodwin, Doris Kearns. *Team of Rivals: The Political Genius of Abraham Lincoln.* New York: Simon and Schuster, 2005.

Hamilton, Charles, and Lloyd Ostendorf. *Lincoln in Photographs: An Album of Every Known Pose.* Norman: University of Oklahoma Press, 1963.

Katz, D. Mark. *Witness to an Era: The Life and Photographs of Alexander Gardner.* New York: Viking Penguin, 1991.

Leonard, Elizabeth D. *Lincoln's Avengers: Justice, Revenge, and Reunion after the Civil War.* New York: Norton, 2004.

Shaffer, Samantha. "The Lincoln Assassination Broadside." Unpublished essay, History Department, the George Washington University, December 2013, 1–6.

Wills, Gary. *Lincoln and Gettysburg: The Words That Remade America.* New York: Simon and Schuster, 1991.

PART THREE

The Emergence of a Modern City
1866–1960

National Farm School (pages 138–39)

Goode, James M., and Laura Burd Schiavo. *Washington Images, Rare Prints and Maps from the Albert H. Small Collection.* Washington, DC: Historical Society of Washington, D.C., 2004.

Washington, D.C. (pages 140–41)

Dobberteen, Anne. "A Sketch of the Executive Department Buildings." Unpublished essay, Washington, DC, 2013.

Goode, James M. *Capital Losses: A Cultural History of Washington's Destroyed Buildings.* 2nd ed. Washington, DC: Smithsonian Books, 2003.

Leech, Margaret. *Reveille in Washington 1860–1865.* New York: New York Review, 1941.

Scott, Pamela. *Capital Engineers: The U.S. Army Corps of Engineers in the Development of Washington, D.C., 1790–2004.* Alexandria, VA: U.S. Army Corps of Engineers, Office of History Hq., 2005.

————. *Fortress of Finance: The United States Treasury Building.* Washington, DC: Treasury Historical Association, 2010.

————, and Antoinette J. Lee. *Buildings of the District of Columbia.* New York: Oxford University Press, 1993.

The Congressional Library, Capitol, Washington (pages 142–43)

Allen, William C. *History of the United States Capitol, a Chronicle of Design, Construction, and Politics.* Washington, DC: Government Printing Office for the Architect of the Capitol, 2001.

Two Items Relating to Mount Vernon (pages 144–47)

Casper, Scott E. *Sarah Johnson's Mount Vernon: The Forgotten History of an American Shrine.* New York: Hill and Wang, 2008.

Johnson, J. B. *Visitor's Guide to Mount Vernon.* Washington, DC: Gibson Bros., 1876.

McGrath, Nick. "Visitors to Mount Vernon." Unpublished essay, History Department, the George Washington University, 2013.

Reports of the Mount Vernon Ladies' Association of the Union, 1858–1895. Baltimore: Press of The Friedenwald Co., 1896.

Unveiling the Statue of General Thomas, at Washington (pages 148–49)

Goode, James M. *Washington Sculpture, a Cultural History of Outdoor Sculpture in the Nation's Capital.* 2nd ed. Baltimore: Johns Hopkins University Press, 2008.

McGrath, Nick. "The Statue of General George H. Thomas." Unpublished essay, History Department, the George Washington University, December 2013, 1–5.

"The Statue of General Thomas." *Harper's Weekly,* December 6, 1879.

"Virginia's Loyal Son: The Statue in Memory of Gen. George H. Thomas." *Boston Daily Advertiser,* November 20, 1879.

Washington, D.C.—The Meteorological Work of the United States Signal Service (pages 150–51)

Dobberteen, Anne. "The Weather and U.S. Signal Service." Unpublished essay, Washington, DC, February 2014.

"Our Weather Bureau." *Washington Post,* October 10, 1879.

Raines, Rebecca Robbins. *Getting the Message Through: A Branch History of the U.S. Army Signal Corps.* Washington, DC: Army Historical Series, 1996.

Washington, D.C.—The Presidential Party
Passing through the Grand Arch (pages 152–53)

Albanese, Joseph. "The Spectacular Welcoming of James Garfield." Unpublished essay, History Department, the George Washington University, December 2013, 1–6.

"The Decorations: Pennsylvania Avenue Brilliant with Colors—the State Arches." *Washington Post*, March 5, 1881.

"President Garfield's Inaugural." *Leslie's Weekly*, March 19, 1881, 38–39.

The New Gallery of Art, Washington, D.C.,
Renwick & Auchmutz, Architects (pages 154–55)

Dobberteen, Anne. "Dedicated to Art: The Renwick Gallery." Unpublished essay, Washington, DC, March 2014.

Goode, James M. "The Renwick Gallery of the Smithsonian Institution." Unpublished essay for the Historic American Buildings Survey, March 1971.

Nolin, Jillian. "Norfolk Statues Shine Again after Restoration." *Virginia Pilot*, Norfolk, VA, December 30, 2013.

Three Items Relating to the Washington Monument (pages 156–61)

Ching, Christopher. "The United States Mutual Accident Association and the Washington Monument Print." Unpublished essay, History Department, the George Washington University, December 2013.

Gutheim, Frederick. *The Federal City: Plans & Realities*. Washington, DC: Smithsonian Institution Press, 1976.

Harvey, Frederick L. *History of the Washington National Monument and the Washington National Monument Society*. Washington, DC: Government Printing Office, 1903.

"Its Business Fell Off: Receiver for United States Mutual Accident Association." *New York Times*, May 16, 1895.

"Large Accident Benefits: The United States Mutual's Showing for the Year's Business." *New York Times*, February 24, 1887.

Penczer, Peter. *The Washington National Mall*. Arlington, VA: Oneonta Press, 2007.

Shaffer, Samantha. "The Washington Monument on the National Mall." Unpublished essay, History Department, the George Washington University, December 2013, 1–5.

Washington, D.C.—The National Military Drill on the Park South of the White House Grounds (pages 162–63)

"Drilling in the Rain: The National Competition at Washington Ended." *New York Times*, May 29, 1887.

"The National Drill at Camp Washington." *Frank Leslie's Illustrated Newspaper*, June 4, 1887.

Walsh, Kristine. "The National Military Drill." Unpublished essay, History Department, the George Washington University, 2013.

Birdseye View of the National Capital Including the Site of the Proposed World's Exposition of 1892 and Permanent Exposition of the Three Americas (pages 164–65)

Bolotin, Norm, and Christing Laing. *The World's Columbian Exposition: The Chicago World's Fair of 1893*. Champaign: University of Illinois Press, 1992.

Kelly, John. "World's Fair in D.C.?" *Washington Post*, September 7, 2011.

A New Dissected Map of the World with a Picture Puzzle of the Capitol at Washington (pages 166–67)

Danesi, Marcel. *The Meaning of Puzzles in Human Life*. Bloomington: Indiana University Press, 2002.

Dobberteen, Anne. "The Story of the Jigsaw Puzzle." Unpublished essay, Washington, DC, January 2014, 1–6.

Williams, Anne D. *The Jigsaw Puzzle: Piecing Together a History*. New York: Berkley Books, 2004.

Flood at Pennsylvania Avenue and 6th Street N.W. (pages 168–69)

Ambrose, Kevin, Dan Henry, and Andy Weiss. *Washington Weather: The Weather Sourcebook for the D.C. Area*. Fairfax, VA: Historical Enterprises, 2002.

"Distress at Our Doors: One Hundred Families Made Destitute." *Washington Post*, June 8, 1889.

Dobberteen, Anne. "Flood on Pennsylvania Avenue." Unpublished essay, Washington, DC, 2013.

"In the Heart of the City: The Market House an Island, and the Pennsylvania Depot Flooded." *Washington Post*, June 2, 1889.

Johnson, Willis Fletcher. *The History of the Johnstown Flood*. Philadelphia: Edgewood, 1889.

"The Trains and the Mails: Order Is at Last Coming out of the Chaos of the Flood." *Washington Post*, June 4, 1889.

Two Items Relating to the Creation of Rock Creek Park (pages 170–73)

Dobberteen, Anne. *Charles Carroll Glover and the Creation of Rock Creek Park*. Unpublished essay, Washington, DC, November 2013.

Sturtevant, Lee. *A Short Biography of Charles Carroll Glover (1846–1936)*. Collection of the Historical Society of Washington, D.C. Washington, DC: printed privately, 2002.

"Won for the People: How Rock Creek Park Was Gained for the City." *Washington Evening Star*, October 4, 1890.

Glimpses of Glen Echo, the National Chautauqua, on the Lower Potomac River, near Washington, D.C. (pages 174–75)

Cohen, Roger S., Jr. "The Glen Echo–Cabin John Area of Montgomery County, Maryland." *Montgomery County Story*, August 1964.

Dobberteen, Anne. "Glen Echo Chautauqua." Unpublished essay, Washington, DC, January 2014.

Merrick, Dorothy. "Great Educational Center Was Glen Echo—Once." *Washington Post*, May 7, 1944.

Mujica, Barbara. "Glen Echo National Park: You Name It, They've Got It." *Montgomery County Journal*, June 29, 1979.

The Pennsylvania Railroad's Union Station, Washington, D.C. (pages 176–77)

Cooper, Rachel. *Images of Rail: Union Station in Washington, D.C.* Charleston, SC: Arcadia, 2011.

An Automobile Line-Up at Washington (pages 178–79)

Albanese, Joseph. "The Treacherous Glidden Cup Race of 1906." Unpublished essay, History Department, the George Washington University, December 2013.

Laux, James. "Alexander Winton." *Encyclopedia of American Business History and Biography*. New York: Facts on File, 1990, 468–72.

Old Washington, D.C., Steamboats of the Potomac River (pages 180–81)

Consolidated Merchant Vessel Documentation, 1936–1976, *Records of the US Coast Guard*. Record Group 26, A1 Box 13, Folder 105908, National Archives.

Consolidated Merchant Vessel Documentation, 1936–1976, *Records of the US Coast Guard*. Record Group 26, A1 Box 182, Folder 224391, National Archives.

Crew, Harvey W. *Centennial History of the City of Washington, D. C.* Dayton, Ohio: United Brethren Publishing House, 1892.

Henderson, Alexander. "Honeymooners Mourn Suspension of Boat Line." *The Washington Post and Times Herald*, Dec 22, 1957.

"Potomac Cruises Attract Throngs." *The Washington Post*, July 10, 1938.

Prince, Richard E. *Seaboard Air Line Railway: Steam Boats, Locomotives, and History*. Bloomington, Indiana: Indiana University Press, 1969.

"S.S. Potomac Is Off on a Beach Cruise at 9 A.M." *The Washington Post*, July 17, 1938.

"A Steam Packet Ending Its Runs: Baltimore's 'Old Bay Line' Closes Chesapeake Service." Special to *The New York Times*, April 8, 1962.

Index

A NOTE ON THE TYPE

John Bell (1746–1831), an English publisher of newspapers and books, started the British Letter Foundry in 1788. Employing the talented punchcutter Richard Austin (fl. 1788–1830), the foundry produced the notable Bell type, considered today a great English type in the tradition of William Caslon and John Baskerville. Inspired by the work of the Frenchmen Pierre Simon Fournier and Firmin Didot, Bell and Austin created what the renowned typographic scholar Stanley Morison has referred to as the first English modern-style typeface, one whose design is characterized by greater stroke contrast and vertical stress than other English types of the period. American type founders copied the Bell type as early as 1792. In 1864, the American book publisher Henry O. Houghton acquired type cast from the original Bell matrices for use by his Riverside Press, which later employed such typographic luminaries as Daniel Berkeley Updike and Bruce Rogers. Updike liked the Bell type so much he created his own version called Mountjoye and Rogers followed suit with his typeface Brimmer. Stanley Morison supervised a facsimile revival of the Bell type by Monotype, in collaboration with Stephenson-Blake, to celebrate the centenary of John Bell's death in 1931.